Niagara ESCARPMENT

PHOTOGRAPHS BY SANDY BELL, VIC MACBOURNIE AND JOHN MACRAE
INTRODUCTION BY JOAN LITTLE

LORIMER

JAMES LORIMER & COMPANY LTD., PUBLISHERS
TORONTO

James Lorimer & Company Ltd. acknowledges the support of the Ontario Arts Council. We acknowledge the support of the Government of Canada through the Book Publishing Industry Development Program (BPIDP) for our publishing activities. We acknowledge the support of the Canada Council for the Arts for our publishing program. We acknowledge the assistance of the OMDC Book Fund, an initiative of Ontario Media Development Corporation.

The Canada Council | Le Conseil des Arts
for the Arts | du Canada

ONTARIO ARTS COUNCIL
CONSEIL DES ARTS DE L'ONTARIO

Cover design: Meghan Collins

Library and Archives Canada Cataloguing in Publication
Bell, Sandy, 1951-
 The Niagara Escarpment : a photographic journey from Niagara Falls
to Tobermory / photographs by Sandy Bell, Vic MacBournie and John
MacRae ; introduction by Joan Little.

ISBN-13: 978-1-55028-934-3
ISBN-10: 1-55028-934-9

 1. Niagara Escarpment--Pictorial works. 2. Niagara Escarpment--Description
and travel. I. MacBournie, Vic, 1959- II. MacRae, John III. Title.

FC3095.N5B44 2006 917.13 C2006-903450-8

James Lorimer & Company Ltd., Publishers
317 Adelaide Street West, Suite #1002
Toronto, ON
M5V 1P9
www.lorimer.ca

Printed and bound in Canada.

CONTENTS

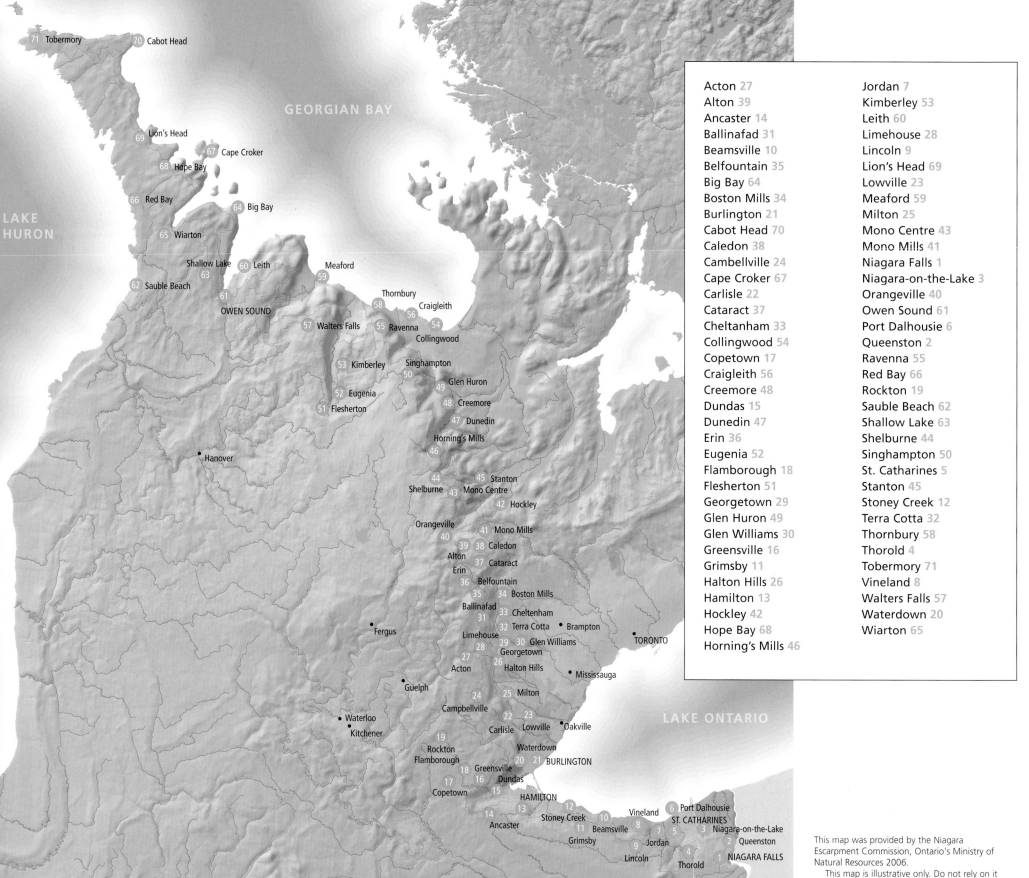

GEORGIAN BAY

LAKE HURON

LAKE ONTARIO

71 Tobermory
70 Cabot Head
69 Lion's Head
67 Cape Croker
68 Hope Bay
66 Red Bay
64 Big Bay
65 Wiarton
63 Shallow Lake
60 Leith
62 Sauble Beach
61 OWEN SOUND
59 Meaford
58 Thornbury
56 Craigleith
54 Collingwood
57 Walters Falls
55 Ravenna
53 Kimberley
50 Singhampton
49 Glen Huron
52 Eugenia
48 Creemore
51 Flesherton
47 Dunedin
Horning's Mills 46
44 45 Stanton
Shelburne 43 Mono Centre
42 Hockley
Orangeville
40 41 Mono Mills
39 38 Caledon
Alton 37 Cataract
Erin
36 Belfountain
35 34 Boston Mills
Ballinafad 33 Cheltenham
31 32 Terra Cotta
Limehouse 30 Glen Williams
28 29
27 Georgetown
Acton 26 Halton Hills
24 25 Milton
Campbellville
22 23 Lowville
Carlisle Oakville
19 Waterdown
Rockton 20 21 BURLINGTON
Flamborough
18 Greensville
17 16 Dundas
Copetown 15 HAMILTON
14 13 Stoney Creek
Ancaster 12
11 Beamsville Vineland 6 Port Dalhousie
Grimsby 8 ST. CATHARINES
9 Jordan 7 5 3 Niagara-on-the-Lake
Lincoln 2 Queenston
Thorold 1 NIAGARA FALLS

Hanover
Fergus
Guelph
Waterloo
Kitchener
Brampton
TORONTO
Mississauga

Acton 27	Jordan 7
Alton 39	Kimberley 53
Ancaster 14	Leith 60
Ballinafad 31	Limehouse 28
Beamsville 10	Lincoln 9
Belfountain 35	Lion's Head 69
Big Bay 64	Lowville 23
Boston Mills 34	Meaford 59
Burlington 21	Milton 25
Cabot Head 70	Mono Centre 43
Caledon 38	Mono Mills 41
Cambellville 24	Niagara Falls 1
Cape Croker 67	Niagara-on-the-Lake 3
Carlisle 22	Orangeville 40
Cataract 37	Owen Sound 61
Cheltanham 33	Port Dalhousie 6
Collingwood 54	Queenston 2
Copetown 17	Ravenna 55
Craigleith 56	Red Bay 66
Creemore 48	Rockton 19
Dundas 15	Sauble Beach 62
Dunedin 47	Shallow Lake 63
Erin 36	Shelburne 44
Eugenia 52	Singhampton 50
Flamborough 18	St. Catharines 5
Flesherton 51	Stanton 45
Georgetown 29	Stoney Creek 12
Glen Huron 49	Terra Cotta 32
Glen Williams 30	Thornbury 58
Greensville 16	Thorold 4
Grimsby 11	Tobermory 71
Halton Hills 26	Vineland 8
Hamilton 13	Walters Falls 57
Hockley 42	Waterdown 20
Hope Bay 68	Wiarton 65
Horning's Mills 46	

This map was provided by the Niagara Escarpment Commission, Ontario's Ministry of Natural Resources 2006.

This map is illustrative only. Do not rely on it as being a precise indicator of routes, location of features, nor as a guide to navigation.

PREFACE

The Niagara Escarpment means many things to different people. To the millions of tourists that flock to Niagara Falls it is a grand, bustling, crowded place full of exciting things to do and see. To the skier, it offers a chance to get away for a weekend during the long winter months. To the birdwatcher, hiker, and mountain biker it provides an opportunity to experience nature in their own special way.

For a photographer, the Niagara Escarpment is all of these things and more. Although many of the images in this book capture the grand vistas the escarpment offers in such abundance, it is often the small details hidden in the nooks and crannies, along the back roads, streams, and fields within this remarkable World Biosphere Reserve, that make it a special place for photographers. It's the fern that has found a foothold in a crack in the limestone wall; the fawn following confidently alongside its mother, stopping only briefly to glance over at the photographer who is focused so intently on the pair as they disappear into the forest edges. We would have liked to include more of these intimate details in the book, but decided that we would leave it up to you to discover your own hidden gems and special places as you explore the escarpment.

As photographers, we find the Niagara Escarpment offers us the ability to escape the demands of daily life and get lost in the natural world without driving hundreds of miles. In minutes, we can be in one of the many Conservation areas that have played a major role in preserving this incredible area. Even in the heart of Hamilton, the most industrialized city along the escarpment, the opportunities to experience nature are endless. A few hours' drive to the northern reaches of the escarpment, and we are in a whole different world, where we may stumble across a grouping of wild orchids or, on a larger scale, a black bear and her cub.

And yet, those of us living along the escarpment so often forget to take advantage of all it has to offer. We take for granted that the trees will always be there; that the streams will always run clear and cold; that the wetlands will be forever protected; and that the wildlife will always have a home. Yet, we know that modern society is constantly putting pressure on these last wild places. It is important that we all do our part to protect these valuable places—not only for our own benefit, but also for the enjoyment of our children and their children.

Remember, take only pictures; leave only footprints.

Sandy Bell
Vic MacBournie
John MacRae

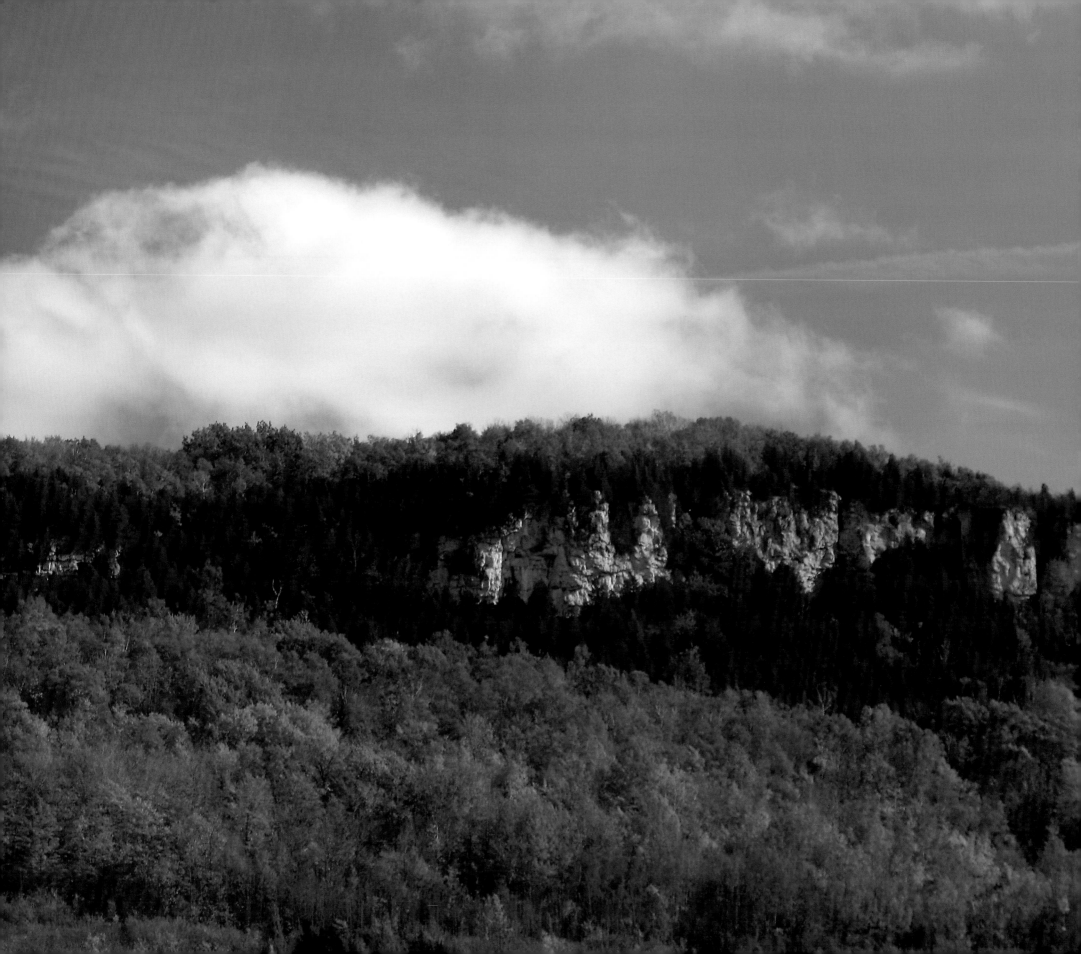

INTRODUCTION

by Joan Little

Ontario's Niagara Escarpment creates a dramatic focal point in the landscape as the mountainous rock formation curves for 725 kilometres (450 miles) from Queenston to Tobermory. Because of its shape, it is often called "The Giant's Rib."

Although the term "Niagara Escarpment" refers only to the section of the formation between Queenston and Tobermory, the escarpment ridge of which it is part first appears near Rochester, New York, generally follows the south shore of Lake Ontario from Queenston to Hamilton, then swings around the end of the lake, and strikes out north to Tobermory at the tip of the Bruce Peninsula. From there it disappears under Lake Huron, reappearing on Manitoulin Island, following the top of Lake Michigan, then continuing down the west side of the lake, into the Door Peninsula in Wisconsin.

The escarpment was formed some four hundred million years ago after the receding of the ancient sea. Over many more millions of years its face was sculpted, as glaciers, meltwaters, and weathering wore away the softer, surrounding layers of shale, leaving the more resistant dolostone. The result was a topography that varies from the steep cliff faces of Georgian Bay to the high rolling hills of Caledon and Mono Township (near Orangeville), where layers of soil and rock were deposited over the ridge. The retreat of the glaciers incised deep valleys, such as the Beaver Valley, northeast of Flesherton, and created chasms, which channelled some of the bedrock into outliers (pronounced out-lie-ers), parts of the escarpment separated from the main formation. One example is the Milton Outlier, of which Rattlesnake Point is part. Because the Niagara Escarpment originated from sediment in a tropical sea, the rock is layered, made up of soft shale and sandstone, and topped by the ultra-hard dolostone (or dolomite) so desirable to the aggregate industry, which provides stone, sand, and gravel for construction.

In the southern section of the escarpment is the Niagara Peninsula, a favourite tourist destination because of Niagara Falls and the area's great agricultural bounty. The unique soil and microclimate of the escarpment bench (a terraced level between the base and the top of the escarpment in that area) enables the growing of superb grape varieties, and popular wineries have flourished here. Hamilton is the industrial hub of this southern part of the escarpment.

The central portion, north of Lake Ontario, running through Halton and Peel Regions and Dufferin County, has excellent farm land. Halton is known for its many great scenic lookouts; in Peel

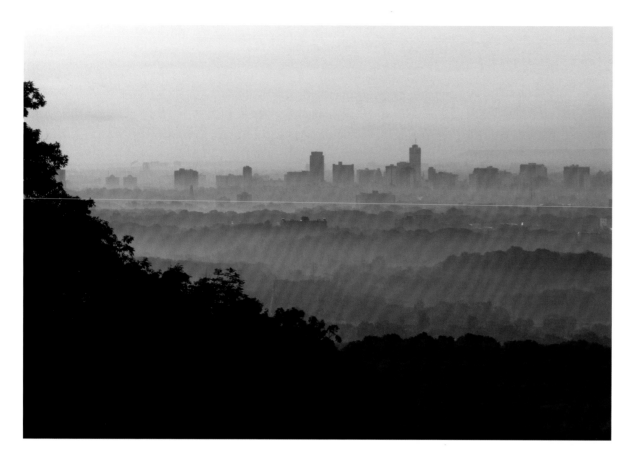

Beamer Conservation Area, just above Grimsby, is one of the best spots in southern Ontario for watching migrating raptors, and Turkey Vultures ride the thermals along most parts of the escarpment all summer. An area near Wiarton with the delightful name of the Slough of Despond yields treasures for the bird watcher. In spring a Scarlet Tanager may appear, while a dull brown American Bittern, camouflaged by reeds, neck stretched skyward, *ge-dunks* his welcome. Those are experiences that make the escarpment a magical place.

Along the escarpment some 53 mammals, 36 reptiles and amphibians, 91 fish species, 98 butterflies, and 37 types of wild orchids have been identified, which gives some idea of the richness of the diversity. Over 40 fern species thrive in Grey and Bruce Counties.

The escarpment is also home to an impressive number of endangered species. The Southern Flying Squirrel is on both Environment Canada's and Ontario's list of vulnerable mammals. Nocturnal, it is under ten inches long, weighs about two ounces, and is big-eyed and appealing. This little animal requires mature deciduous forests, so scientists were excited to find a breeding population in 1999 in Hamilton's Red Hill Valley on the escarpment. But that was before the Red Hill Expressway construction began in 2004, and the impact of that project is yet to be seen.

The Massasauga Rattlesnake still exists in Bruce County, and the rare, and threatened, Jefferson Salamander, dark grey and nondescript, occurs mainly in southern areas around Halton. It, too, has unique habitat require-

Region and Dufferin County, the ridge is harder to discern, covered by gentle, rolling hills formed by the masses of material deposited on the rock millions of years ago by glacial action and meltwaters.

North of Dufferin County, the scarp faces become prominent again, with the highest peaks in the ski areas at Devil's Glen and Osler Bluff south of Collingwood. On the Bruce Peninsula, stark white escarpment cliffs border Georgian Bay.

The variety of escarpment vistas is astounding. A drive down the Clappison Cut on Highway 6 near Waterdown presents a wide-screen panorama of the city of Hamilton, Lake Ontario,

distant landmarks, and even the escarpment's ascent again across the lake. Views from Burlington's Mount Nemo and Milton's Rattlesnake Point are pastoral, seeming to open out forever. At countless spots along the limestone cliffs of the Bruce Peninsula, hikers can pause for breathtaking views of Georgian Bay, whose waters change in mood from dark and angry to tranquil and sparkling.

The escarpment is home to exceptionally diverse flora and fauna. It provides habitat for over 198 breeding bird species, although about 300 species may be seen during a year as transients pass through. The Bald Eagle and Hooded Warbler are two notable breeders.

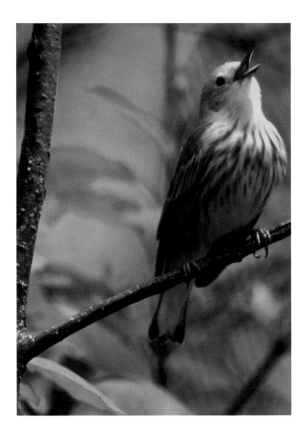

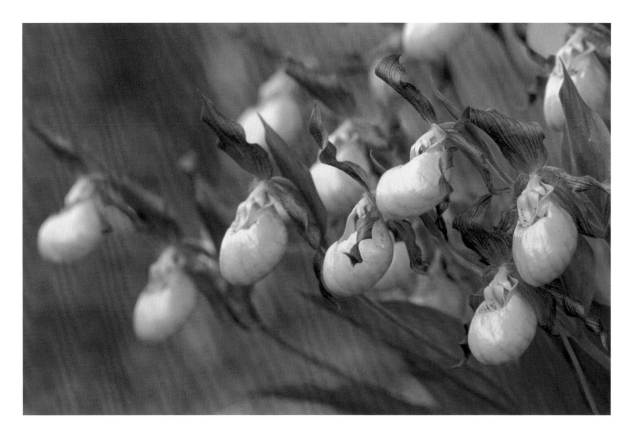

ments, and this habitat is shrinking. Efforts to protect its habitat have presented a problem for aggregate companies seeking expansions to their quarries in the area.

The Hart's Tongue Fern occurs only on the escarpment. In northern areas, along with ferns, orchids such as the Yellow Lady's Slipper thrive, and if you are really lucky you may see the delicate Calypso Orchid. Stunted cedar trees up to 1,650 years old have been discovered growing from the rock along the escarpment's edge, their age amazing even the scientists who found them. These are not the only ancient treasures of the escarpment; it contains more than a hundred significant geological sites, including some of the world's best exposures of rocks and fossils of the Silurian and Ordovician periods, which occurred four hundred to five hundred million years ago.

In *The Niagara Escarpment*, photographers Sandy Bell, Vic MacBournie, and John MacRae have presented the beauty of the escarpment in all seasons and moods. No one who turns these pages will be able to deny that it is indeed a natural treasure.

It is, however, a treasure that is under constant pressure in our changing world, and it has become clear that constant vigilance is necessary to preserve it—not just for those who enjoy it today, but for future generations. The escarpment's many wetlands and forests, the variation in soils and climates, provide the unique ecosystems that sustain the diversity of flora and fauna. Today, wildlife corridors connect many of the escarpment's regions. Develop or drain the wetlands, cut down the forests, drive a highway through a sensitive area, and the entire system collapses.

To acknowledge that the escarpment environment is indeed unique, and in hopes that the action would lead to a recognition of its importance, in February 1990 UNESCO (United Nations Education, Scientific and Cultural Organization) named it a World Biosphere Reserve—only the sixth in Canada at the time. It is currently one of only thirteen in Canada, and part of a network of more than four hundred sites worldwide.

But not everyone agrees with the degree of protection afforded the escarpment. Along its length there is pressure from landowners to permit the land to be used for housing or commerce. With building lots commanding high prices today, the entire escarpment is in demand, and areas with great views are subject to particular pressure. Niagara Region's location makes it a prime target for applications for uses to serve nearby large populations—more highways, quarries, and tourism—even though its specialty agricultural land is irreplaceable. Halton and Peel Regions are under constant pressure from the aggregate industry because of their proximity to markets in the greater Toronto area, and are also in a perfect location for golf and conference/convention facilities. Dufferin County is increasingly attractive to commuters because of its pastoral communities. The ski areas of Simcoe and Grey Counties are also appealing, not just as locations for ski services, but for the condos to go along with them. The municipalities are having a hard time keeping up with demands for services from the ski communities. Bruce County, perhaps because it is farther away, is not under as severe pressure.

Luckily, years before "escarpment" was a household word, there were those who understood the importance of the Niagara Escarpment: naturalists, photographers, artists, hikers, and conservation organizations among them. The Hamilton Naturalists' Club spawned many of its strongest advocates. Today the Bruce Trail Association and many naturalists' clubs are active along the escarpment, focusing not only on the Giant's Rib itself, but on such issues as water quality and stream rehabilitation in the general region.

Ray Lowes, a Hamilton naturalist, grew up in Saskatchewan, where boys could run and walk anywhere, where "trespassing" was a foreign notion. In 1960 he had a dream: to create an Ontario walking trail. The Niagara Escarpment, from Queenston to Tobermory, provided the ideal setting, with its diversity of animal and plant life and its seeming wilderness close to urban areas. After years of discussions and planning, and countless hours spent by a horde of volunteers, his dream was realized: the 725-kilometre (450-mile) Bruce Trail opened in 1967. Today's Bruce Trail Association (with its Walking Fern symbol) is made up of nine local clubs along the length of the escarpment. The trail, a continuous footpath, now covers more than 800 kilometres (nearly 500 miles), including over 300 on side trails, and receives about four hundred thousand visits a year. It is one of Ontario's most popular recreational facilities, attracting numerous international tourists. Even today much of the trail is on private land because private landowners generously allowed it. It is estimated that, if the association had to buy that land, the cost would be about $50 million. In recognition of that generosity, the 8,500 members of the association live by a code when walking the trail: take nothing but photographs, leave nothing but footprints.

Robert Bateman, internationally known wildlife artist, is another alumnus of the Hamilton Naturalists, who later built a Burlington escarpment home and produced some of his best-loved paintings with the escarpment as a backdrop. Always generous to escarpment causes, he has lent his name and donated art to many groups working to improve its protection, and remains an outspoken supporter of the escarpment and the environment.

The escarpment has always been special to those living near it, such as Lowes, Bateman, and many others, but it took public outrage and a group of protesters to spur the government to act for its protection. By the early 1960s residents were already sick of seeing their escarpment carried away a truckload at a time to pave the universe. The final straw was the Dufferin Gap, a raw, gaping hole blasted through the face of the escarpment in 1962, north of Highway 401 near Campbellville, by an aggregate company. Citizens pleaded for relief from the blasting and from heavy gravel-truck traffic, and asked Premier John Robarts to "do something."

That "something" resulted in the commissioning of Professor Len Gertler in 1967 to prepare "a wide-ranging study of the Niagara Escarpment with a view to preserving its entire length." The 1968 Gertler Report led to groundbreaking legislation, when Premier Bill Davis's Progressive Conservative government was in office, which protected the escarpment, and led also to a subsequent escarpment plan, Canada's first environmental plan.

The Niagara Escarpment Planning and Development Act (NEPDA), passed in June 1973, set out how the escarpment would be managed. The purpose of the act is "to provide for the maintenance of the Niagara Escarpment

and land in its vicinity substantially as a continuous natural environment, and to ensure only such development occurs as is compatible with that natural environment." The act called for the creation of a Niagara Escarpment Commission (NEC) to deal with development along the escarpment, to consult widely with the public, and to prepare a Niagara Escarpment Plan (NEP).

The government acted swiftly. It established a main NEC office in Georgetown (with local offices in Grimsby and Thornbury), hired a staff of capable planners, and appointed a commission, which held its inaugural meeting in November 1974.

Ontario appointed seventeen NEC members—one councillor from each of the eight counties or regions along the escarpment, plus nine members from the public, one as chair. Two of the first members of the public on the commission were Ray Lowes and Robert Bateman. That first busy commission travelled the length of the escarpment frequently, holding public meetings. In some areas it met strong resistance and occasionally outright venom. Independent-minded farmers and rural landowners resented "ivory-tower city folks" telling them what they could do with their own land. At a massive citizens' rally at the Orangeville Raceway, Premier Davis was hung in effigy. In the village of Duntroon, NEC planners leaving a public meeting late at night found their tires slashed. In Grey and Bruce Counties, shotgun shells appeared in the mailboxes of northern commissioners, local reeves, and known escarpment supporters.

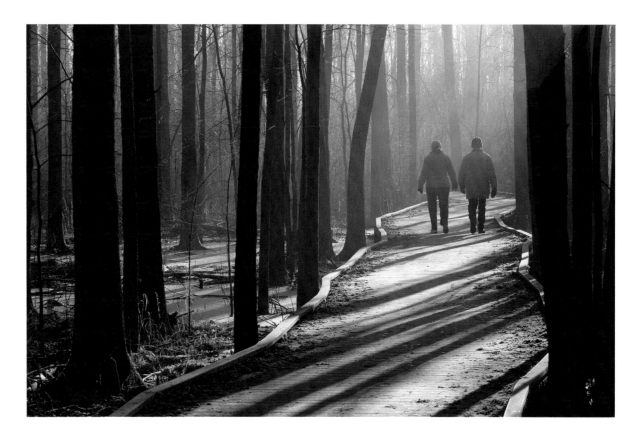

Arriving at the escarpment plan wasn't simple. The government didn't have a blank piece of paper on which to draw. There were already towns and cities, and homes, subdivisions, farms, businesses, and recreational uses on private land. The final Niagara Escarpment Plan, devised by that busy commission after its travels and consultations, covered only about a third of the land originally considered. Finally released in June 1985, it recognizes a system of over one hundred escarpment parks. It has seven land-use designations: Escarpment Natural, Protection, Rural, Recreation, Urban, Minor Urban, and Mineral Resource Extraction. They permit varying degrees of development, with environmental considerations at the fore. "Escarpment Natural"

land is afforded the highest level of protection because much of it covers the escarpment face, forests, wetlands, and areas of high environmental significance. It recognizes existing uses, and a home may be built on an existing vacant lot. Some uses permitted on "Escarpment Protection" lands (usually buffer lands to the "Natural" lands), include new agricultural operations and associated small-scale commercial and industrial uses. "Escarpment Rural" is much less restrictive. Its uses include campgrounds, golf courses, cottage industries, bed-and-breakfast establishments, and new licensed pits and quarries that produce less than twenty thousand tonnes annually, but it allows applications to amend the NEP to permit large new pits and

quarries. (Amendments undergo rigorous review and public consultation.)

The final four designations permit more development. "Escarpment Recreation" applies to the ski areas, and to limited shoreline (cottage) areas around Georgian Bay. Beaver Valley and the Blue Mountains (near Collingwood) are the largest ski areas. Subdivisions are allowed in the ski areas, but, except for previously approved subdivisions, not on escarpment slopes.

"Mineral Resource Extraction" recognizes existing licensed pits and quarries. The "Urban" designation is the least protective and covers the cities and large towns within the NEP. Small villages and hamlets (for example, Limehouse, Belfountain, and Springmount) are listed as "Minor Urban" areas. The NEP encourages development in Urban and Minor Urban areas, rather than in areas assigned the more restrictive designations.

A development permit system is used for escarpment development. Plans are filed with the NEC, and then agencies that may be affected by the development (for example, a health unit, conservation authority, or municipality) are asked to comment. Approvals for applications that conform to the plan are processed quickly at the staff level, and, if one of the agencies raises concerns, the issue goes to the full commission for a decision. To this day, however, detractors insist that "you can't even paint your barn without the NEC's approval." Nothing could be further from the truth!

Since the plan was first drawn up, the Province has ordered two plan reviews, identifying the issues to be reviewed. The first amended plan, released in June 1994, banned rural subdivisions and eliminated golf courses from the sensitive Escarpment Protection designation (they are still permitted in the less-sensitive Escarpment Rural designation). The second update, in June 2005, focused on winery policies because wineries were now mushrooming in the Niagara region. Another important change was the inclusion of long-term environmental monitoring policies to identify environmental changes and minimize environmental deterioration. The next review is scheduled for 2015.

The NEC has also initiated a program of annual awards, recognizing particularly sensitive examples of escarpment development, and recipients have been delighted with this affirmation of their efforts.

Ultimately, however, the success of escarpment protection rises and falls on the strength of the seventeen commissioners. In 1986, I was appointed to the commission, and in 1993 was named chair for a three-year term. Commission members during those years were an interesting mix from the pro-conservation and pro-development camps, and this resulted in some frustrating debates.

Of concern to the NEC is the manner in which philosophy changes with changing governments. Today the plan is highly regarded and internationally recognized, but it wasn't always so. The NEC was supported throughout the years when Bill Davis's and Frank Miller's Progressive Conservatives were at Queen's Park, and also through David Peterson's Liberal years, and by the NDP, under Bob Rae. That changed in 1995 with Mike Harris's Progressive Conservative election. During his years, the commission was almost dismantled. Its budget was nearly halved, a third of the staff was eliminated, and its Grimsby office was closed. The Province neither re-appointed expiring members nor replaced them for almost a year.

Worse, rumours were rampant that the government planned to abolish the commission and turn implementation of the plan over to the municipalities. It was a time of despair for the staff, commissioners, and supporters. In addition, when that government appointed members, they tended to be very pro-development—in a commission set up to uphold Canada's first environmental plan. To his credit, Harris's 2002 successor, Ernie Eves, appointed more appropriate members.

Dalton McGuinty's Liberal government, fortunately, took a very supportive approach when it came to power in 2003. They appointed a competent mix of people well suited to deal with the NEP. Among them were a biologist, a videographer/writer, a university lecturer, a farmer, retailers, and a retired NEC planner.

In some ways the NEC had been like an orphan, shunted from family member to family member. It started its life under the aegis of the Ministry of Municipal Affairs, spent a short time under the Ministry of the Environment, and then in the Harris years was moved to the Ministry of Natural Resources (ironically, the same ministry that issues licences for pits and quarries). The commission remains under that ministry today.

The commission, the plan, and the govern-

ment itself have come under loud attack from several groups over the years.

One group formed in the early 1990s, the Niagara Escarpment Landowners Coalition, had members who were from development interests, ski resorts, golf clubs, and wineries, farmers, and planning consultants. They worried that the NEP could derail their plans. They approached municipal councils, asking them to take over responsibility for issuing development permits, because a single escarpment-wide agency is more likely to make consistent decisions along the escarpment's length than are eight different county/regional councils, which might have differing agendas. The Harris regime appointed one of that group's activists to the commission. The group even tried to get the NEC's World Biosphere Reserve status removed, claiming that the commission had not been doing adequate monitoring.

The Niagara Peninsula has long been famous for its tender fruit farms and vineyards, but its estate wineries are a recent phenomenon. One divisive commission debate occurred around 1990, when a farmer wanted to turn a vineyard into a subdivision. The application was refused. This land, part of the escarpment bench, has excellent soils and a unique microclimate that stimulates the growth of wonderful new grape varieties, which are now a staple in the production of Niagara's high-quality wines. Its VQA (Vintners Quality Alliance) wines are in great demand now. Had the farmer succeeded, no doubt other subdivision applications would have followed, leading to what? Not today's wonderful wineries!

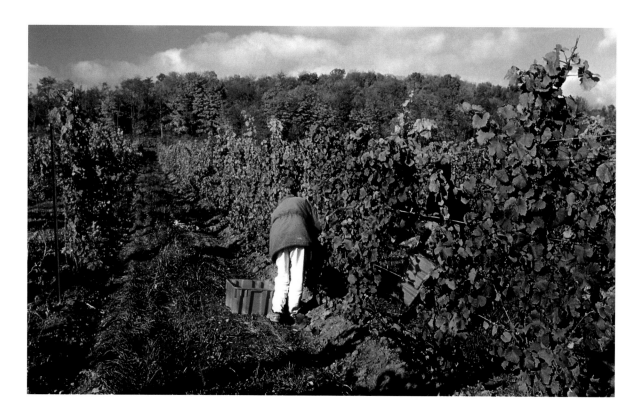

The growth of the wineries has been a difficult issue for the NEC. As they achieved success, wineries have asked for more and more tourism uses on their lands—among them, restaurants, a culinary centre, a lecture theatre, fifty-six overnight cottages "to enhance the winery experience," large outdoor events, and so on. The difficulty lies in balancing the agricultural capacity of the land and the need for clean drinking water and adequate sewage disposal against the intensity of tourist-oriented extra uses. It's a competitive market, so pressures are likely to increase.

There have, of course, also been battles along the way that the commission has lost. Hamilton is the escarpment's industrial city, but even in the city proper there are wooded escarpment trails and countless lovely waterfalls. Unfortunately, Hamilton is also the site of the Red Hill Valley Expressway, approved by the provincial cabinet in March 1987, following an environmental assessment and a joint board hearing (Ontario Municipal Board and Environmental Assessment Board). The provincial cabinet ordered the NEC to issue a development permit. Today, approvals lapse, but at this time there was no sunset clause to the cabinet-approved permit, and few conditions. In 2004, when Hamilton was preparing to start construction, Aboriginal groups and other expressway opponents pleaded with a newly appointed NEC to squelch the approval, but there was no legal basis to do it. The expressway is a 1950s answer to a 2006 problem, and required blasting of the actual escarpment face to construct.

The Dufferin Aggregates application for a quarry extension near Campbellville, in Halton Region, was particularly contentious. Excavation would occur below the water table, requiring dewatering (pumping to keep water away from the quarry floor). Sucking out all that groundwater could have a detrimental effect on the water table, so a complicated system of 126 recharge wells was proposed to return the water to the ecosystem. The system would require ongoing active monitoring and maintenance (and pumping where necessary) in perpetuity, raising long-term environmental and financial concerns. The commission's staff had serious concerns about these long-term effects of the unproven technique, and recommended refusal of the application. Another wrinkle was that Dufferin offered to redesignate adjacent land "Escarpment Natural," which some commissioners saw as "let's make a deal" planning.

In October 2002 only five of the seventeen Harris-appointed commissioners voted against Dufferin's proposal and in favour of protecting the escarpment. Commissioner Robert Boraks claimed that this unproven system of pumping and returning the water in perpetuity would put the escarpment "on life support," and opponents were horrified and appealed the decision. Both sides hired hydrogeologists for the hearing, who not surprisingly presented opposing opinions on the system's viability. The Consolidated Joint Board ruled in favour of the proposal. Our grandchildren will be the final judges of this decision.

If there is one recurring public criticism of the NEP, it is that it is too liberal about pits and quarries. Frustration with quarries led to the initial Gertler Report, but escarpment quarrying is still widespread. It is understandable that aggregate producers are keen to mine the escarpment. The rock is of an excellent quality, near the surface, cheap to produce, and close to the largest markets. However, it has been a disappointment for many people who live in the areas that, when the aggregate in nearby quarries was depleted, the quarries did not close. Instead the aggregate companies have been making ongoing applications to expand onto adjacent lands.

The whole purpose behind a Niagara Escarpment Plan was to protect the escarpment. Its strength is its emphasis on preserving natural areas, wetlands, and escarpment parks, many of which would surely have disappeared by now without the plan's protective measures. The ecological value of forest cover, wetlands, and unbroken wildlife corridors cannot be overemphasized. And in today's world, where "intensification" is the buzzword, what would our urbanized world be like without green oases?

Today, despite its many problems and challenges, Canada's first environmental plan is the envy of other countries. International groups frequently visit the NEC for advice on establishing similar protective plans. Not far from home, the Oak Ridges Moraine Plan was modelled after the NEP, and there are similarities in the province's 2005 Greenbelt Plan, established to prevent urban sprawl onto good

agricultural land in southern Ontario. Greenbelt legislation also finally transferred to the NEP escarpment lands that had been included in the Parkway Belt for temporary protection back in the 1970s.

Biosphere reserves such as the Niagara Escarpment have to have one or more protected core areas that preserve significant ecological features. The escarpment parks and land designated "Escarpment Natural" fulfil that mandate. Buffer zones around those cores may be used in ways that do not affect the protected areas. Biosphere reserves are not sterile; they recognize a variety of other land uses. The preserved natural areas in the reserves are a standard by which to measure the effects of human activity on the environment. In 1992 the NEC's director was invited to a biosphere conference in Seville, Spain, to explain how the unique escarpment plan works. The NEC received a further honour in 2004, when it was the recipient of the Canadian Institute of Planners' "Vision in Planning" award.

No history of the protection of the Niagara Escarpment would be complete without recognizing the influence of a great volunteer organization—the Coalition on the Niagara Escarpment, or CONE. It is a coalition of over thirty environmental organizations, and has been the escarpment's most persistent advocate, contributing valuable research, supporting land acquisition, and lobbying against inappropriate development. It was begun in 1978 by a whirlwind named Lyn MacMillan (later an NEC commissioner), and has constantly lobbied the government on NEC issues.

CONE was instrumental in gaining support for the initial NEP, although this gained it hostility in some areas. It lobbied the provincial government against several inappropriate developments, often successfully, and actively supported land acquisitions. During the years when the commission was not judicious in carrying out its mandate CONE monitored commission meetings, and even issued annual report cards on members' voting patterns. In 1995 it received the Lieutenant Governor's Award for Conservation.

CONE raised funds to install "Escarpment Country" road signs along the escarpment and, later, signs reading "Welcome to the Niagara Escarpment—A World Biosphere Reserve." It even produced a 104-page book, *Protecting the Niagara Escarpment: A Citizen's Guide*. Its Web site, www.niagaraescarpment.org, offers excellent publications, including books on the geology, ferns, orchids, and waterfalls of the escarpment.

A huge investment of time and expertise went into CONE's "Water Policy for the Niagara Escarpment" study, which it presented to the commission in late 2004. Another significant endeavour was a study on comparative property values inside and outside the NEP area, which provided the first proof that properties inside the plan had a higher value than those outside. Most importantly, it appealed several poor commission decisions, with a high success rate.

In addition to CONE, naturalists' clubs, as they have been for decades, are strong supporters of the escarpment, and local citizen groups have formed when they've seen threats to their escarpment areas. Artists such as Bateman and

singer and songwriter Sarah Harmer lend their visibility to the cause. In 2005, Harmer released the song "Escarpment Blues" on her *I'm a Mountain* album, raised funds with her "I Love the Escarpment" tour along its length, and was instrumental in forming a local group, PERL (Protect Escarpment Rural Lands), when North Burlington was slated for an expanded quarry. Opposition to pits and quarries has spawned several other groups, including Halton's POWER (Protect Our Water and Environmental Resources). It was POWER that joined with CONE to appeal the Dufferin Aggregates approval.

As they consider the future, the escarpment's protectors face many new and continuing challenges, such as the ongoing aggregate applications for quarries, the limited carrying capacity of natural areas for recreational use, commercial water-bottling, new highways, and the building of large-scale wind farms, to name a few.

Tomorrow's escarpment will bear witness to today's decisions by individuals, the Province, municipalities, and the NEC. May it remain the magnificent presence it is today—a presence that is reflected in the following pages.

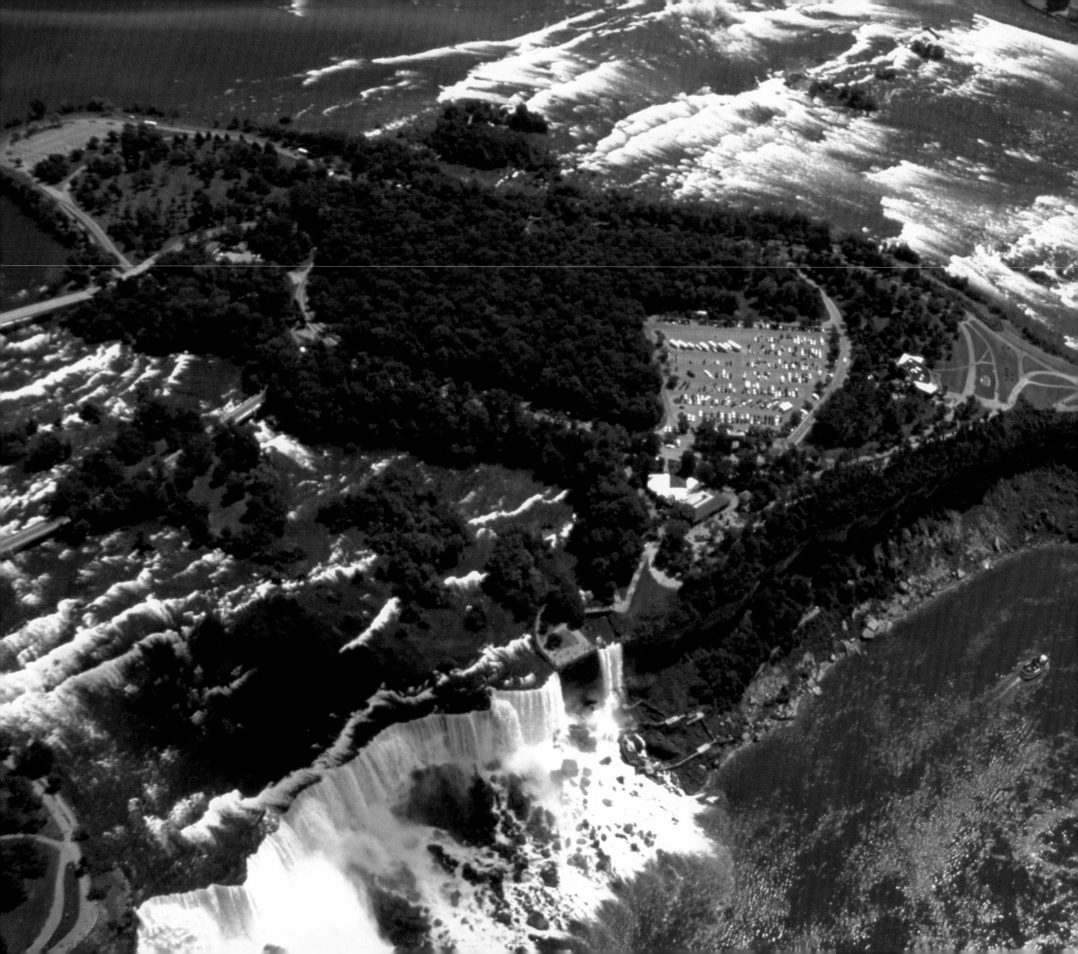

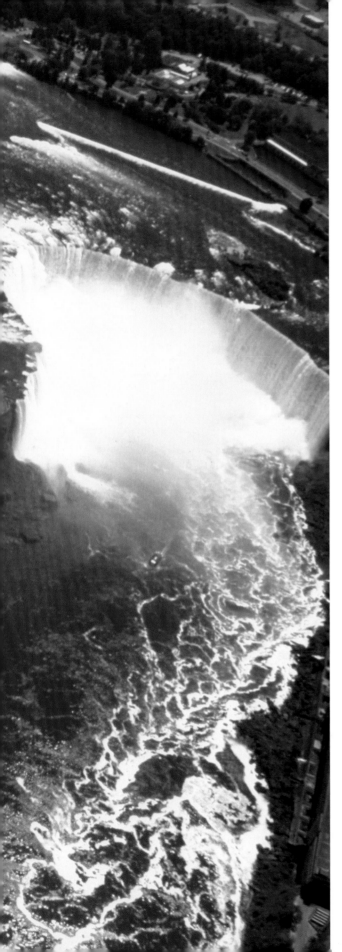

1 NIAGARA PENINSULA

THE NIAGARA ESCARPMENT stretches 725 kilometres, from Queenston near Niagara Falls to Tobermory at the tip of the Bruce Peninsula. It is breached by the rushing waters of the Niagara River and the 11-kilometre gorge between the edge of the escarpment and Niagara Falls. The busy tourism areas that have grown up surrounding the falls quickly give way to some of the finest agricultural land in southern Ontario. This region enjoys a distinct microclimate thanks to the moderating effects of both Lakes Erie and Ontario. The favourable climate, together with a rich soil, makes the area ideal for growing tender fruits, especially premium wine grapes.

This intensive agriculture and the growing urban areas leave little room for the original Carolinian-zone forests that once covered this area. But the surviving forests and woodlots along the escarpment can be spectacular, both in the spring, when spring flowers, including Trillium, Hepatica, Jack-in-the-pulpit, and Spring Beauty carpet the forest floor, and in the fall, when the forests take on the rich colours of the changing season.

Left: The Niagara River, flowing from Lake Erie to Lake Ontario, is divided at Niagara by Goat Island before flowing over the American and Canadian falls. The cataract was originally named by the Mohawk Indians, who called it "Onghiara," their term for "thunder of the waters." The first recorded visit to the falls was made by the explorer La Salle's expedition in 1678. The rock face is receding at the rate of one-third of a metre each year, but the number of visitors to this natural wonder continues to grow.

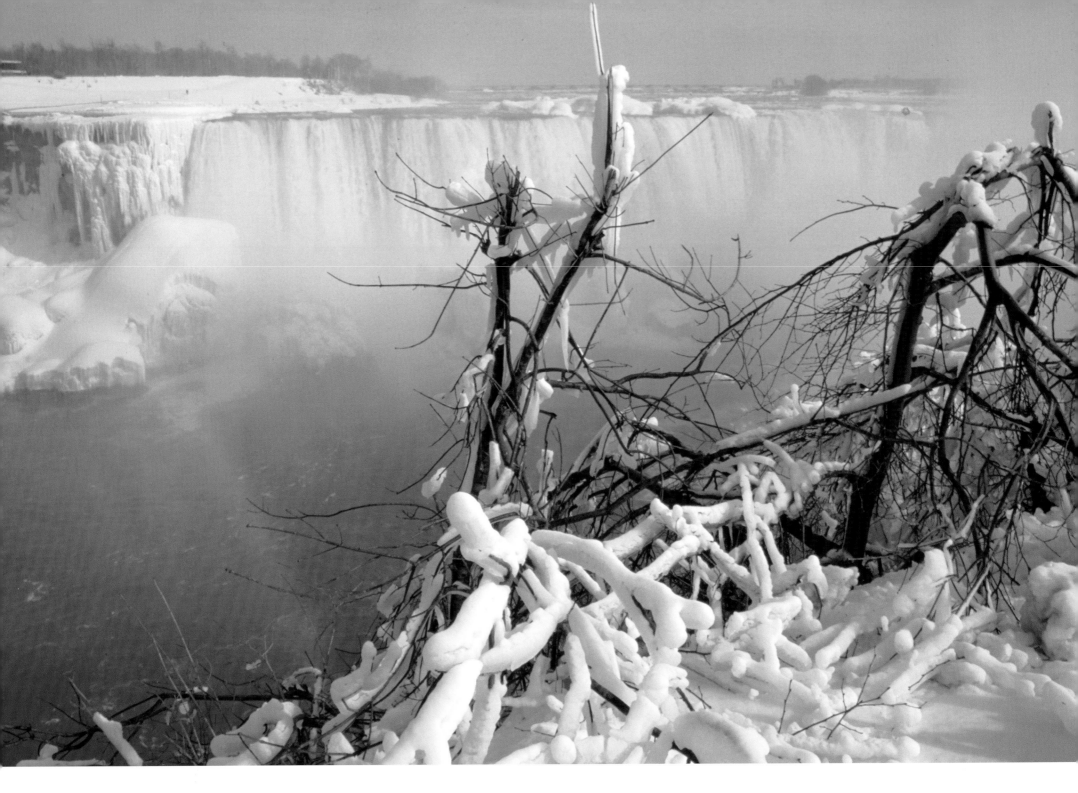

Winter at Niagara Falls creates a totally different spectacle. While they make walking around the falls area difficult, the ice formations are spectacular.

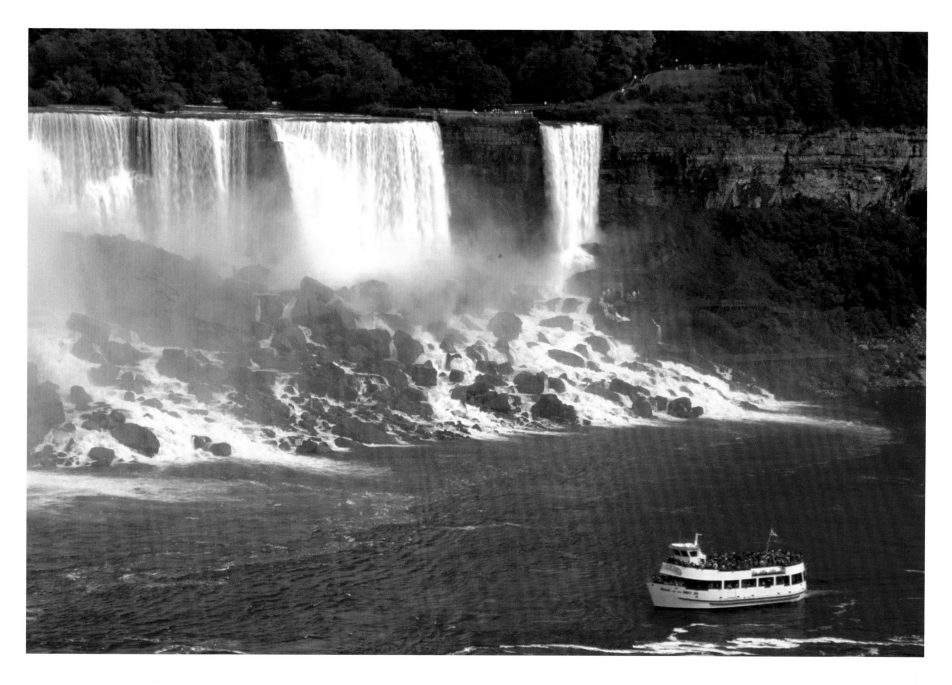

The *Maid of the Mist* continues to be one of Niagara Falls's premier tourist attractions. Since 1846, visitors, including presidents, prime ministers, royalty, and movie stars, have donned raincoats and boarded the boats for a close-up view of the falls.

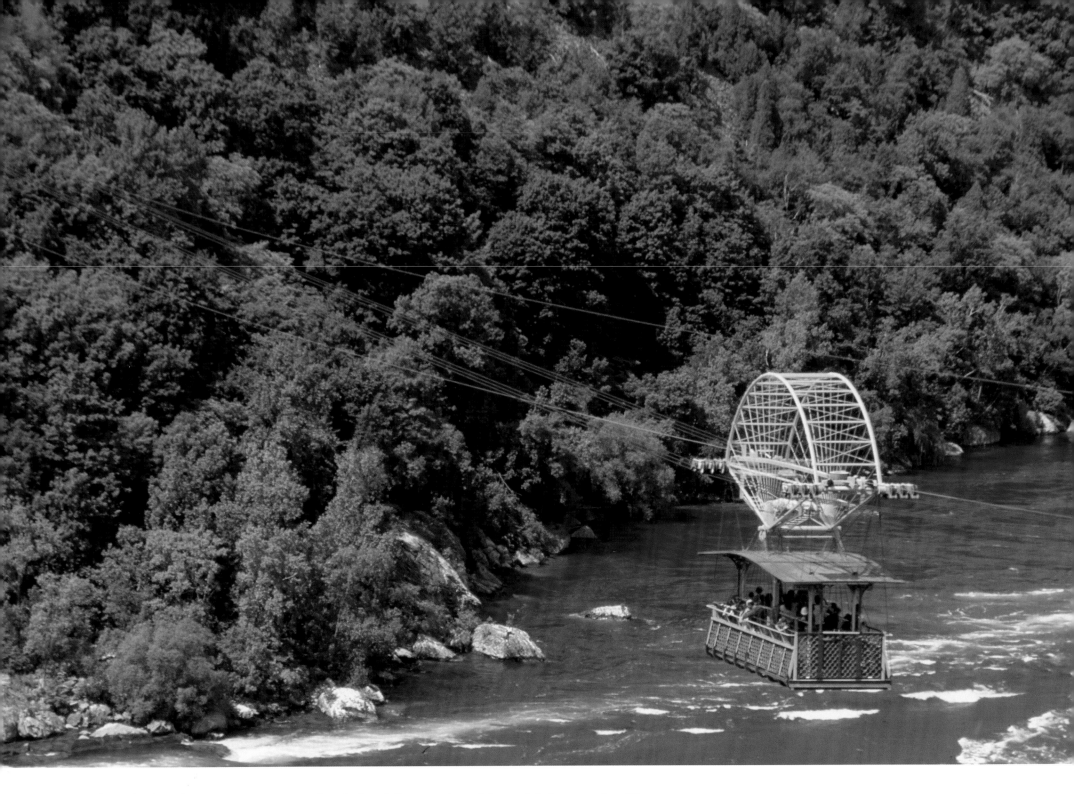

The whirlpool Aero car, just north of the falls, carries visitors high over the Niagara Gorge's fascinating whirlpool on a one-kilometre ride that lasts about ten minutes. Riders experience magnificent views of the gorge, the whirlpools, and the hydroelectric facilities from the Spanish-designed Aero cars.

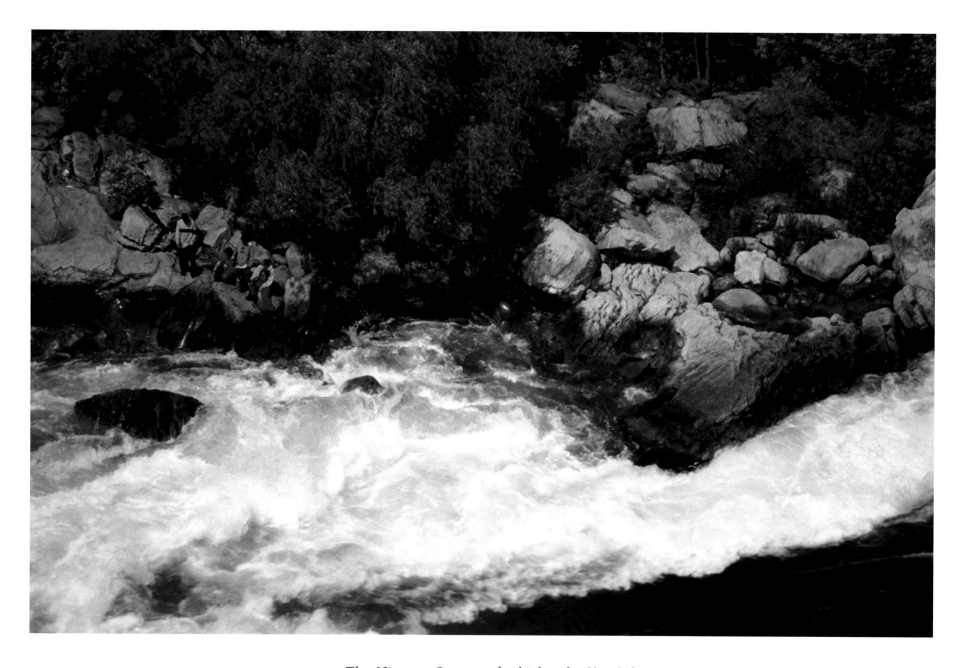

The Niagara Gorge and whirlpool offer fishermen an opportunity to land the big one, although the steep slope and often-slippery rocks make navigating in and around the gorge particularly dangerous.

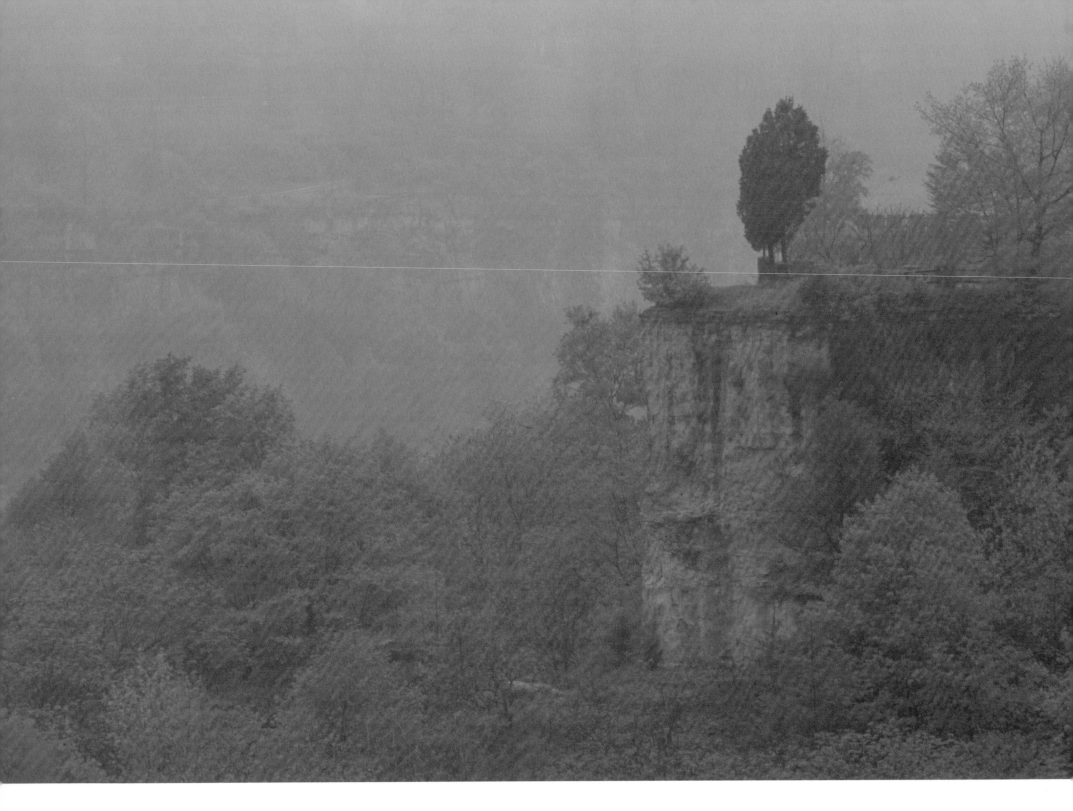

Downriver from the falls and the whirlpool, the Niagara Gorge is at its narrowest. The cliffs drop steeply to the river and rapids.

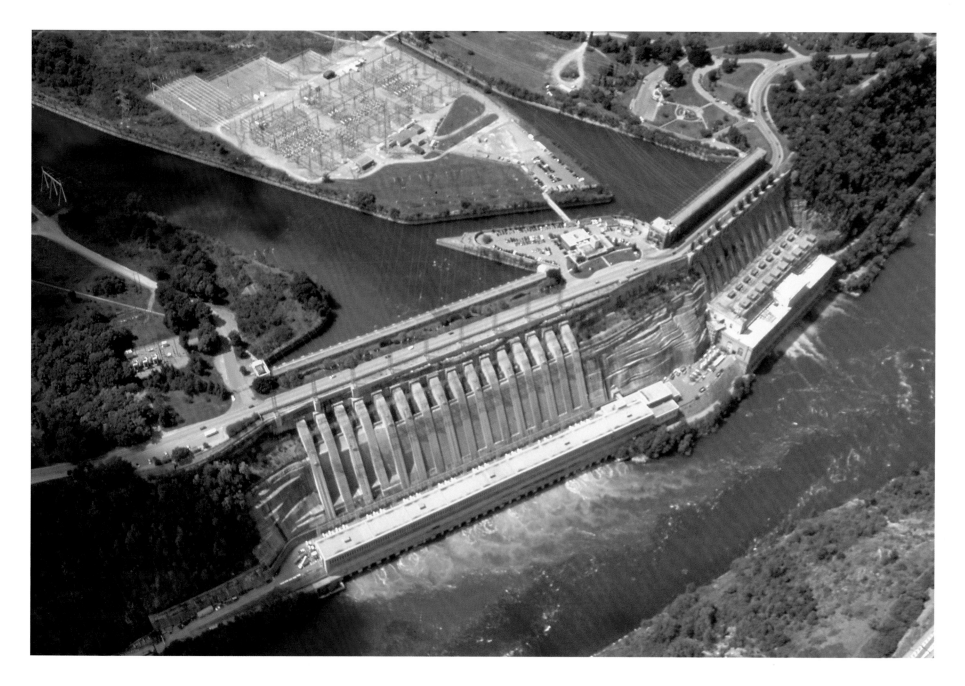

The Sir Adam Beck hydroelectric generating facility, opened in 1958. It derives its supply of water via a tunnel that originates upstream from the actual falls and travels under the city of Niagara Falls. The supply is increased at night, so as not to adversely diminish the amount of water cascading over the falls during the tourist hours.

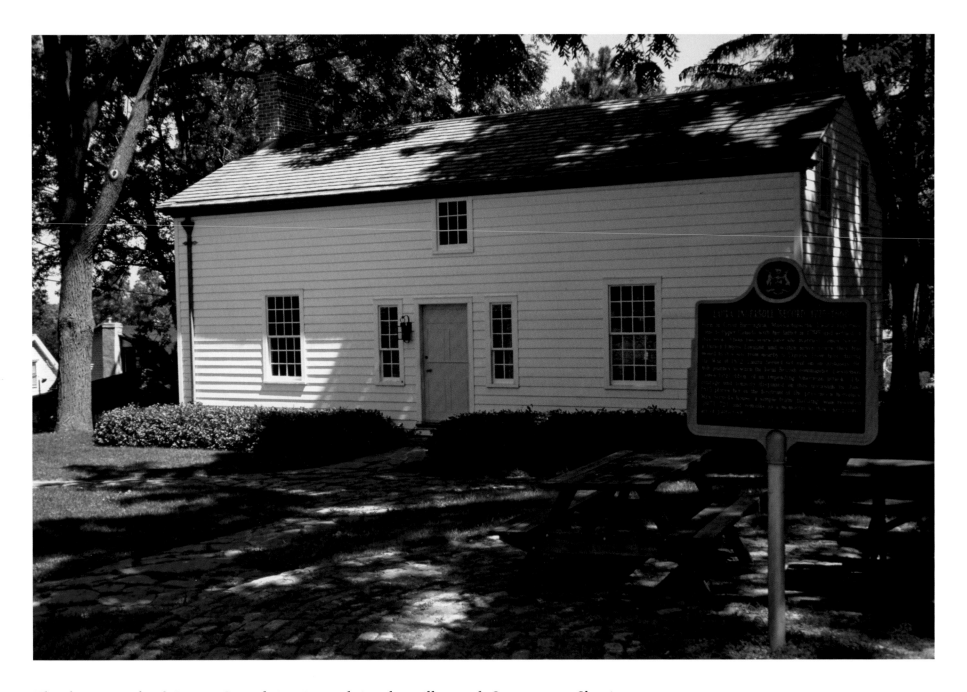

The homestead of Laura Secord is situated in the village of Queenston. She is remembered for her heroism during the War of 1812, when she walked thirty-two kilometres to warn the British of an impending attack by the American forces.

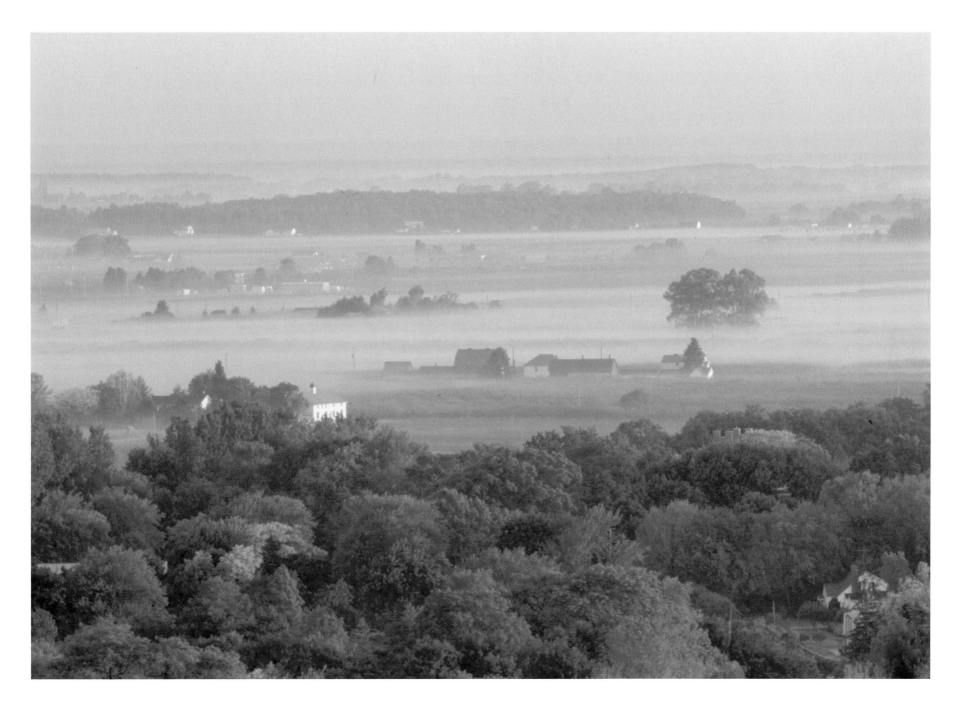

The countryside around Niagara-on-the-Lake, viewed from Queenston Heights. This early-morning scene shows the world-class agricultural lands, dotted with barns and cottages.

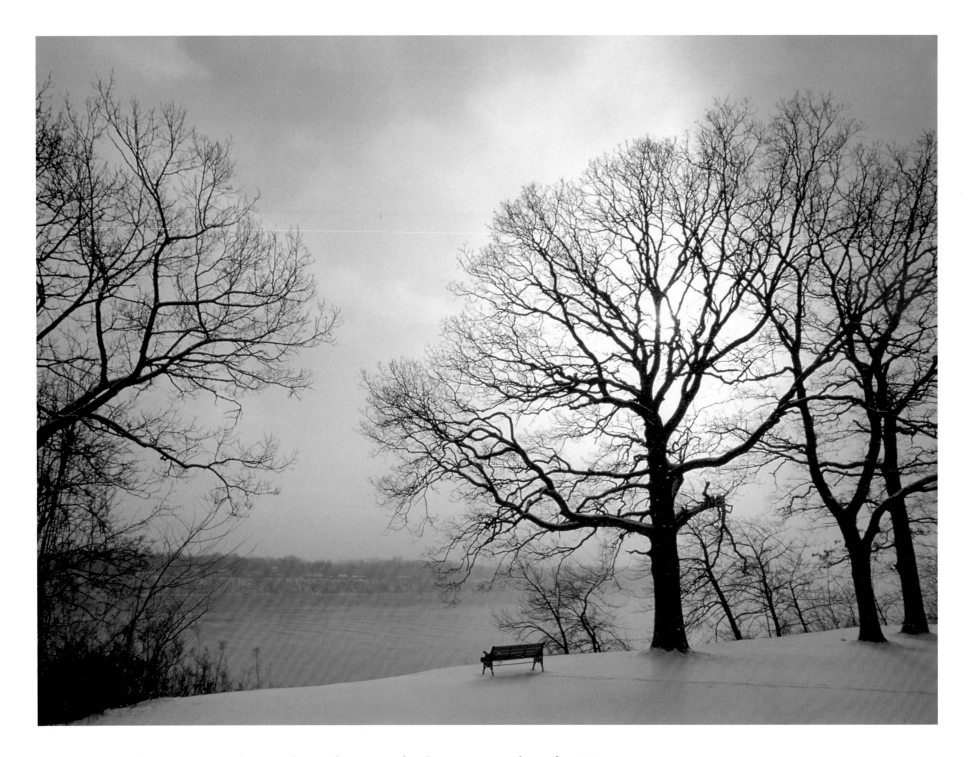

This scene on the Niagara Parkway is located just north of Niagara-on-the-Lake. Winter provides many wonderful moments at this lookout over the Niagara River.

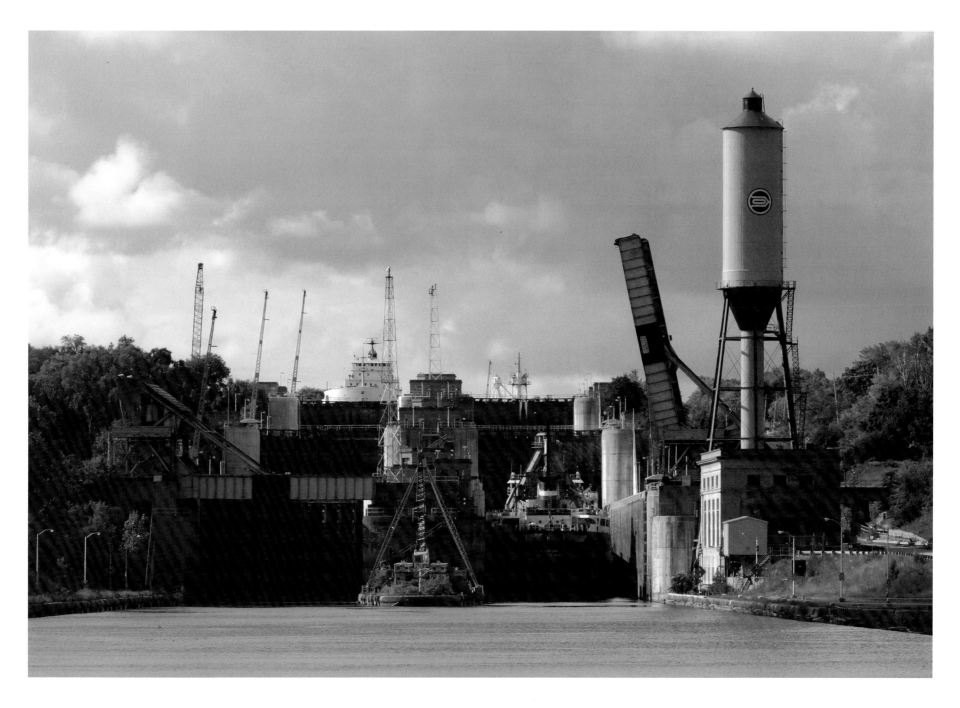

The Welland Canal is important for its ability to move ships full of cargo up and down the escarpment, connecting Lake Erie with Lake Ontario. The twinned locks at Lock 4 in Thorold allow simultaneous locking of ships in both directions. Approximately 3,000 vessels move through the canal each year.

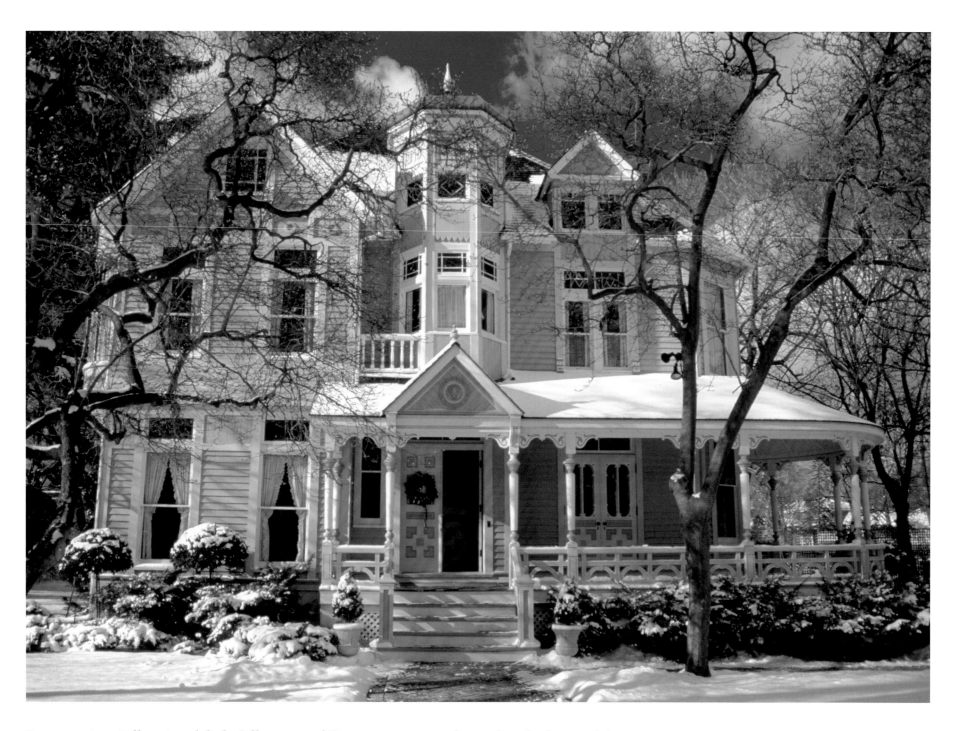

Preservation Gallery is a delightfully restored Victorian mansion located in the heart of the village of Niagara-on-the-Lake. The gallery features the artwork of popular artists, Trisha Romance and Alex Colville.

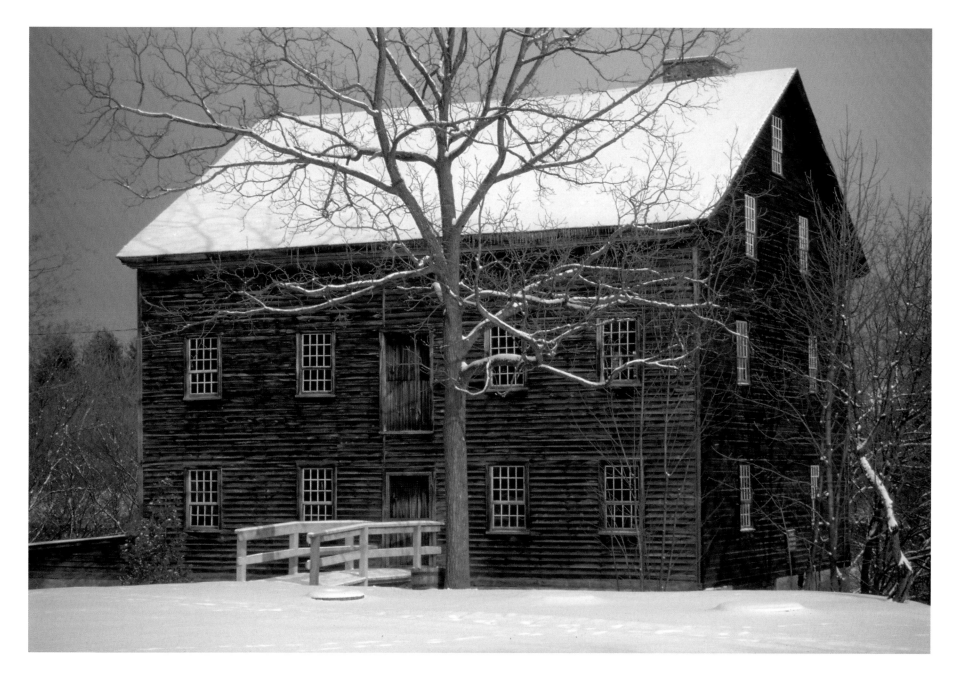

This grist mill is located in the Balls Falls Conservation Area, owned by the Niagara Peninsula Conservation Authority. It was built in 1809 by George and John Ball and remains operational today.

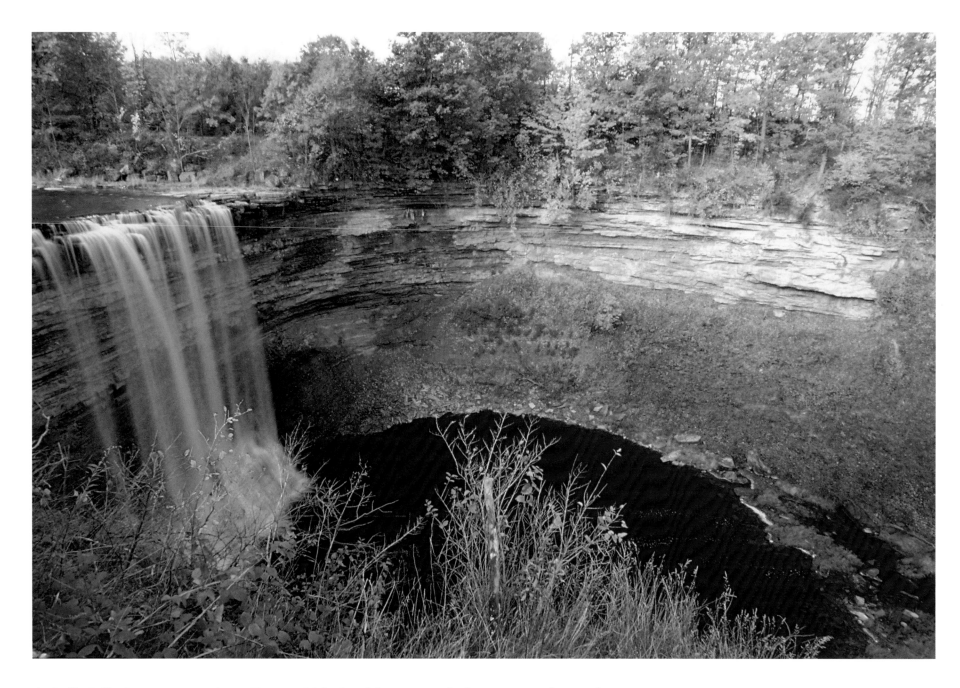

At Balls Falls Conservation Area, Twenty Mile Creek has created a huge gorge where it has eroded the escarpment. Here one can graphically see many of the layers created millions of years ago.

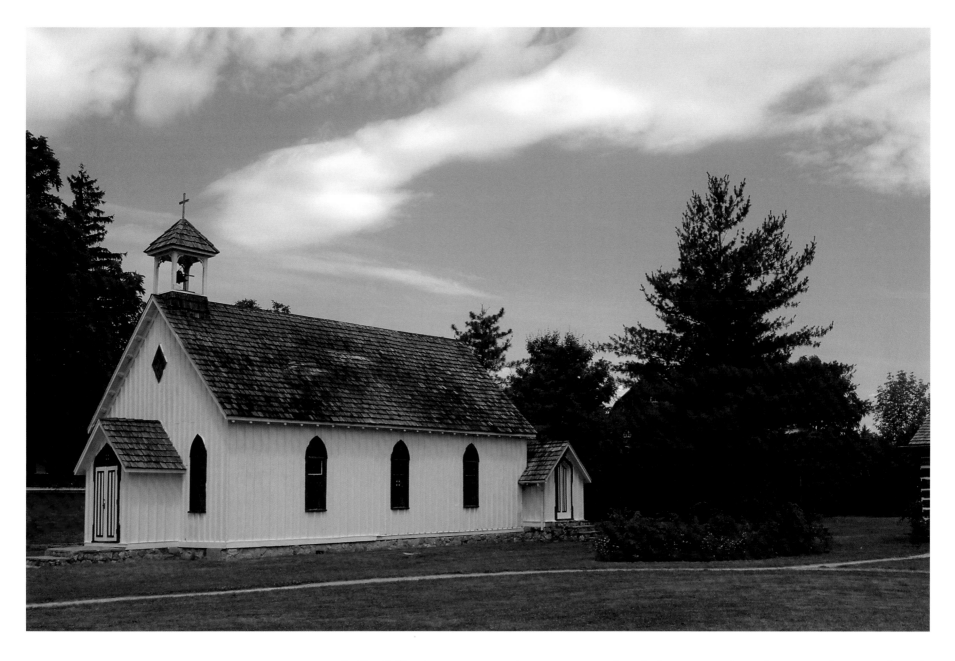

Balls Falls Conservation Area, just south of the town of Jordan, is a historical park operated by the Niagara Peninsula Conservation Authority. In addition to the upper and lower falls that drop a total of 125 feet, the conservation area offers an educational resource, which focuses on pioneer life and its dependency on existing natural resources. The church is one of several historical buildings on the site.

This section of Twenty Mile Creek is located in the agricultural lands above the escarpment. The creek empties into Lake Ontario at Jordan Harbour and drains the second-largest watershed in the Niagara Peninsula.

The asters and goldenrod in an abandoned orchard near Grimsby provide a beautiful palette of colour in September.

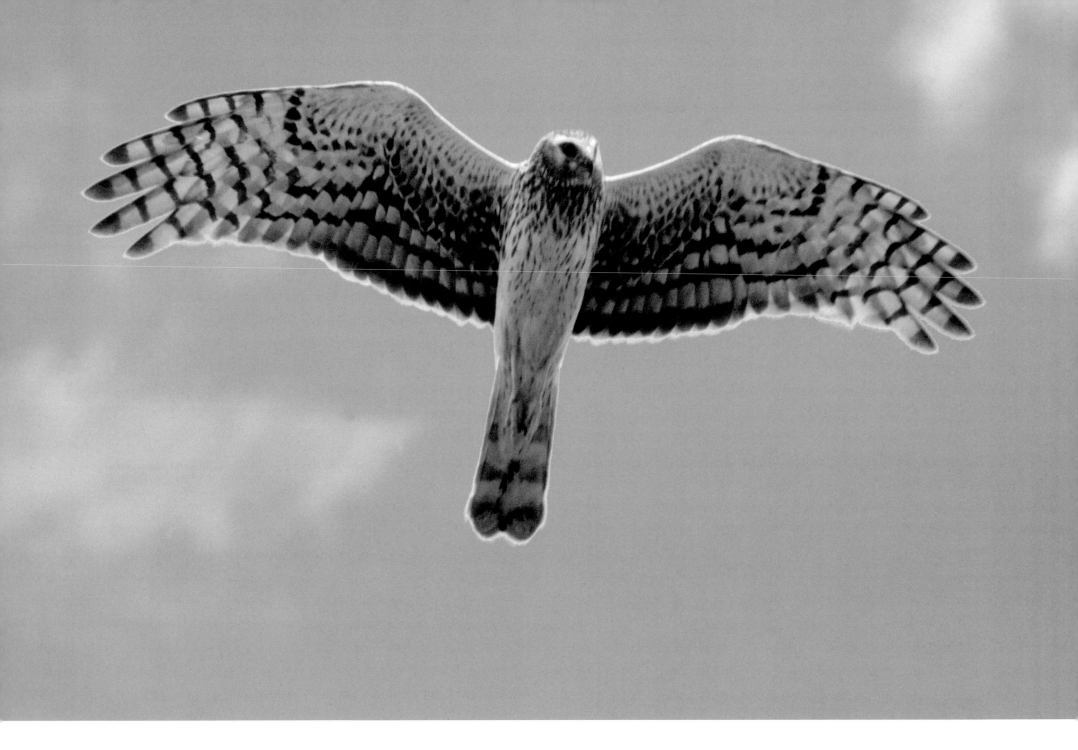

Beamer Memorial Conservation Area is the best vantage point on the Niagara Escarpment to observe the annual hawk migration. This female Northern Harrier is soaring over the landscape.

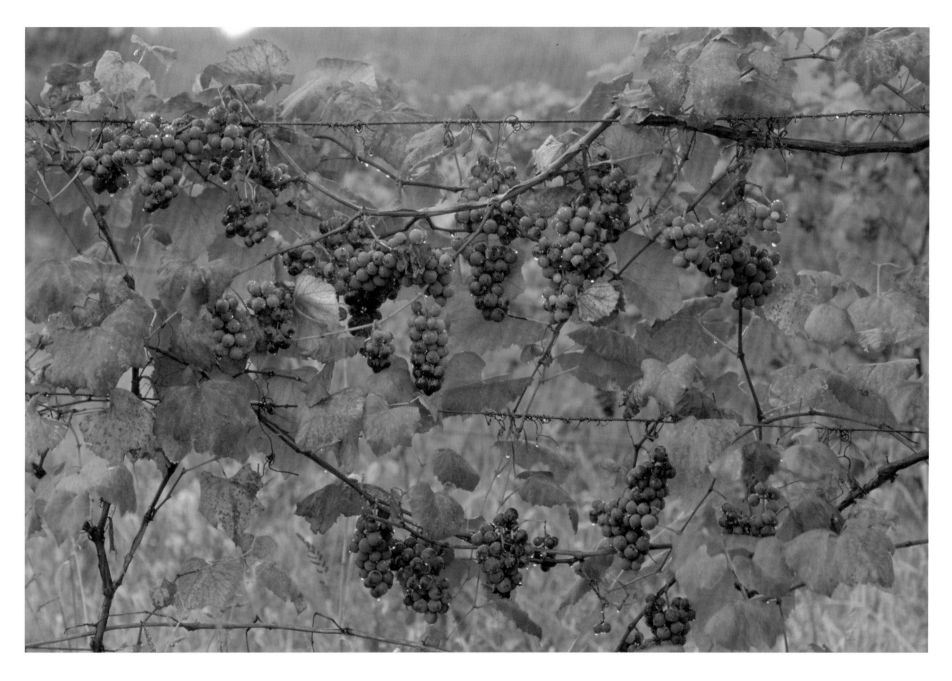

Premium-quality Vinifera grapes ready to be harvested in the Niagara Peninsula wine region. The distinctive soils and unique microclimate are ideal for growing grapes and have created a thriving wine industry with over fifty wineries.

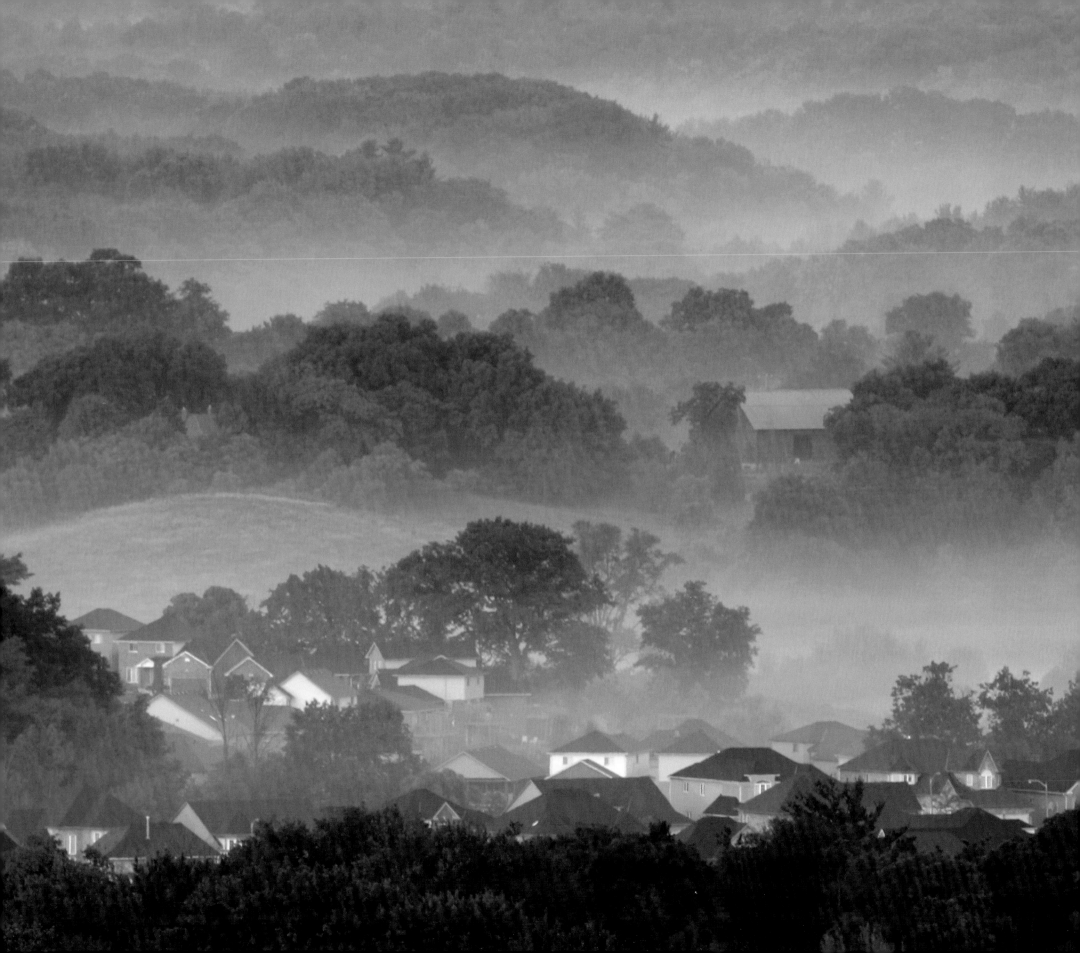

2 HAMILTON ESCARPMENT AND DUNDAS VALLEY

THE NIAGARA ESCARPMENT rises above the City of Hamilton, providing a cool respite to nature lovers who hike the many trails and experience the waterfalls and parks overlooking the busy industrial area below "The Mountain," as it is affectionately called.

The Dundas Valley Conservation Area, with its more than 35 kilometres of trails winding through 1,000 hectares of forest, is home to deer, fox, and coyotes. Here birdwatchers can add to their life lists, and cyclists, joggers, and horseback riders take to the trails.

Spencer Gorge is home to Webster's and Tews Falls—both just shy of the height of Niagara Falls—where numerous streams make their way over the escarpment before emptying into Lake Ontario.

Left: The Dundas Valley is a significant natural area with Carolinian forest and numerous creeks and valleys. The Hamilton Conservation Authority owns over three thousand acres of the valley, protecting it from the urban sprawl that nibbles away at its edges.

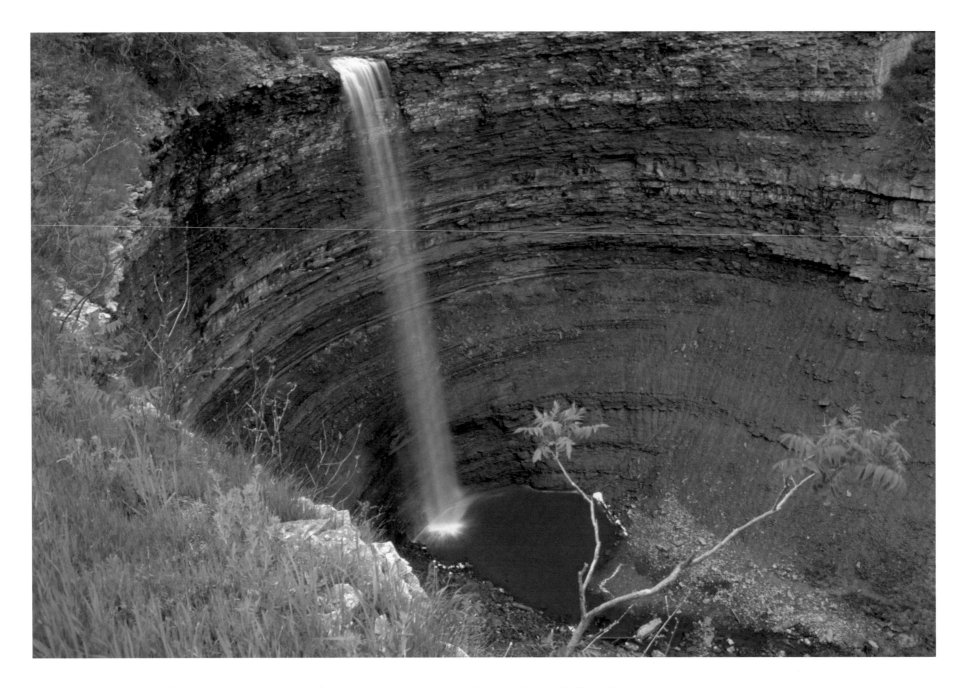

Glacial meltwater flowing over the escarpment carved out this geological "bowl" formation, called the Devil's Punchbowl. A number of stories circulate about how it got its name, but no one seems to know for sure. Stoney Creek now flows over the edge.

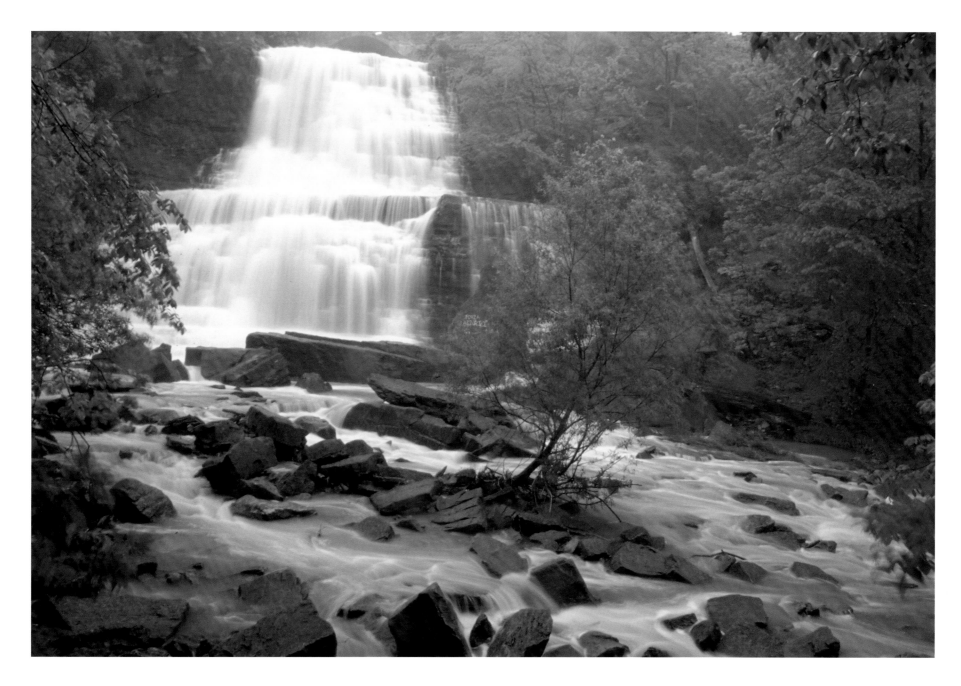

Albion Falls is a classic cascade-style waterfall formed by the Red Hill Creek. It was once considered a potential source for Hamilton's water supply, but increasing urbanization has greatly diminished its flow. Human presence at this site dates back eleven thousand years.

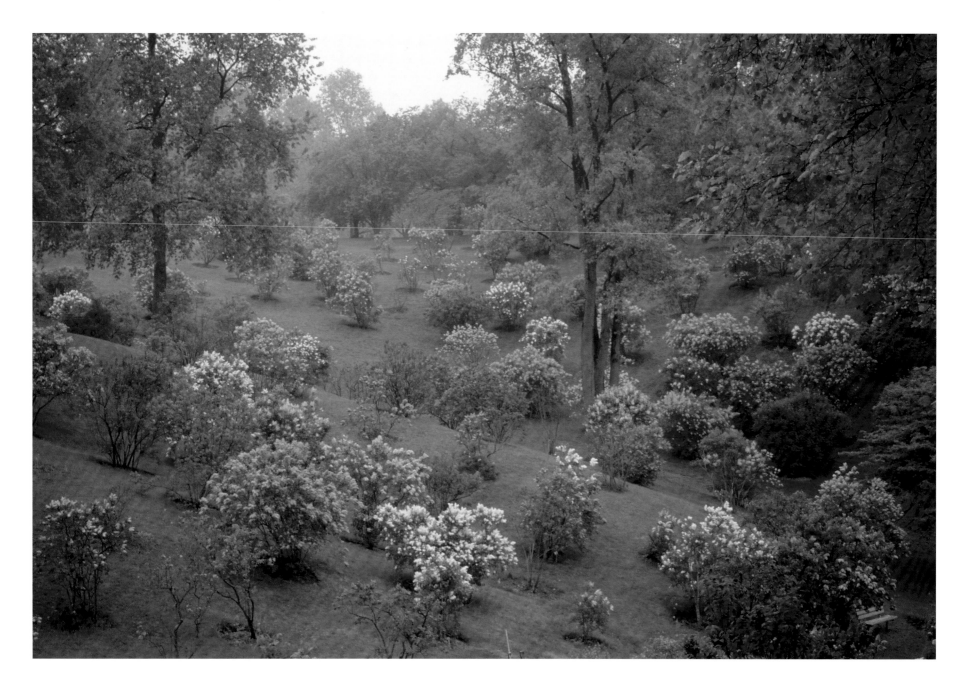

The Lilac Dell at the Royal Botanical Gardens in Hamilton, near the base of the Niagara Escarpment. This is the largest lilac collection in the world, with over eight hundred species and cultivars. They bloom in May with unbelievable fragrance and colour.

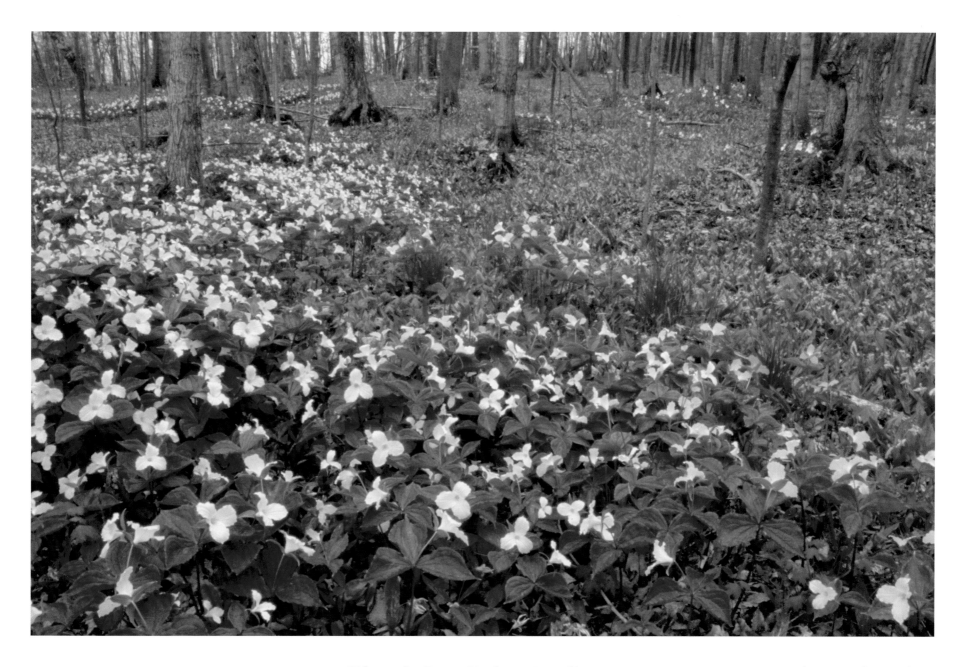

Hiking the Bruce Trail in May offers many opportunities to view the countless White Trilliums in flower. The Trillium is honoured as the official flower of Ontario. This view was photographed in the east end of Hamilton, as the trail enters the city.

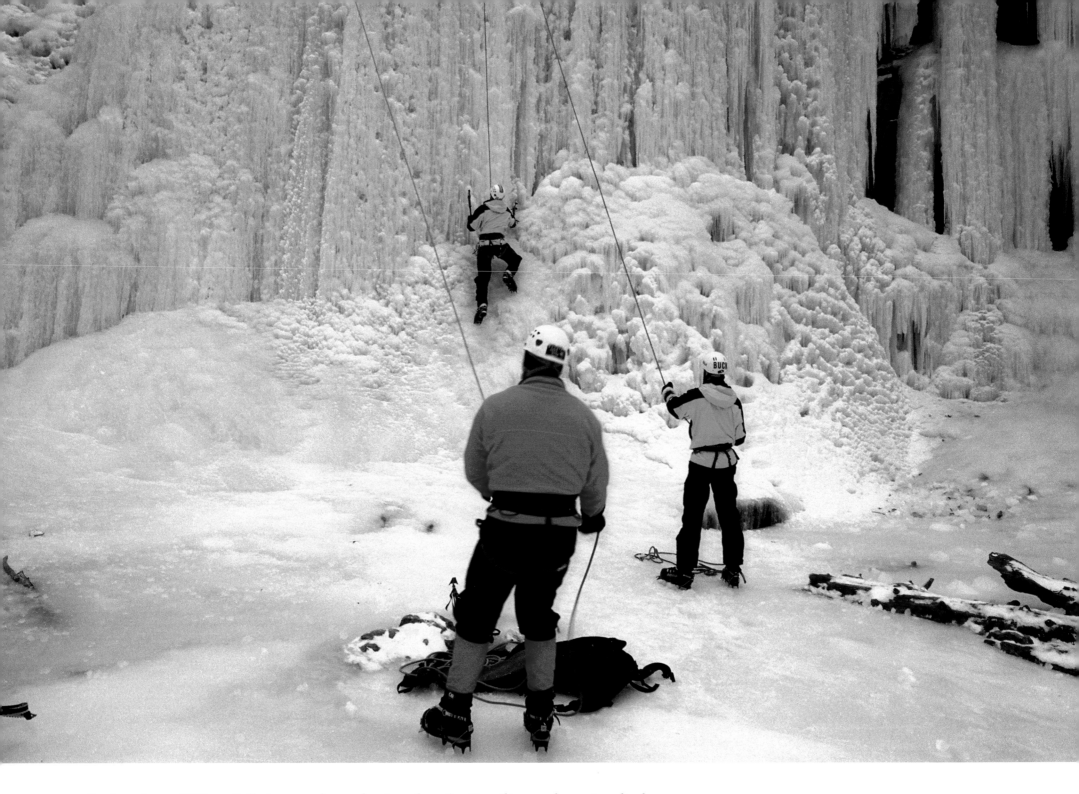

In the winter, Tiffany Falls is a regular gathering place for Hamilton and area ice climbers, who scale the escarpment with the aid of spiked boots and ice axes.

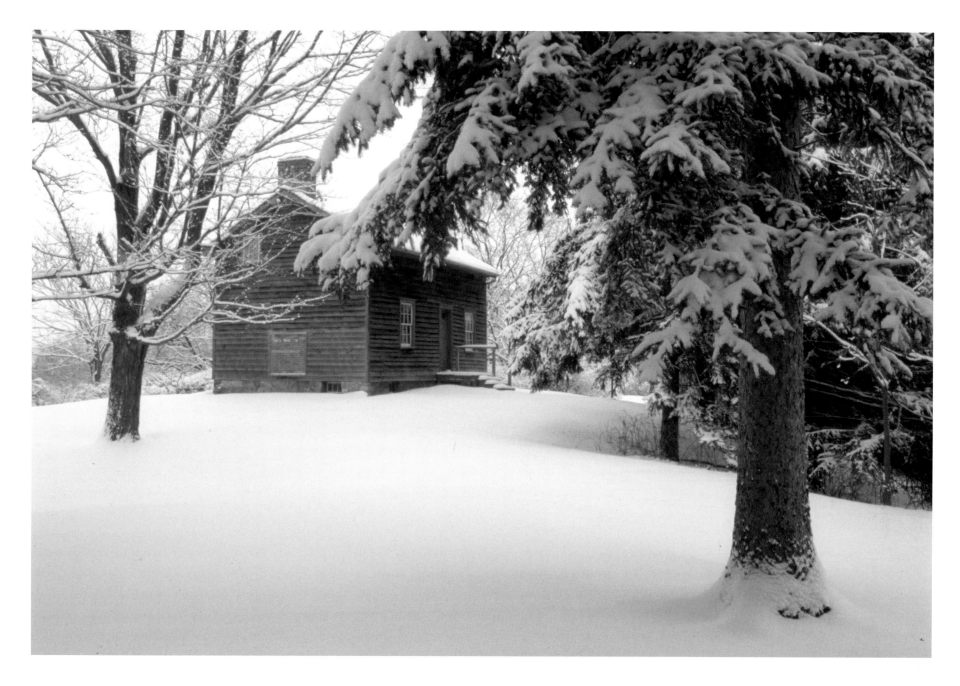

The Griffin Historical House in Ancaster looks out over the Dundas Valley and is operated by the Hamilton Conservation Authority. Built in 1827 by former slaves from the United States, it stands as a testament to the bravery and determination of those slaves who came to southern Ontario through the Underground Railway.

The Bruce Trail is a hikers' paradise, affording them some of the escarpment's most spectacular cliff-side vistas and waterfalls views. The trail, well marked with its familiar white blaze, stretches more than 700 km along the length of the escarpment from Queenston to Tobermory and links the natural features and the more than 100 parks in the Niagara Escarpment Parks System. It is Ontario's oldest and most popular long-distance footpath and the first trail of this nature to be developed and maintained by volunteers.

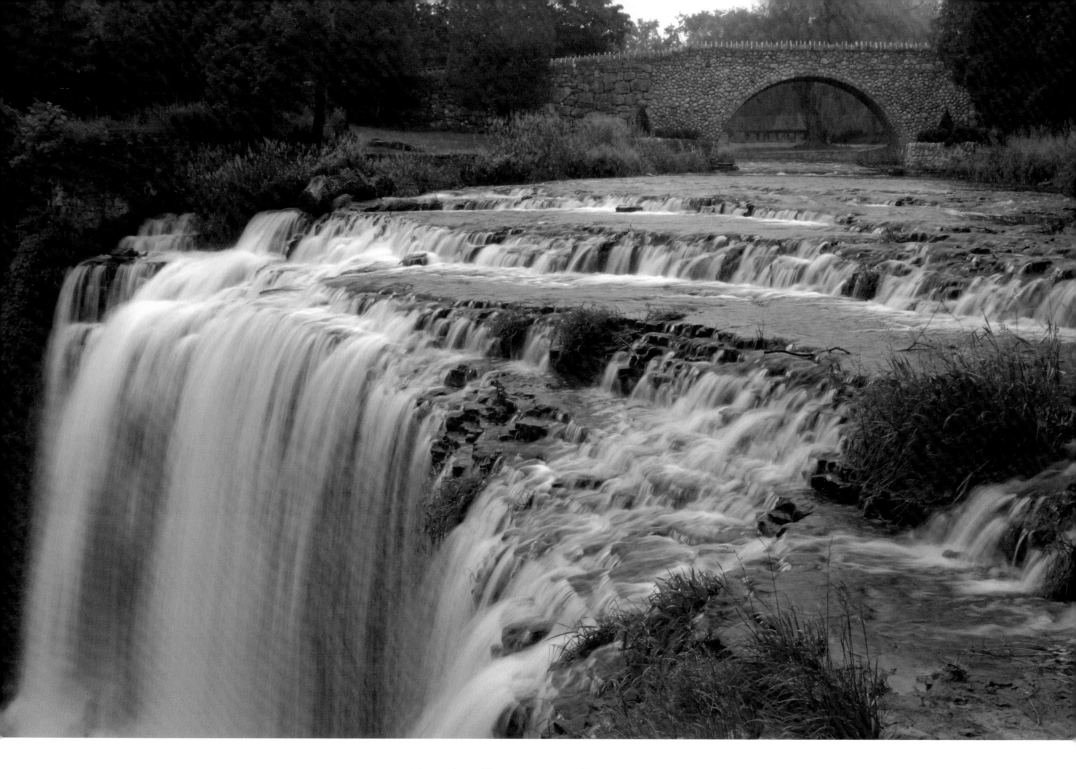

Webster's Falls in Greensville is twenty-two metres high and thirty metres wide. The Webster family purchased the falls and surrounding land in 1819 and is buried nearby. The stone bridge is a designated heritage feature that was restored in 2000 with support from the local community.

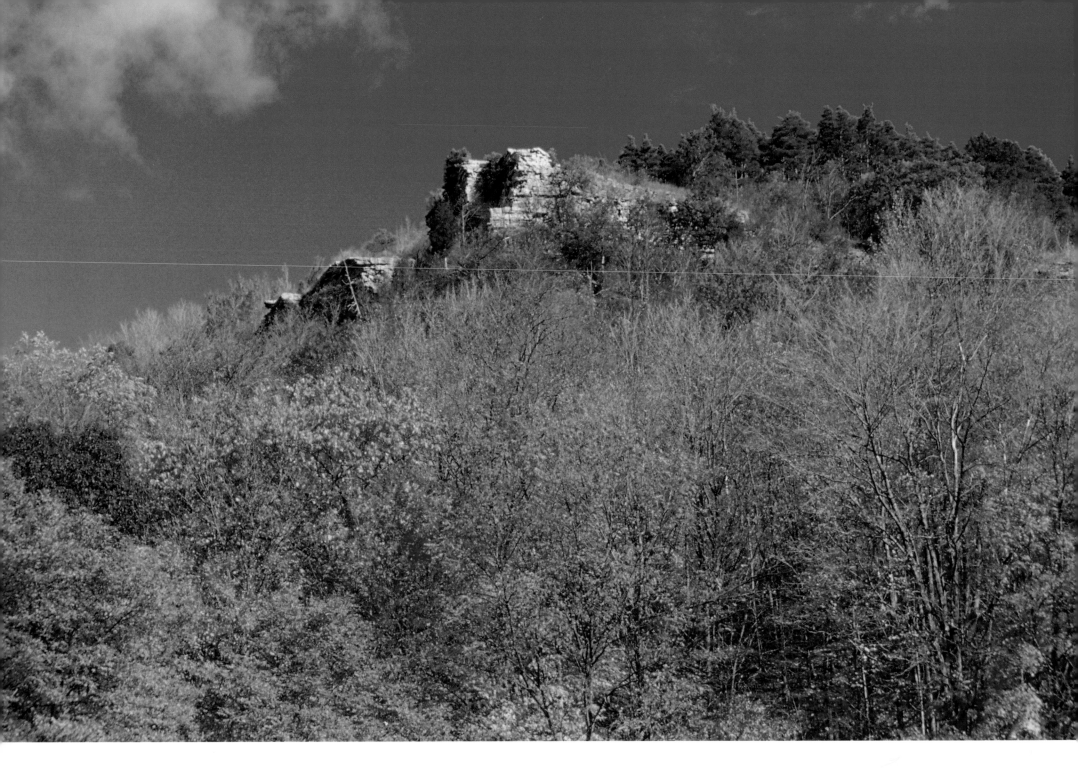

A famous Dundas landmark is the "Peak." Here the escarpment forms a jagged outline as it curves back on itself after the waters of Webster's and Tews Falls eroded away a great deal of it. The Hamilton Conservation Authority owns and manages the property, which can be easily reached along a path from the parking lot at Tews Falls. The site offers wonderful views of the town of Dundas and beyond to its large neighbour, Hamilton.

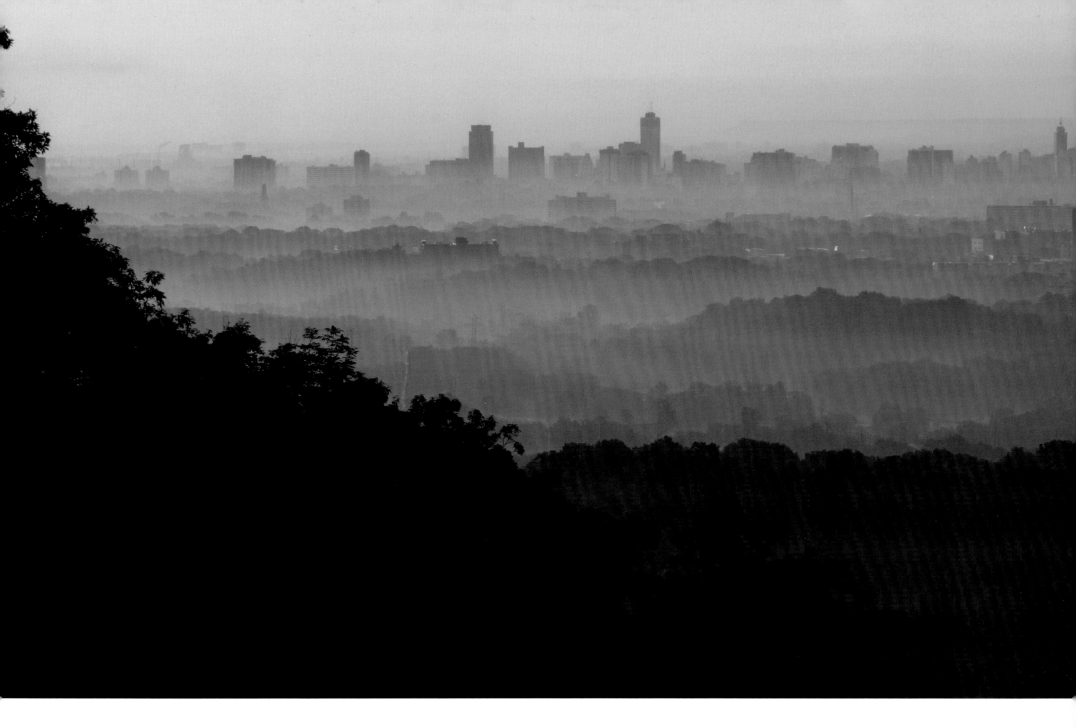

Dundas Peak is found in the Spencer Gorge Wilderness Area. This prominent viewing point looks out over the city of Hamilton and provides a close-up view of the talus slope in the foreground.

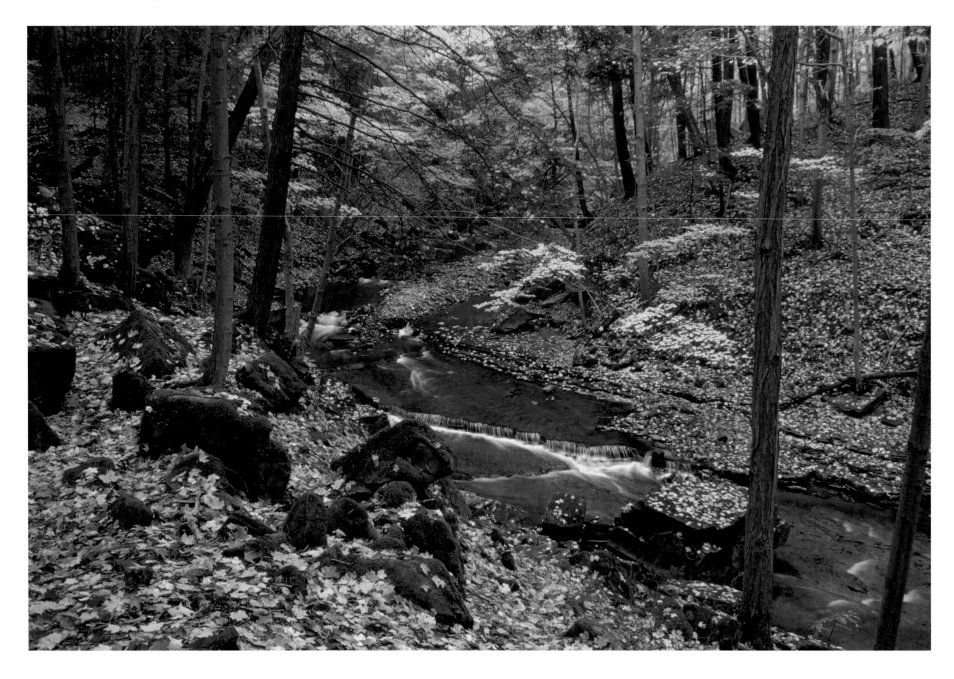

Spencer Creek winds its way through the deeply incised Spencer Gorge. In autumn, the forest floor is heavily carpeted with fallen leaves.

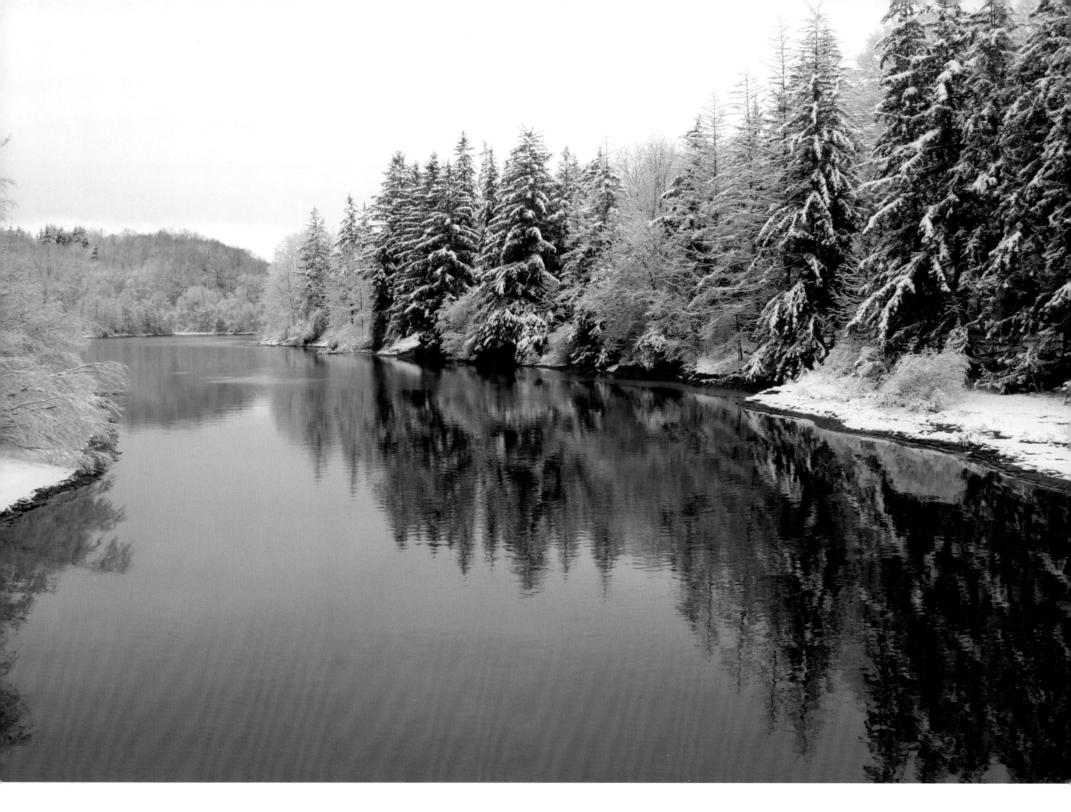

Crook's Hollow reservoir near Greensville under a spring dusting of snow. In the early 1800s, this area of Spencer Creek was dammed, creating one of the major industrial sites in Upper Canada.

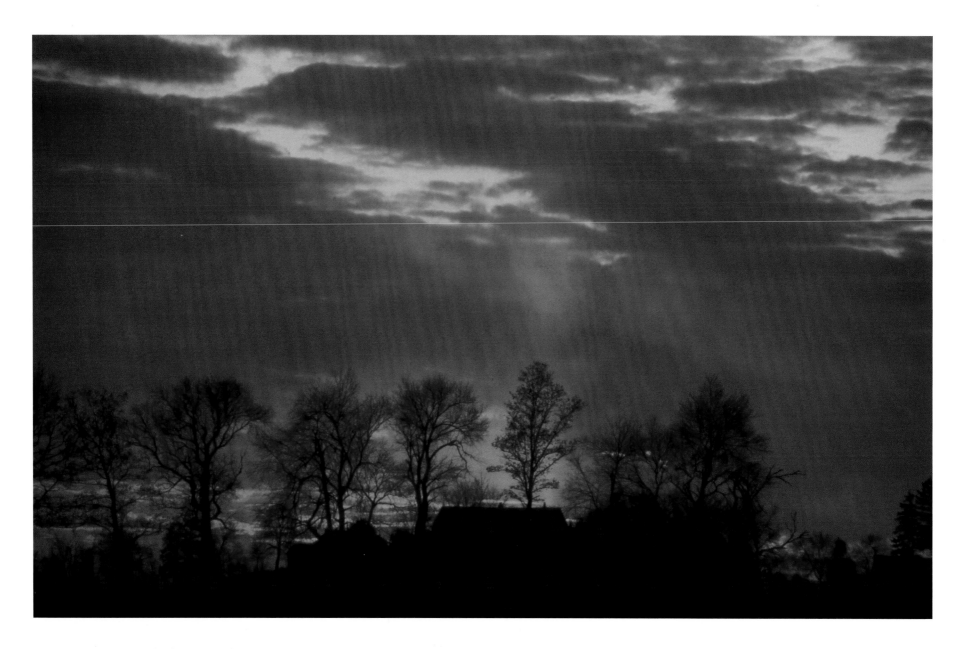

A winter sunset lights up the sky and silhouettes a local farmhouse and fencerow.
Photographed from Weirs Lane, located in the countryside of Flamborough Township.

This roadside scene was captured on the back roads of Flamborough above the escarpment. The trio of poplar trees was found in its autumn glory along a fencerow.

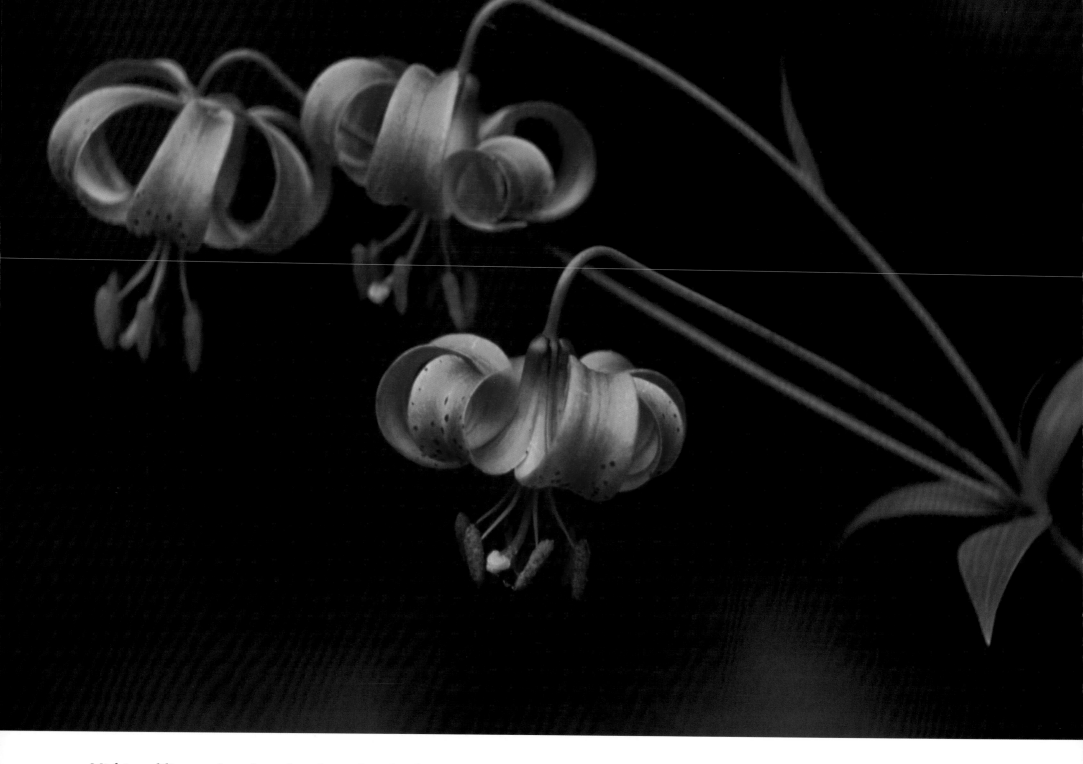

Michigan lilies are found on the edges of wetlands and roadsides, and bloom during the month of July. While they appear similar to the common orange garden lilies, they are never common and are much more refined and delicate.

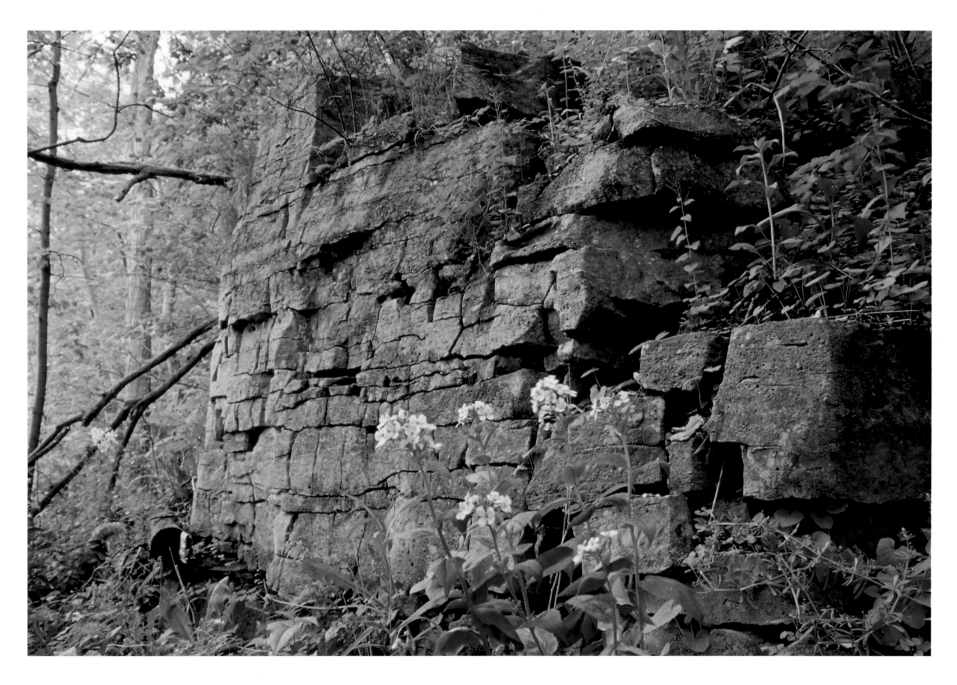

At Rock Chapel, located above Dundas on property owned by the Royal Botanical Gardens, the Geology Department of McMaster University has created an informative exhibit for visitors wishing to learn about the development of the escarpment.

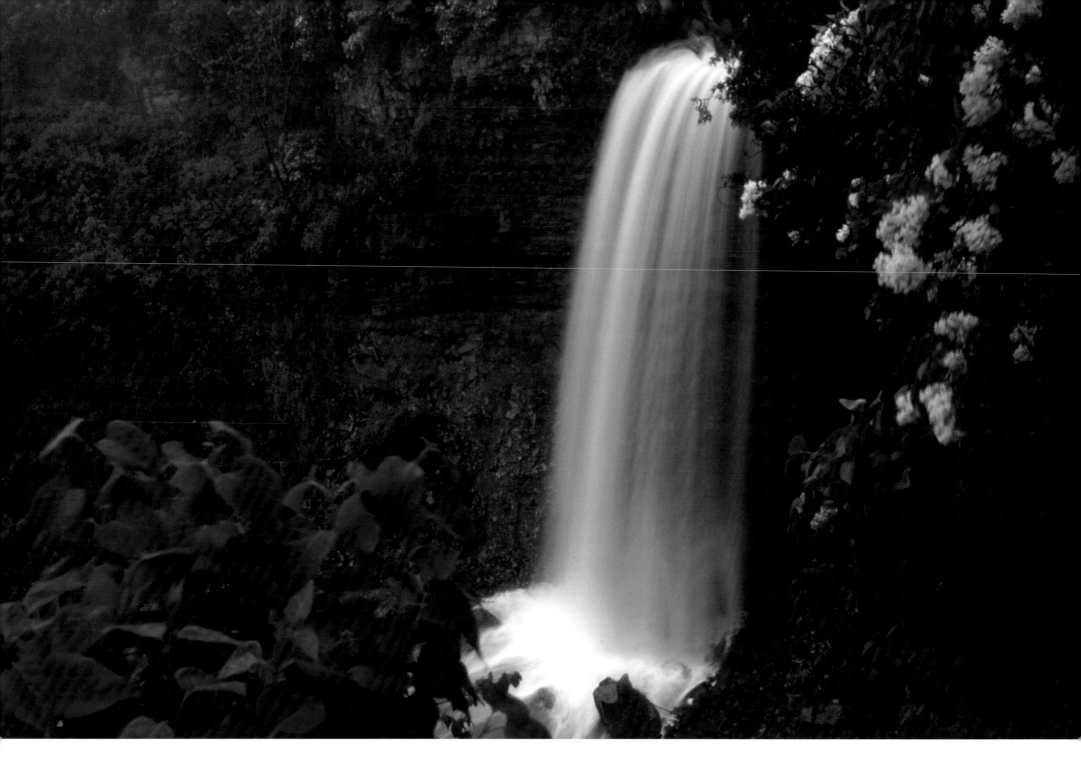

Borer's Falls is tucked away in the tiny hamlet of Rock Chapel. Here the Borer family built a sawmill, which was powered by the falls until insufficient water caused the family to resort to other means of power.

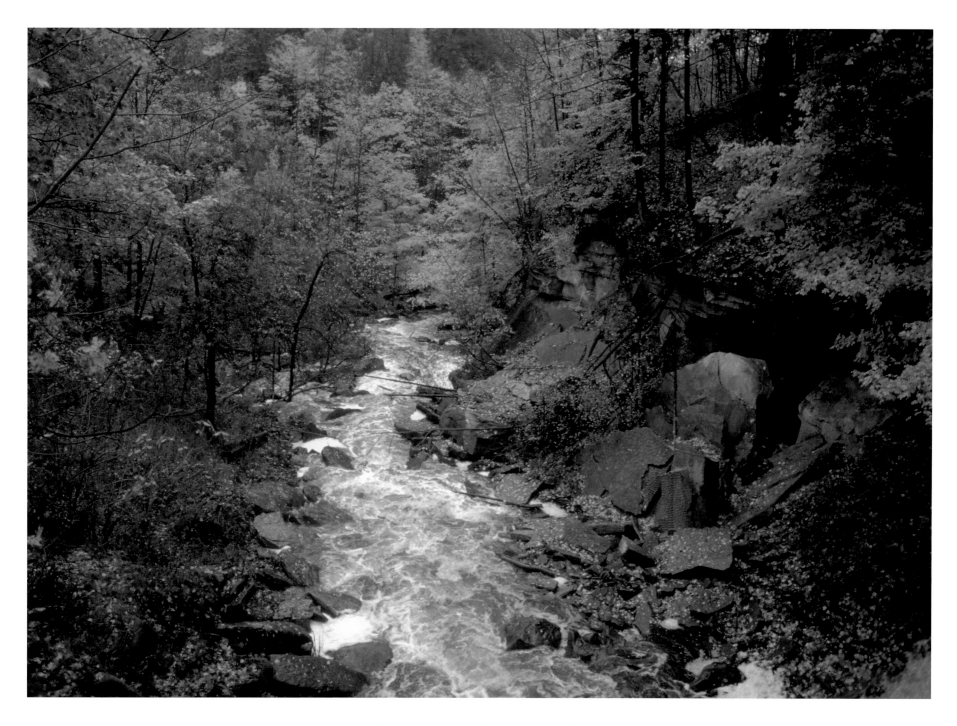

Grindstone Creek in Waterdown plunges over the escarpment into a picturesque valley. This area is known as Smokey Hollow, named after the historic industrial complex that was formerly located in this area.

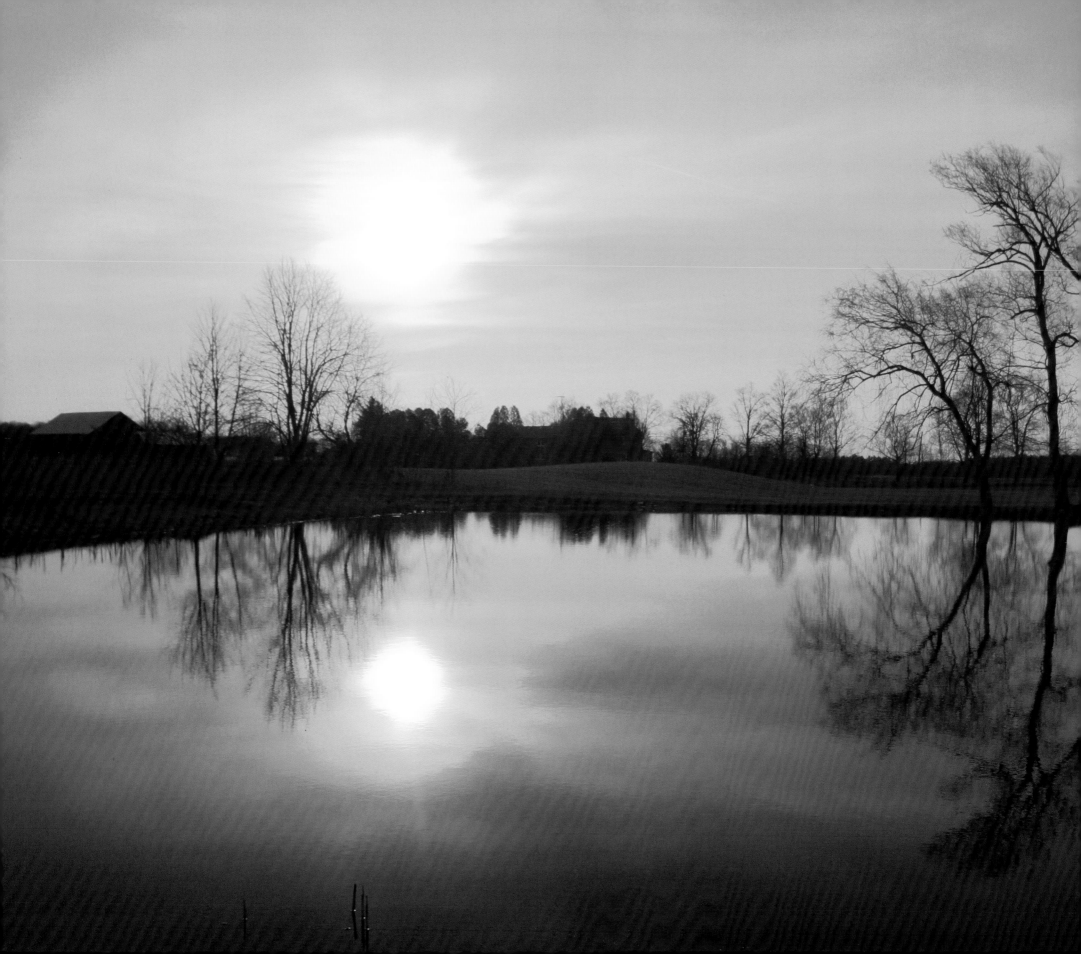

3 HALTON ESCARPMENT

THE ROCKY RIDGE of the escarpment is clearly evident here, rising over the increasingly urban areas of the cities of Burlington, Milton, and Georgetown. Halton's twelve escarpment parks—just a sampling of the more than one hundred parks along the entire length of the escarpment—offer a rich sampling of history, nature, and seasonal recreational activities, from rock climbing on the sheer cliffs at Rattlesnake Point to skiing the escarpment bluffs overlooking Kelso Lake.

Visitors can explore the boardwalk around Crawford Lake and the nearby five-hundred-year-old Indian village, complete with reconstructed longhouses.

Panoramic views are best experienced from the top of Rattlesnake Point, which rises ninety-one metres above the surrounding countryside.

Left: A farm pond located on Walker's Line in the shadow of Rattlesnake Point. The fine reflection was made possible by the calm of an early spring morning.

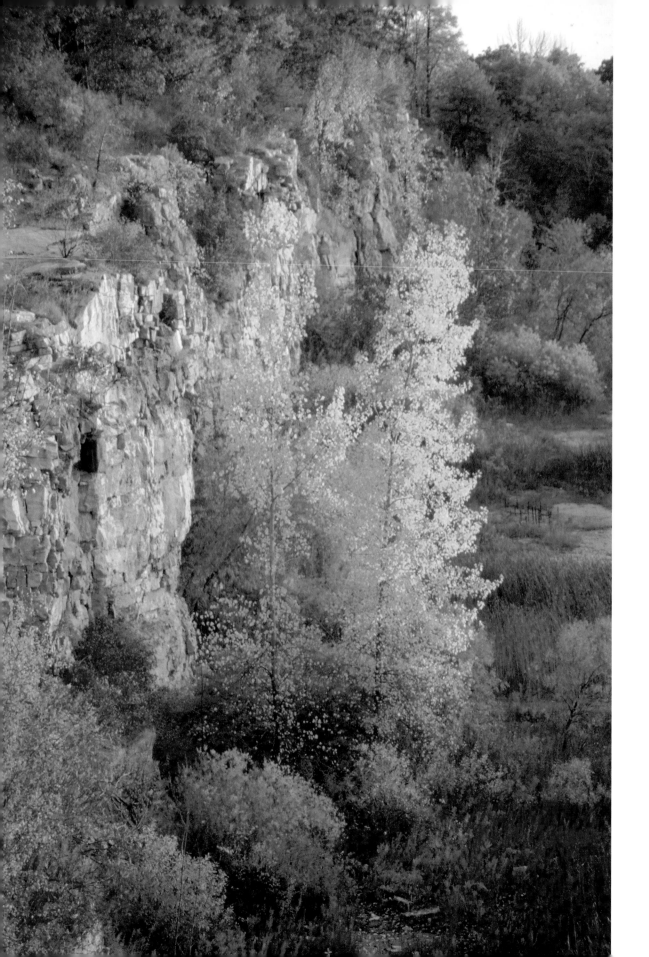

Time can do wonders, as this fall view of the old Nelson quarry shows. The less-than-perfect quarrying operations have left a rough-cut rock face, which allows native plants and other vegetation to grow.

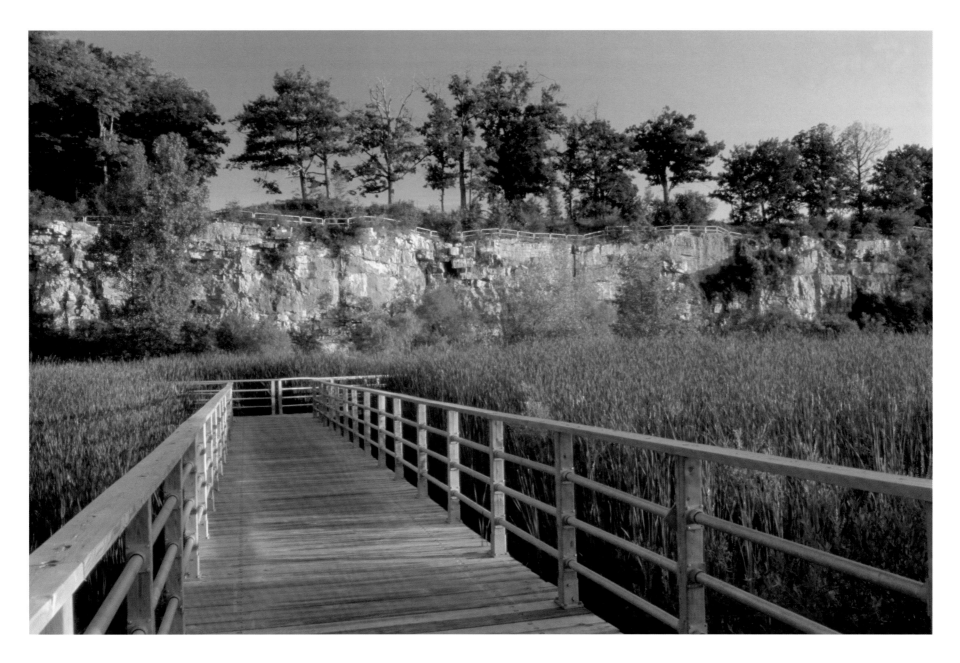

At Kerncliff Park, the City of Burlington has undertaken a restoration project on an old abandoned quarry. A boardwalk now runs through the wetland while the Bruce Trail runs along the cliff edge looking over the park.

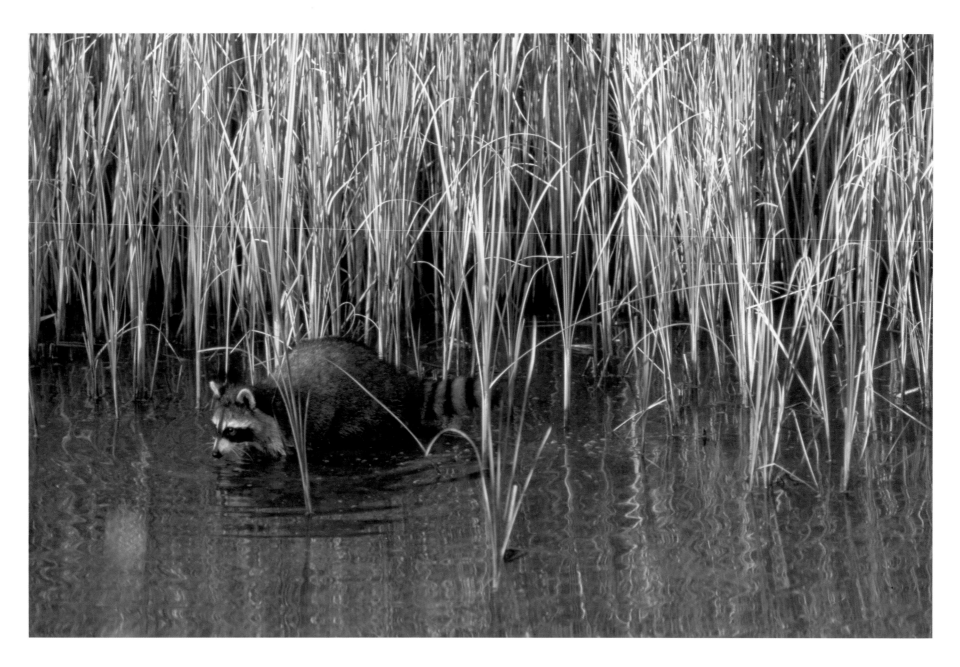

Raccoons are common in the wetlands along the escarpment. This one was found foraging for food in a cattail marsh in Burlington.

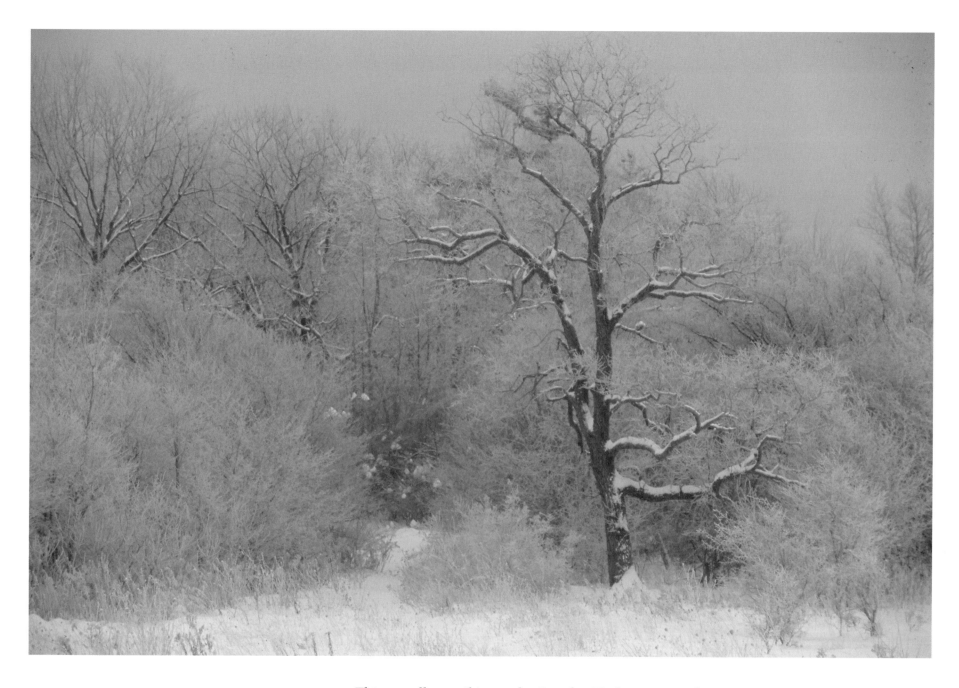

This woodlot trail is on the Dundas Highway in Burlington. It provides quick access to the Bruce Trail and local trails along the escarpment edge.

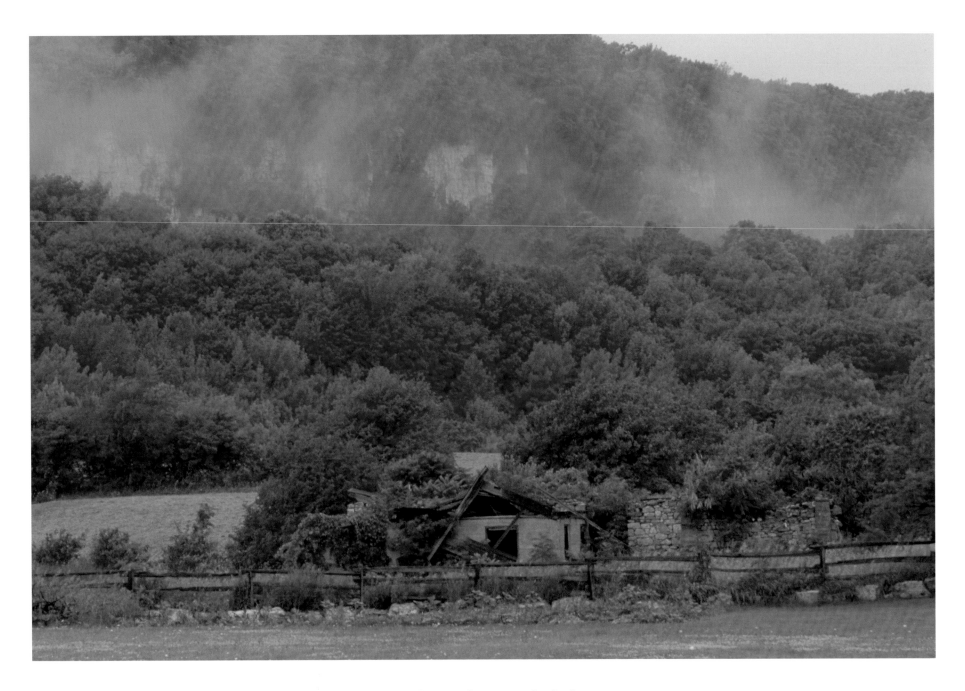

The south end of Mount Nemo, viewed from No.1 Sideroad in Burlington. The lush green growth of the escarpment forest provides a great setting, while the barn ruins add an element of visual interest.

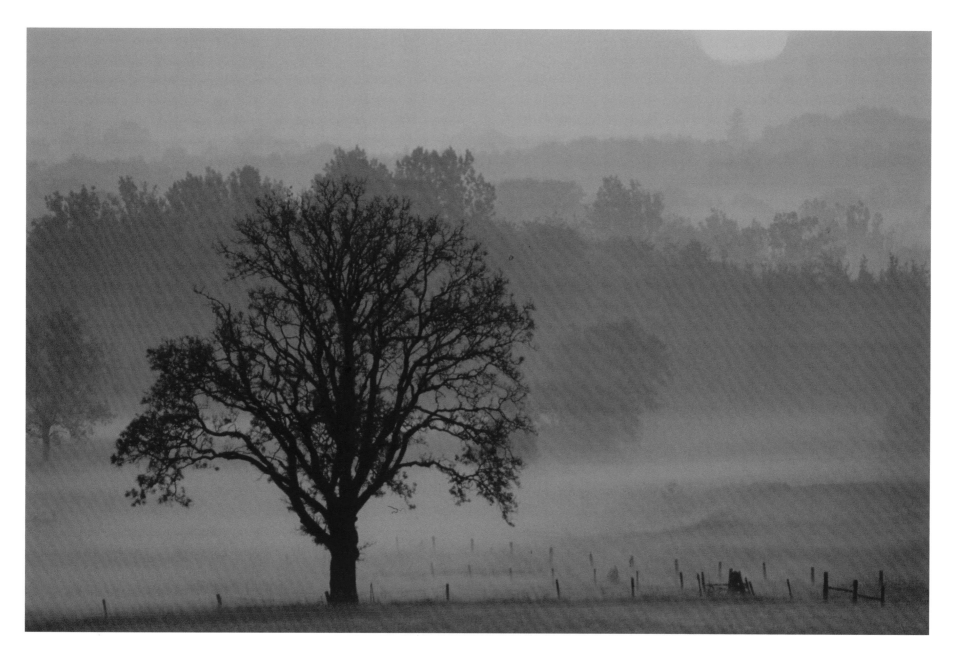

A lone white oak stands as a sentinel overlooking the misty country fields shortly after sunrise.

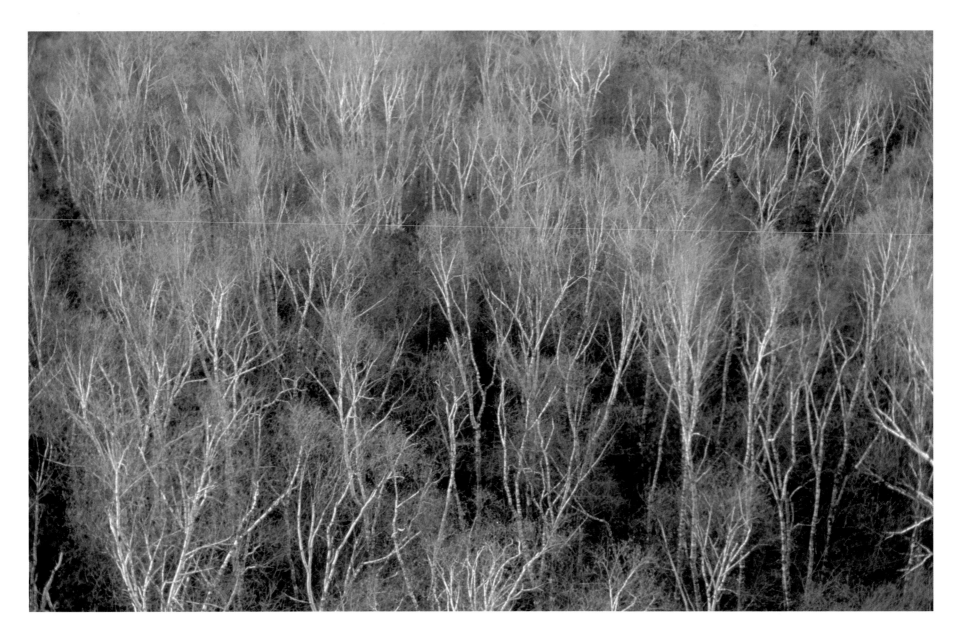

The talus-slope forest below Mount Nemo in North Burlington. The white birch and white cedar in early spring provide one of those wonderful patterns found in nature.

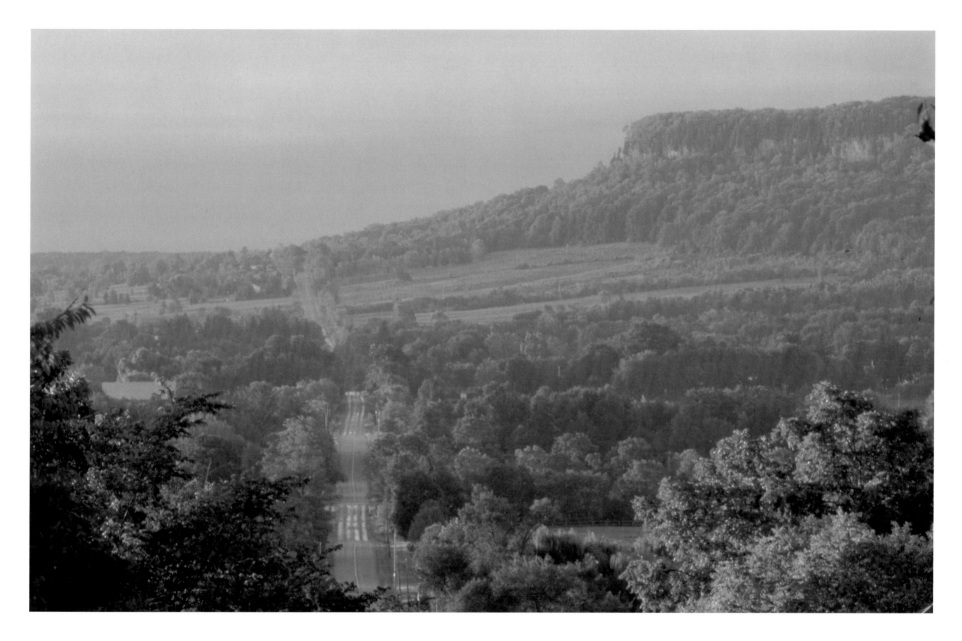

Walker's Line looks like a rollercoaster rising and falling as it runs through the countryside north of Burlington. In this view from Derry Road, one can see Mount Nemo looming above the road.

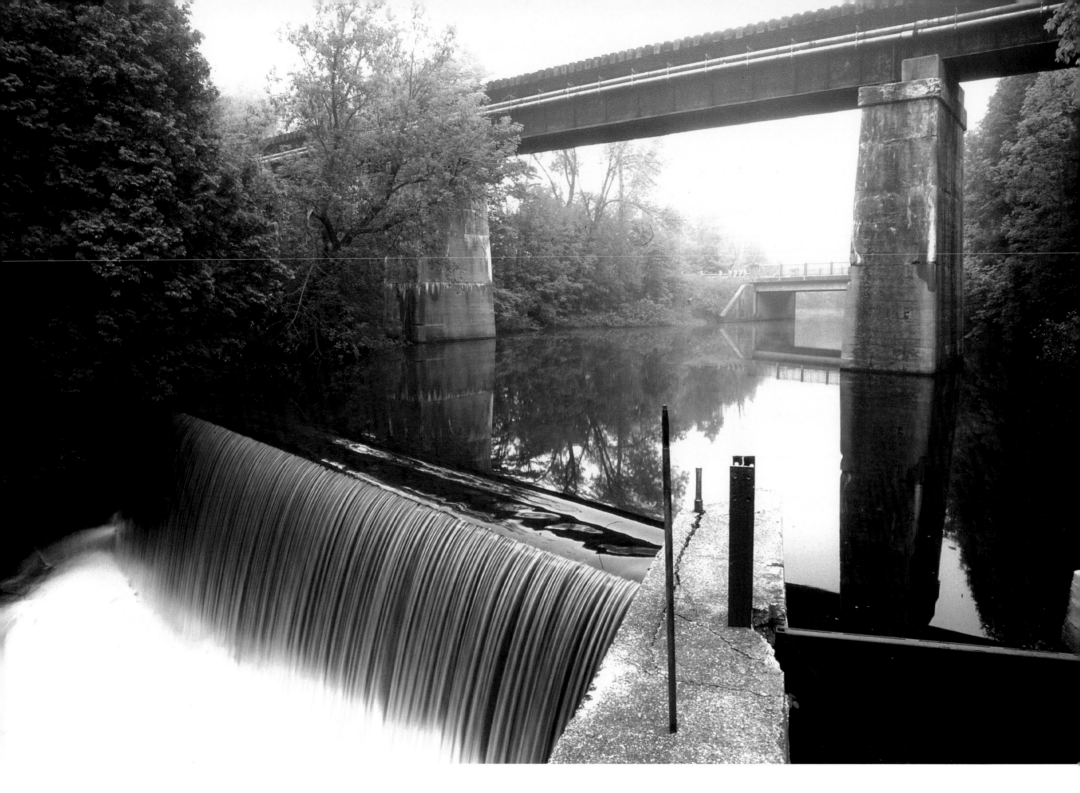

Progreston Dam is located on Bronte Creek outside of Carlisle. Over the years, this area has been the home of three sawmills, two gristmills, and a woollen mill, all of which took advantage of the water power. This private property still incorporates a micro hydro-generating station.

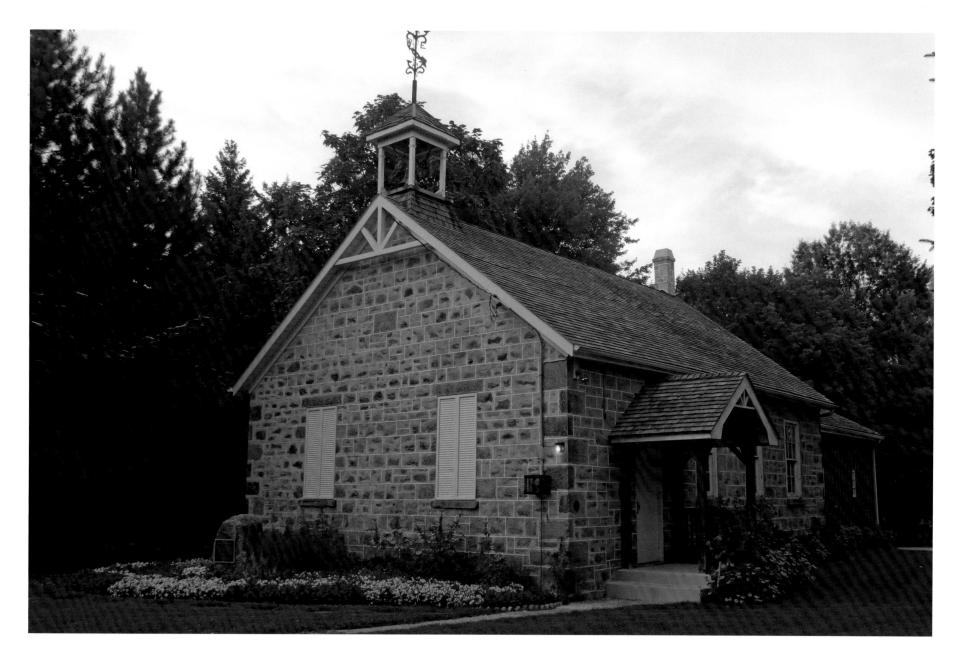

The old stone schoolhouse in Lowville Park, Burlington, was built in 1888 and had only one room. It now serves as a maintenance building for the City of Burlington Parks Department.

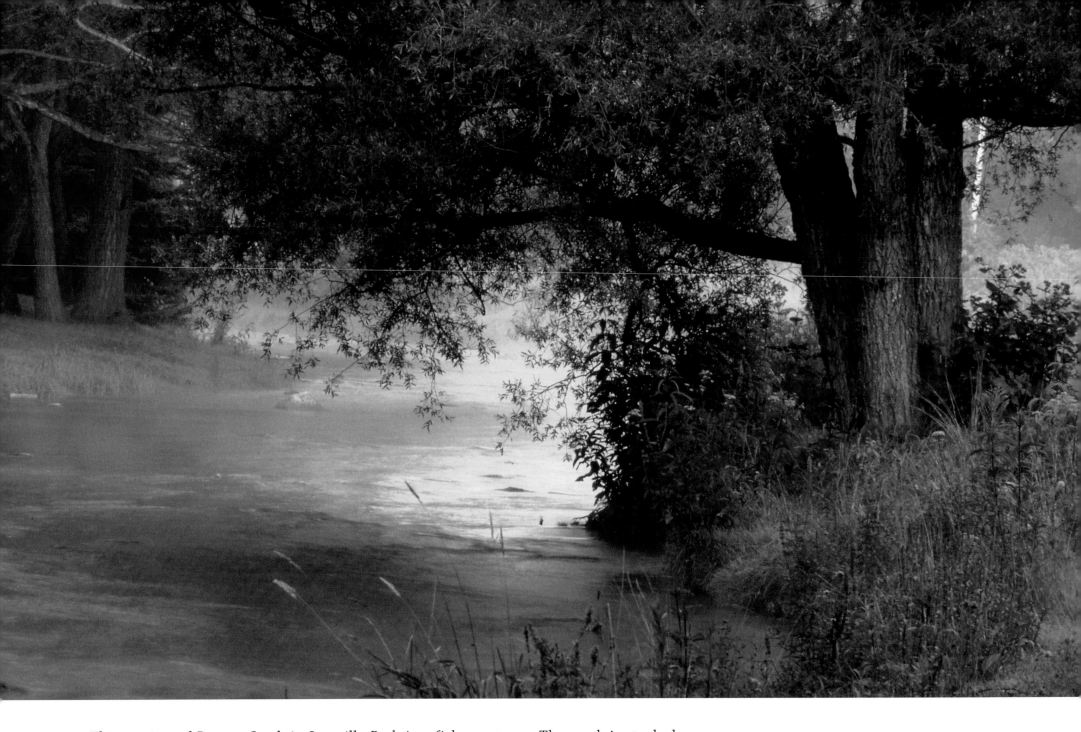

This section of Bronte Creek in Lowville Park is a fish sanctuary. The creek is stocked annually with thousands of rainbow trout and Chinook salmon fry and fingerlings, which make their way to Lake Ontario and return here to spawn.

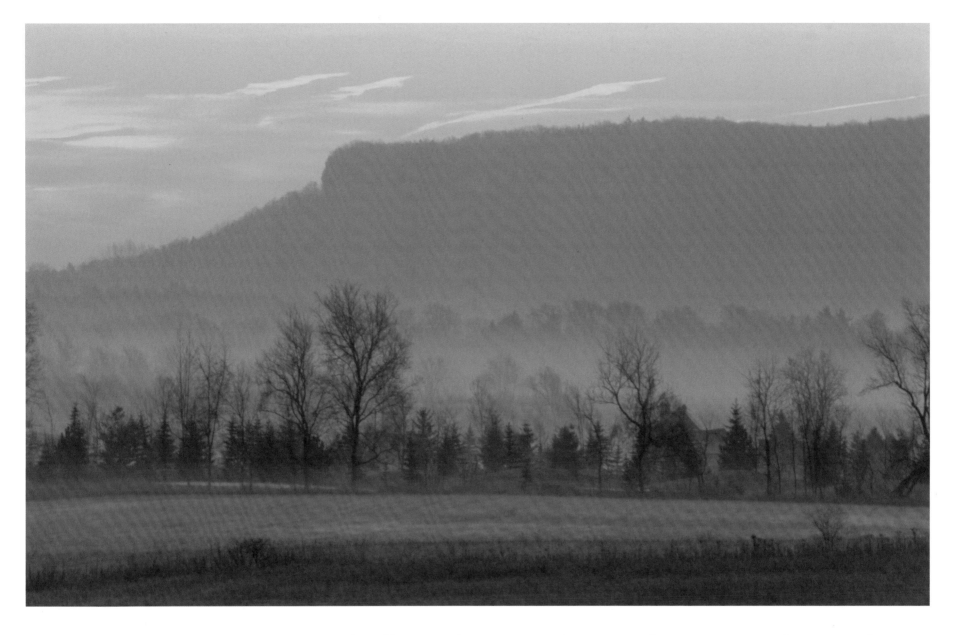

The silhouette of Mount Nemo looms over the misty countryside on an early spring morning. This view is from the Guelph Line, north of the small village of Lowville.

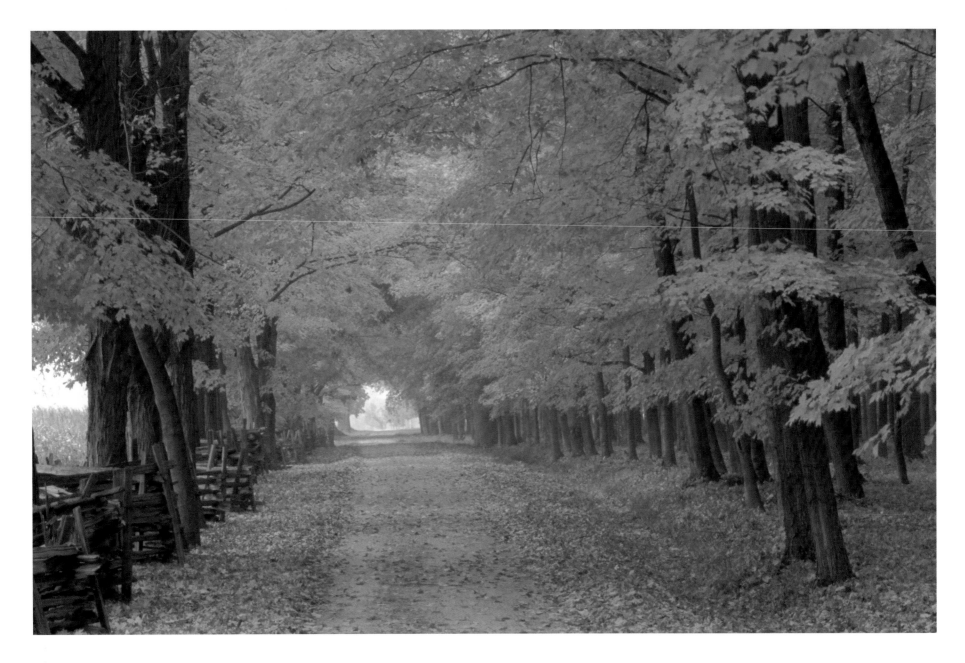

A country lane with an attractive rail fence, located on Appleby Line near Rattlesnake Point.

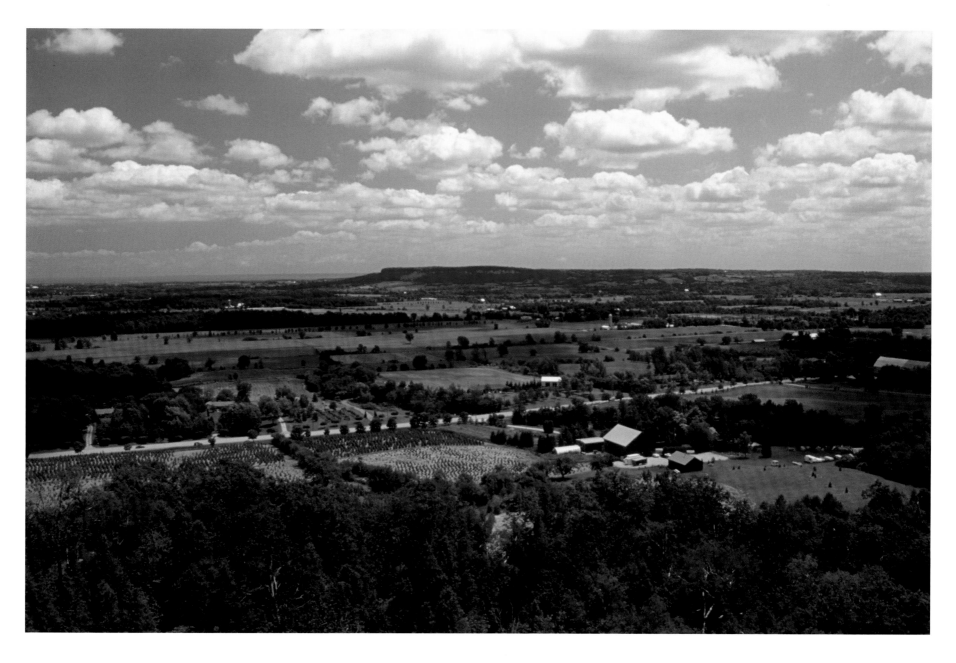

The Halton till plain provides excellent agricultural lands east and south of the escarpment as it winds its way through the region. This spectacular view is from the heights of Rattlesnake Point, looking back towards Mount Nemo in the distance. These lands are protected under the Niagara Escarpment Plan, as well as by the new Greenbelt legislation.

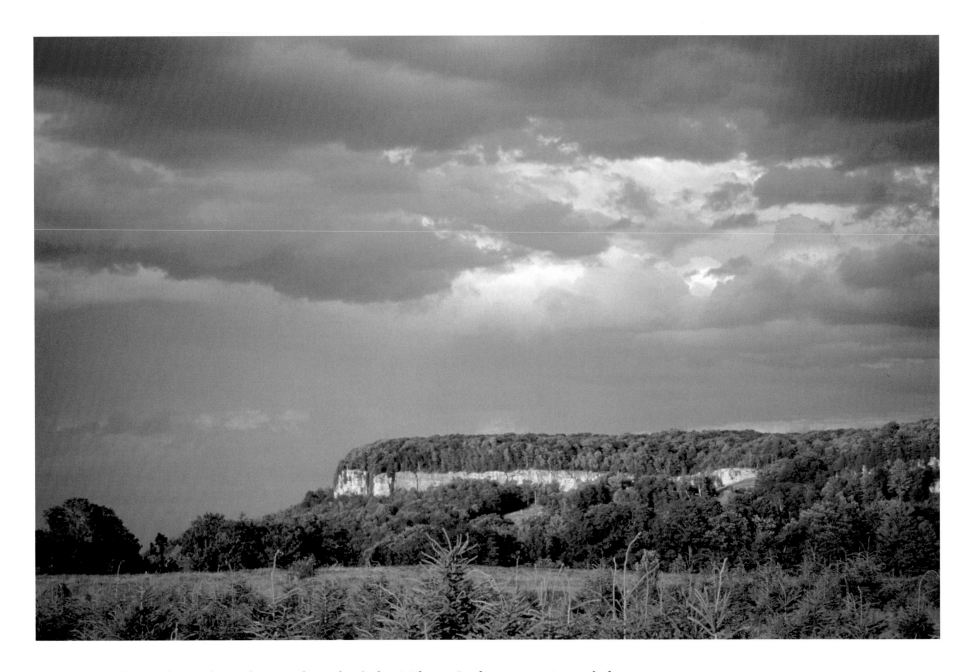

Milton Heights is located at the north end of the Milton Outlier, a section of the escarpment that is separated from the main spine. It is part of Kelso Conservation Area, which attracts hundreds of thousands of visitors each year. The late evening sun lights up the rock face, showing scars left by earlier quarrying operations.

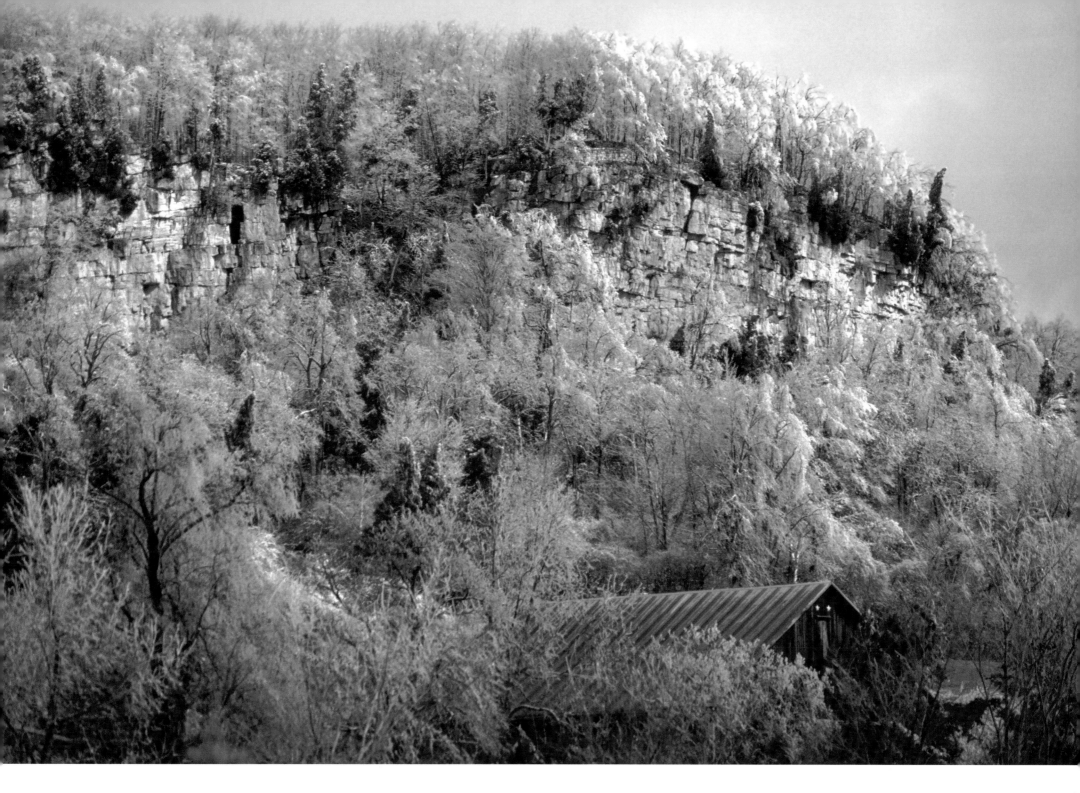

Rattlesnake Point rises over the countryside at the southern point of the Milton Outlier. A rare ice storm has covered the entire countryside in a shimmering silver coating.

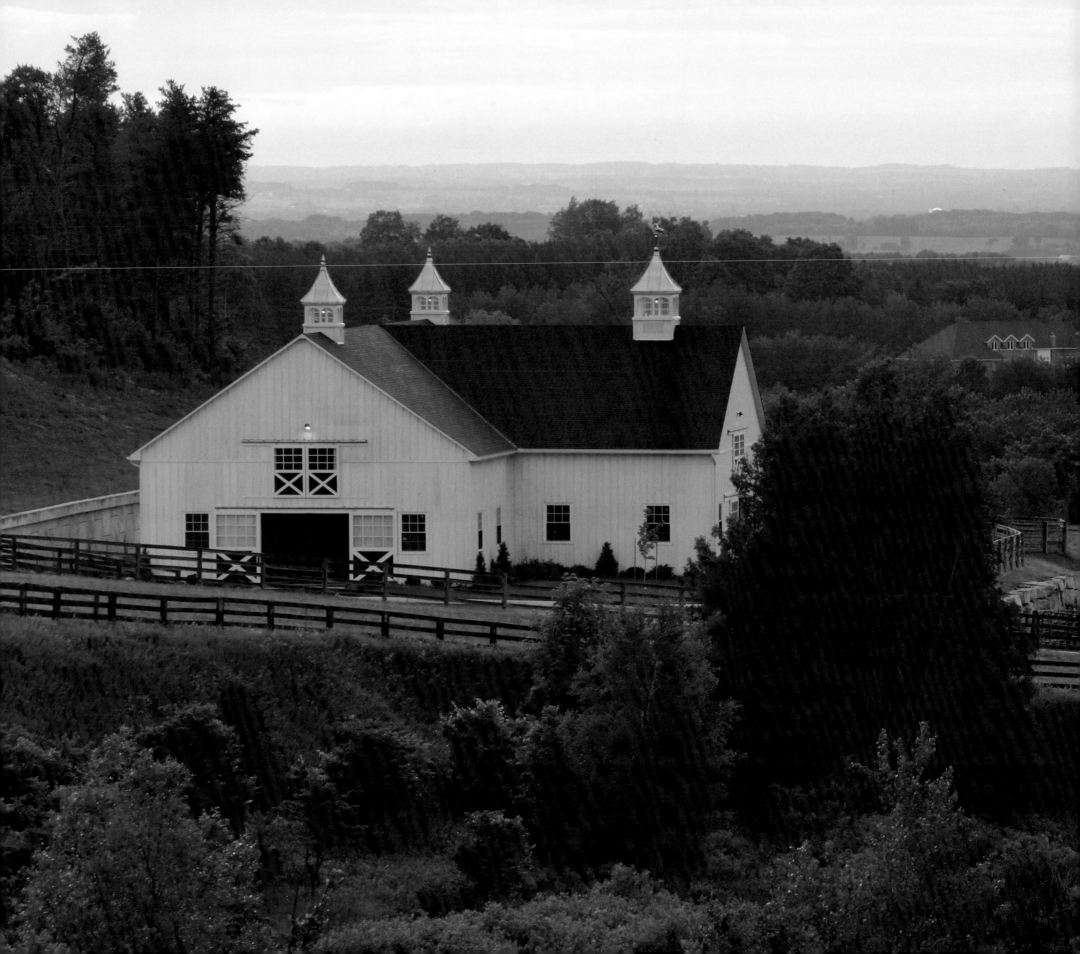

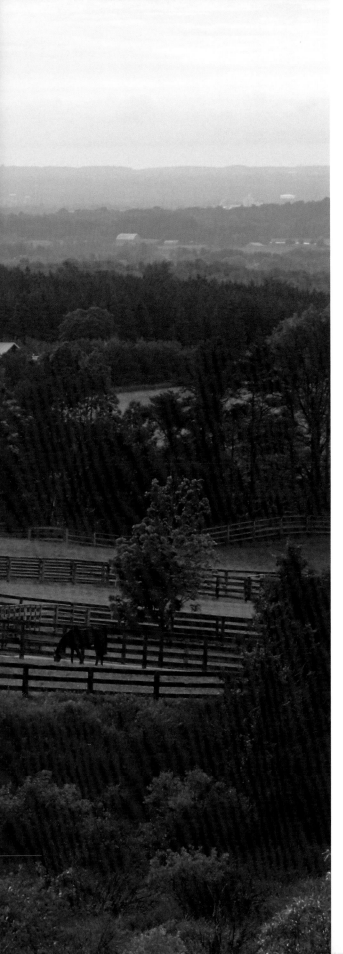

4 CALEDON HILLS

INCREDIBLE VIEWS AND the urban sprawl of the Greater Toronto Area are attracting certain affluence to the area surrounding Caledon Hills. Here, the glacial drift and moraines temper the rough, rocky outcropping of the escarpment.

In the more southern region, the Carolinian zone changes to the Great Lakes–St. Lawrence zone, providing the ingredients for a rich biological diversity.

The Credit River and its many tributaries dominate this area, though the mighty river is but a fraction of the size it will be when it finally empties into Lake Ontario in the City of Mississauga.

The Forks of the Credit Provincial Park is a 282-hectare park where the two branches of the Credit River come together. The Credit drops over the edge of the escarpment near the village of Cataract, offering a spectacular view of the gorge and valley.

Farther north, the Orangeville Moraine provides a huge source of raw material for the many sand and gravel pits in the area.

Left: One of the many fine equestrian farms found throughout the Caledon Hills. This stable is located on the Escarpment Sideroad in Caledon.

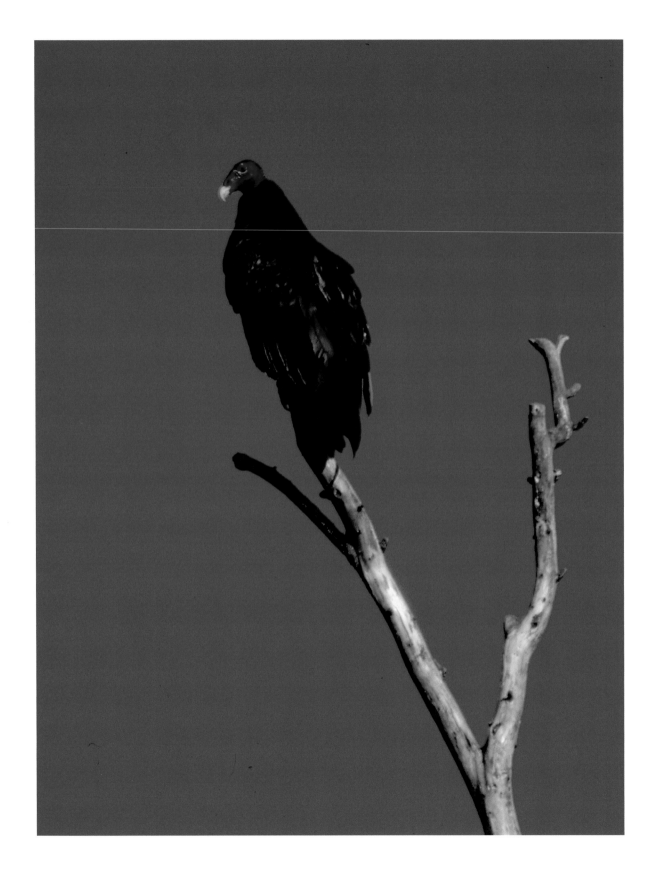

The Turkey Vulture is probably the signature bird for the Niagara Escarpment, because it is often found soaring in the updrafts of the cliffs, searching for carrion. When the winds calm in the early evening, the vultures often find a tree on which to rest like this adult bird.

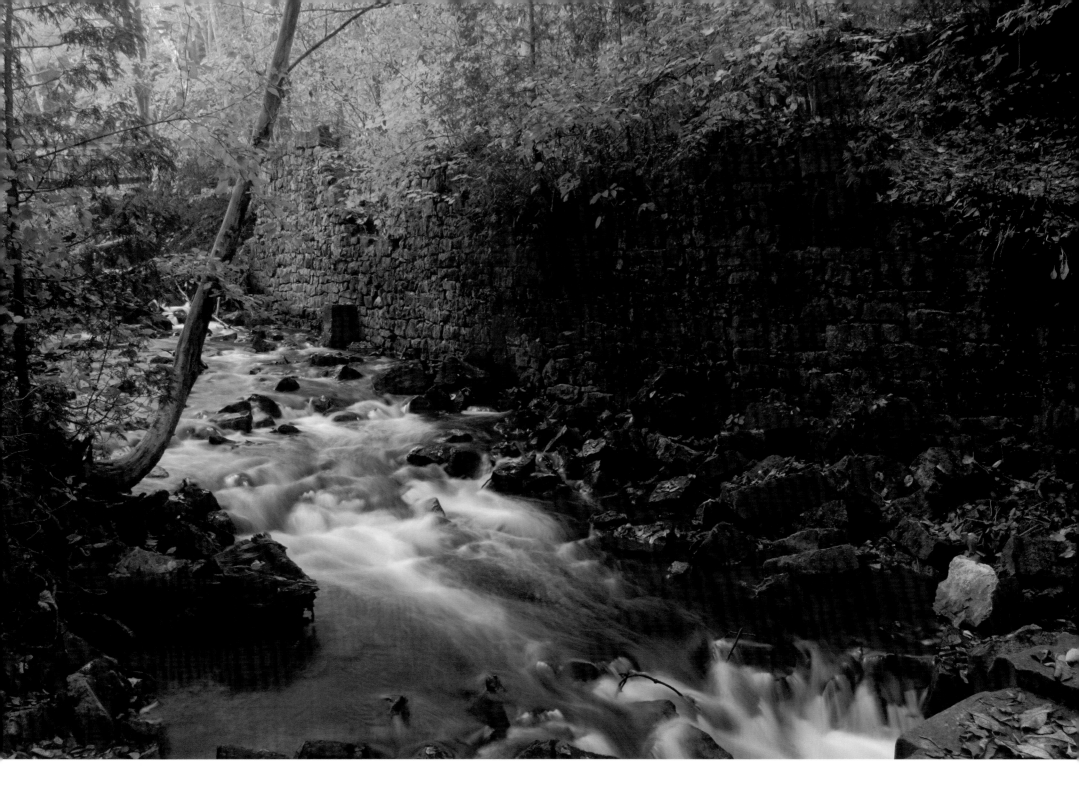

The Limehouse Conservation Area is located in the small village of Limehouse, which is near Georgetown. This old stone mill raceway is found along Black Creek. The raceway and the numerous lime kilns that can be found are cultural remnants of the lime industry, which played an important role in the history of this area.

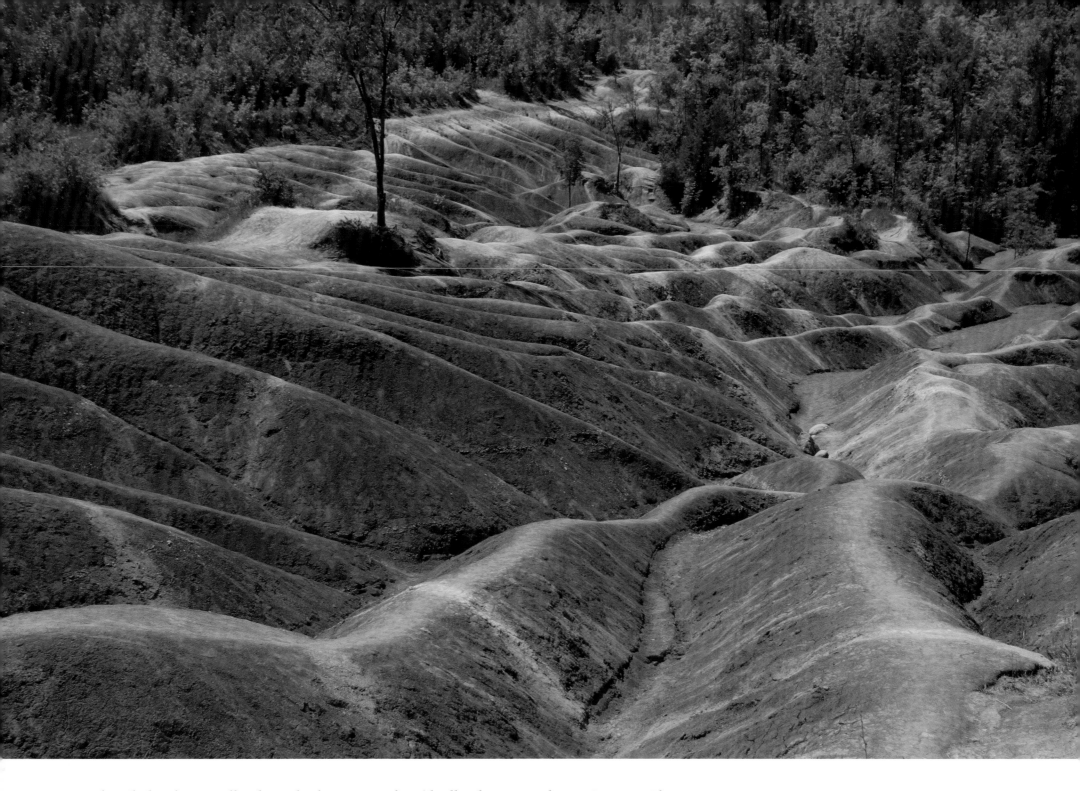

The Cheltenham Badlands is the best example of badland topography in Ontario. This erosional feature of the shale lands below the escarpment's lower slopes was caused at the turn of the century by land clearing and livestock grazing.

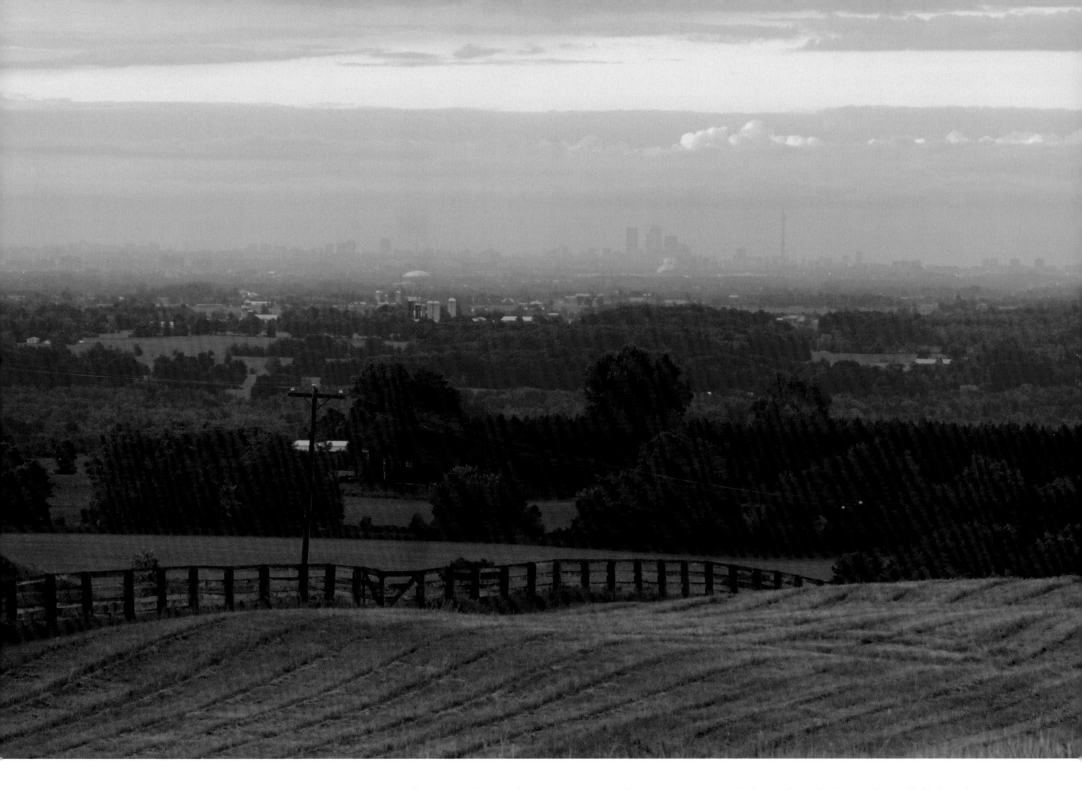

The view from the junction of the Escarpment Sideroad and Horseshoe Hill Road in Caledon. From this spot in the Caledon Hills you can see the vast rolling countryside, with the Toronto skyline approximately fifty kilometres in the distance.

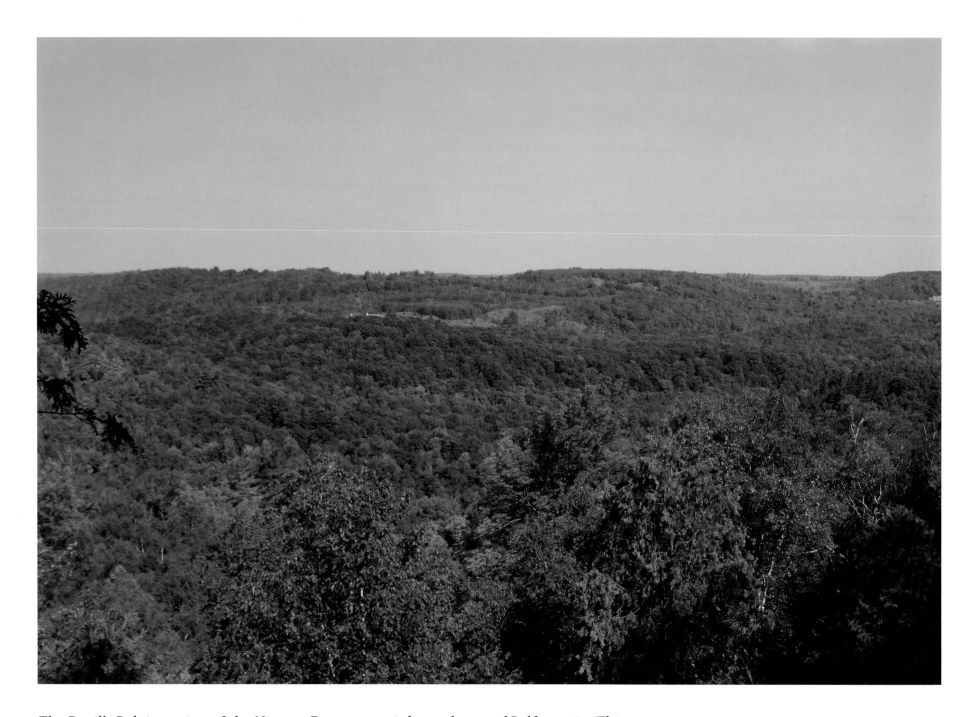

The Devil's Pulpit section of the Niagara Escarpment is located west of Belfountain. This view from the Bruce Trail looks out over the surrounding countryside, which includes a large portion of the Forks of the Credit Provincial Park.

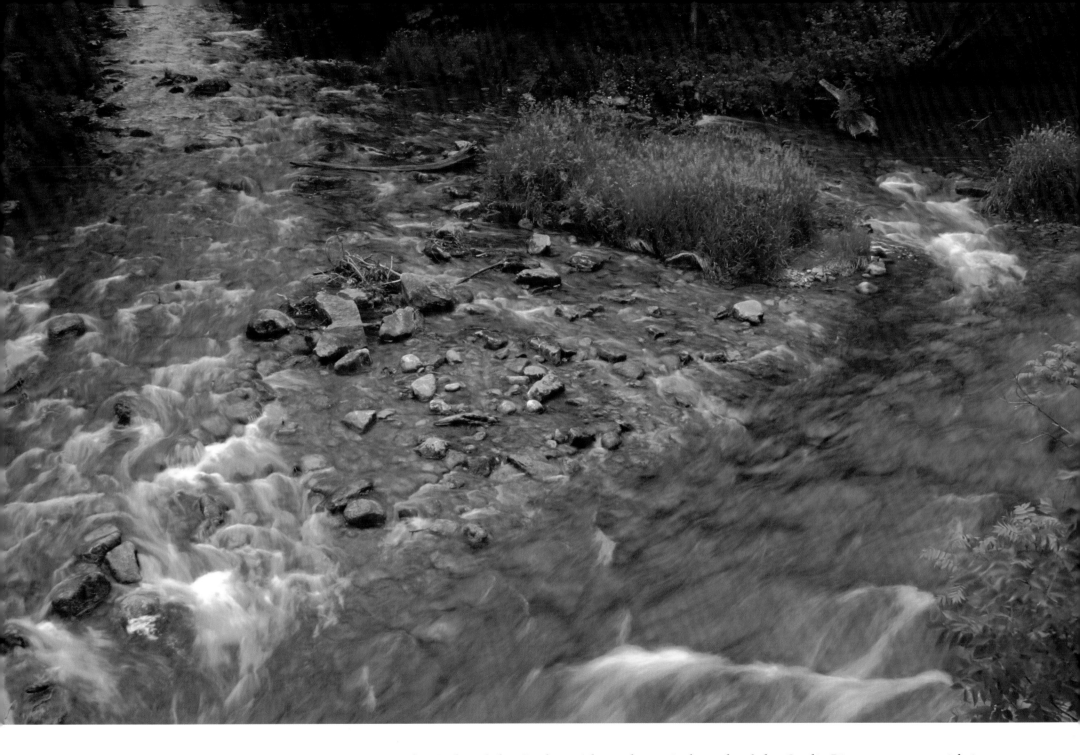

The Forks of the Credit is where the main branch of the Credit River meets up with its west tributary just outside the village of Belfountain. Belfountain is a favourite place for many people to reach the escarpment, and it is close to other small hamlets with wonderful names like Brimstone and Cataract.

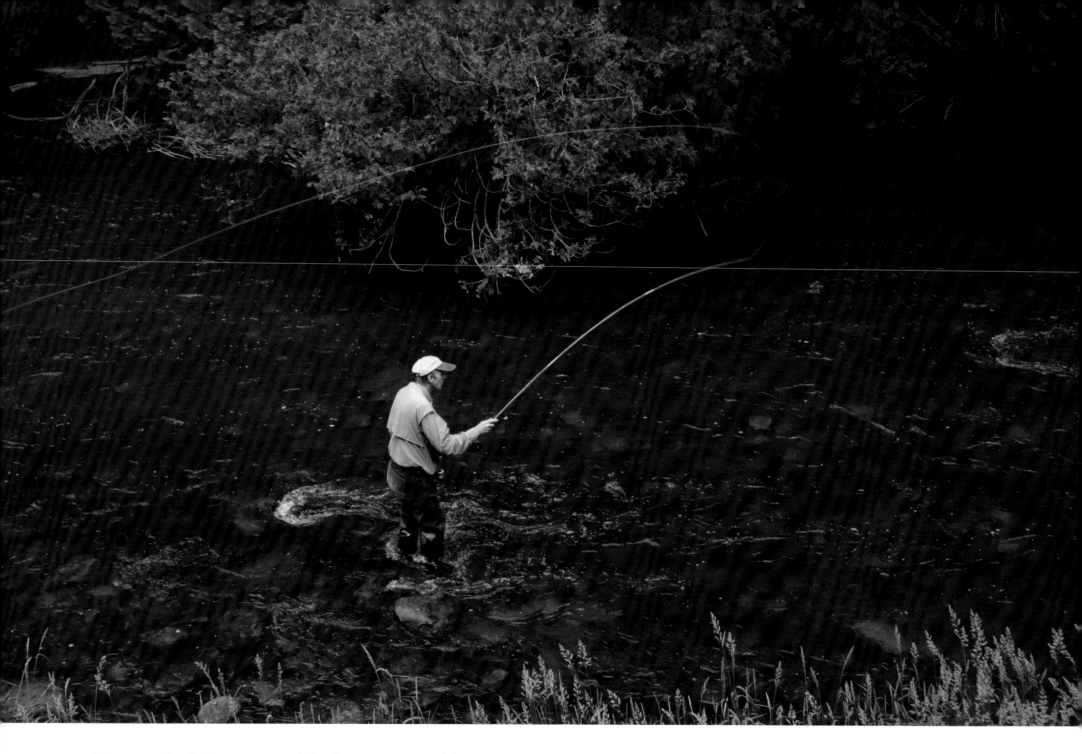

The upper Credit River is one of the few remaining cold-water rivers in southern Ontario. Home to forty-five species of fish, this section of the river is a catch-and-release zone, prized for its brook and brown trout. It's a great place to practise the fine art of fly-fishing.

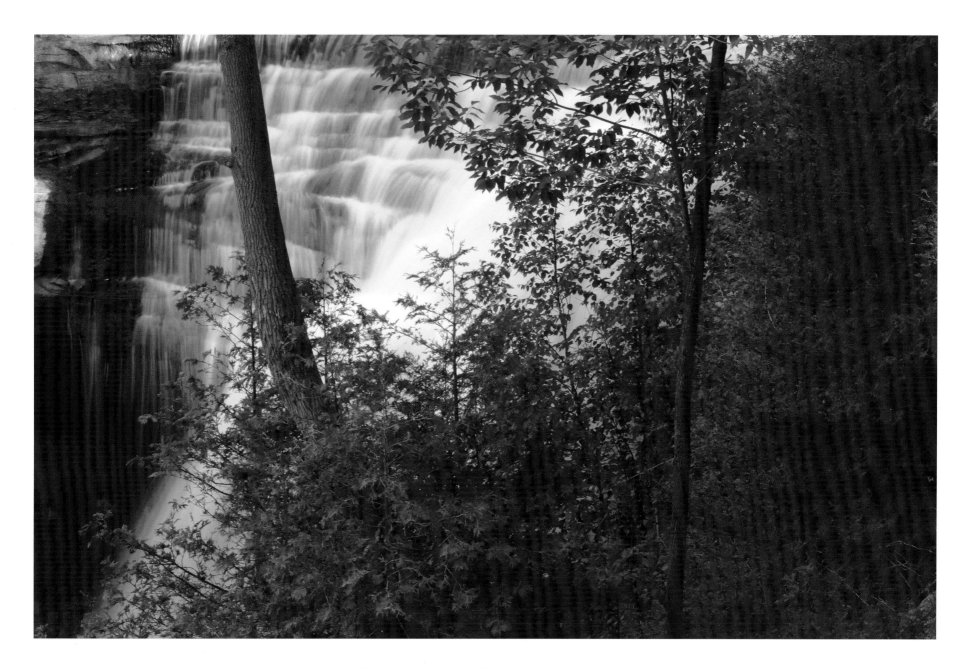

The Credit River falls over the escarpment at Cataract, where it is surrounded by ruins from its days as a power source for industry. The view from the lookout in Forks of the Credit Provincial Park is now partially obscured by growing vegetation.

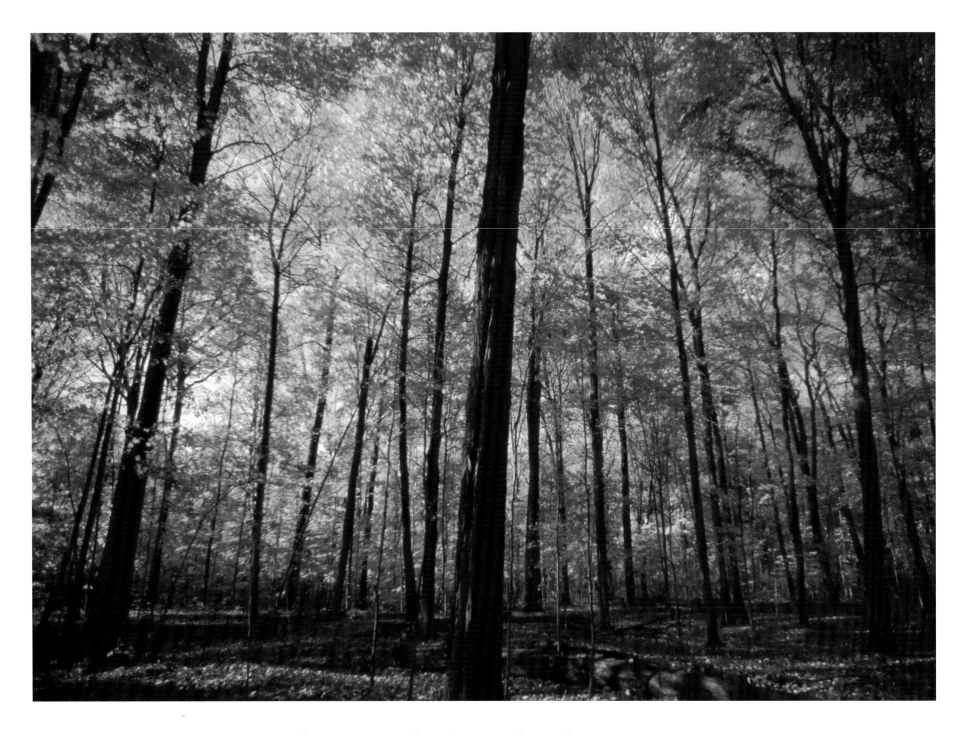

This scene was found off a country road between Erin and Belfountain. The maple-sugar bush has a heavy concentration of sugar-maple trees, whose leaves create a golden ambience in the autumn.

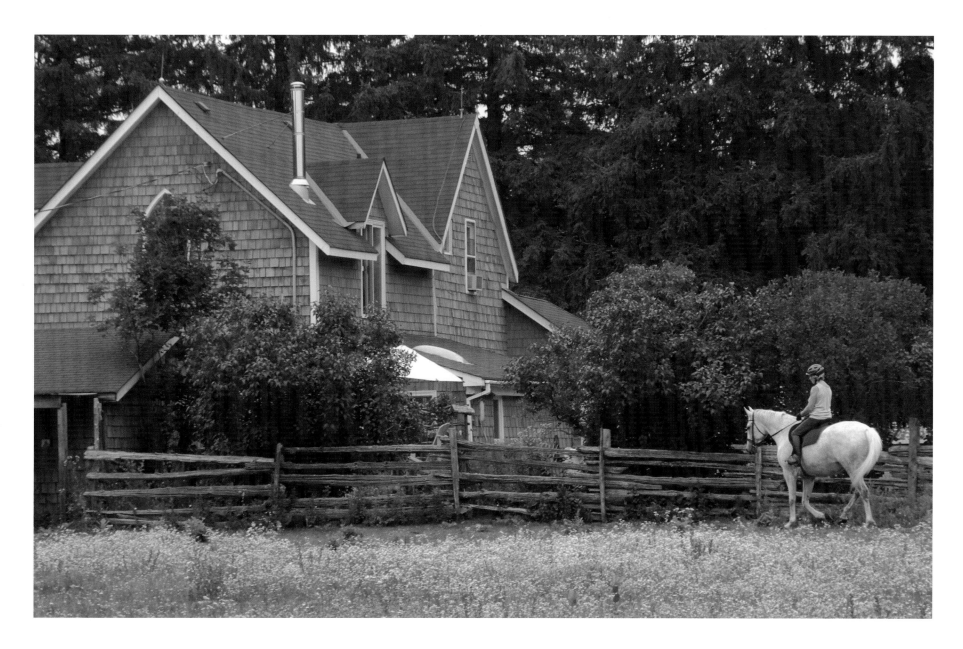

The Caledon area has a history of being home to some of the finest racehorses in Canada.
The rolling hills and open fields make it an ideal place for horse lovers to enjoy a ride.

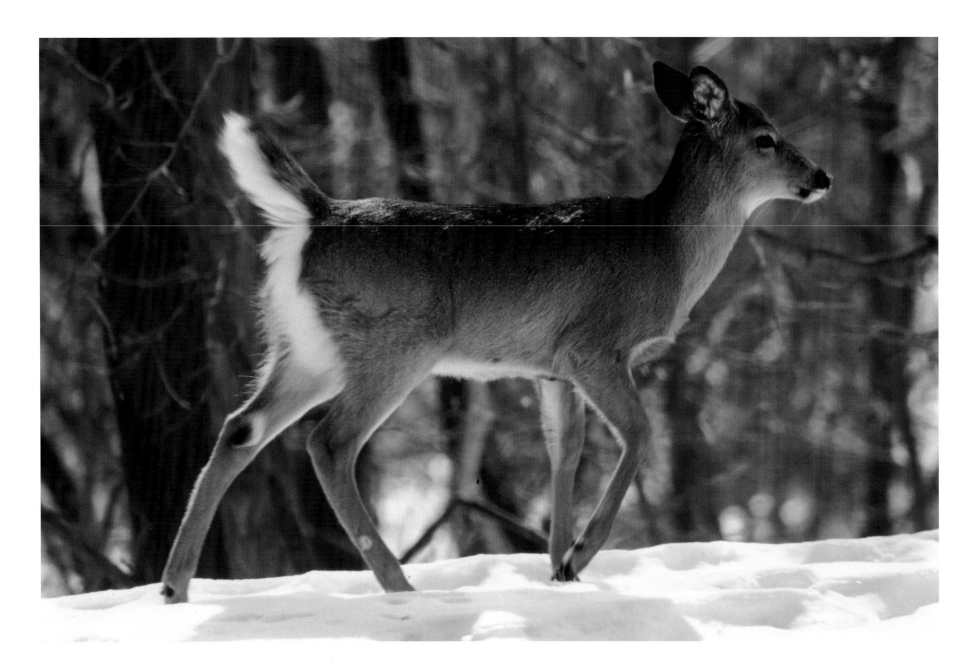

White-tailed deer are seen along the entire escarpment. They have adapted well to the encroaching urbanization and in some areas have become far too numerous due to the lack of natural predators.

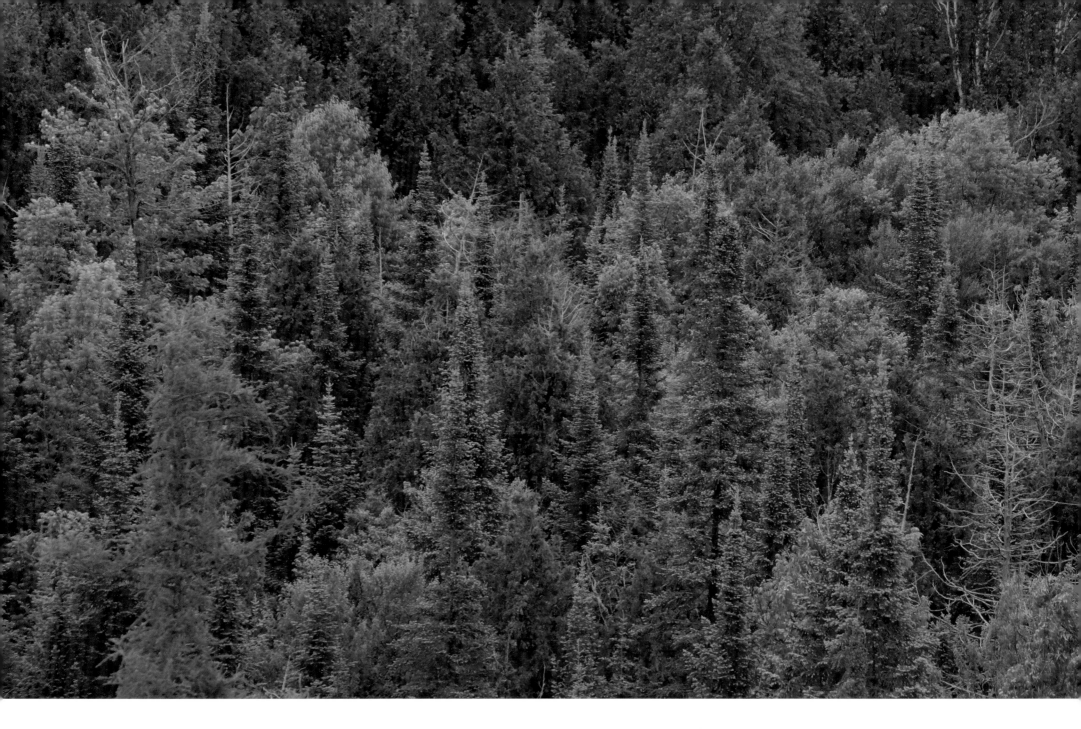

This forested valley is in the headwaters of the Humber River near the town of Mono Mills.

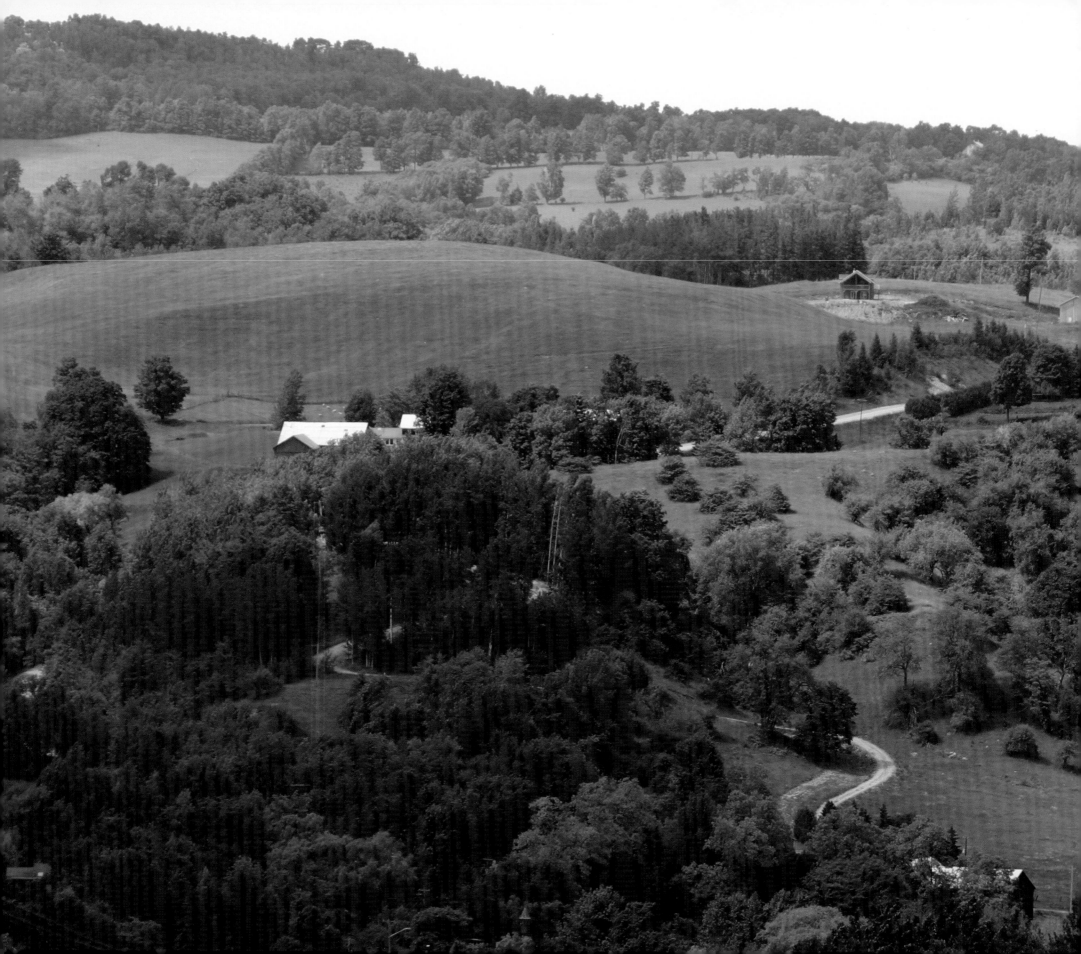

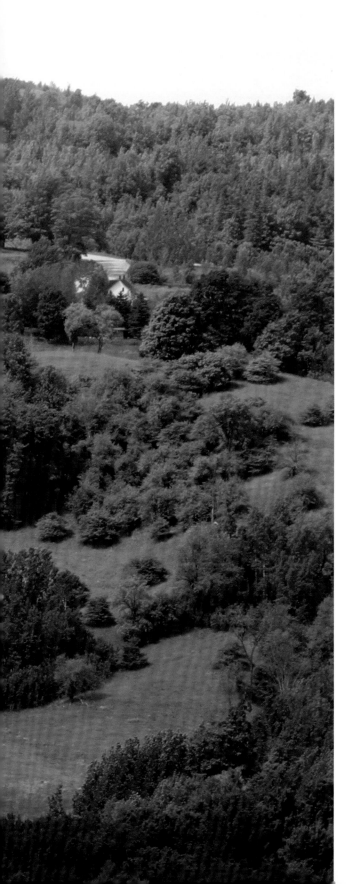

5 DUFFERIN HILLS AND NOTTAWASAGA HIGHLANDS

GONE ARE THE dramatic cliffs and jagged rock faces that are so characteristic of the Niagara Escarpment to the north and south. They are replaced here by glacial deposits that climb softly to great heights, giving magnificent vistas over the Nottawasaga Highlands and the Dufferin Hills.

Among the highlands are deep-cut river valleys formed by the Nottawasaga River and its tributaries. Visitors can explore the region's picturesque hamlets and small villages, which are home to artists' studios and antique and pottery shops, while they take in the gentle, rolling countryside unique to this region of the Niagara Escarpment.

Left: Lavender Hill is located south of the village of Dunedin in the Township of Clearview. This area of the escarpment is known for its rolling topography, with another hill or valley always around the next corner.

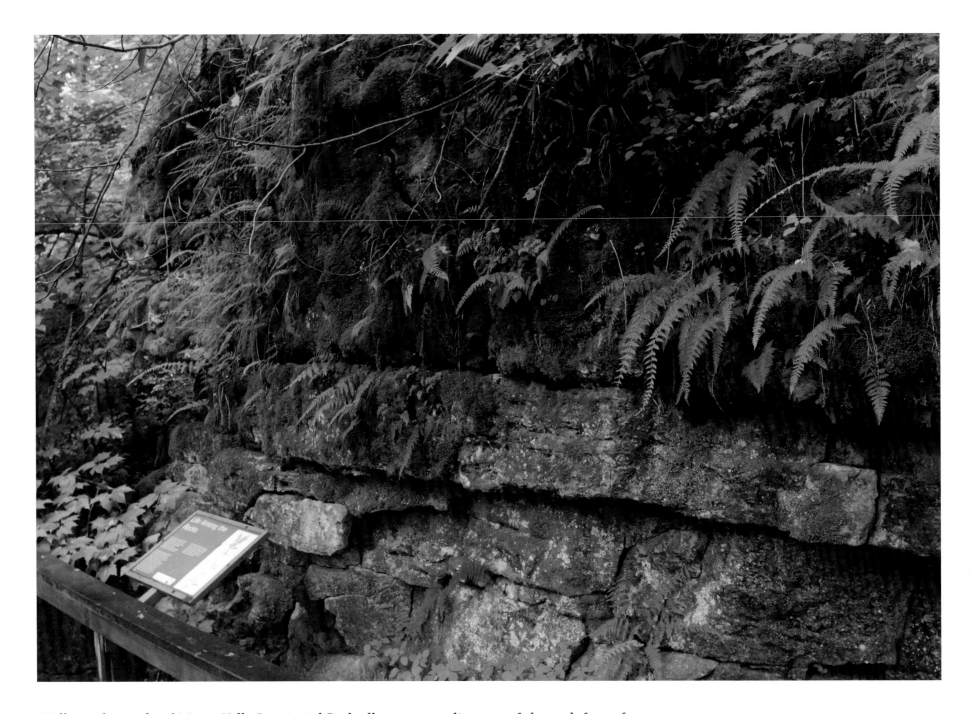

Walking the trails of Mono Hills Provincial Park allows many glimpses of the rock face of the escarpment. Here the ferns growing out of small crevices provide an interesting study for the botanist.

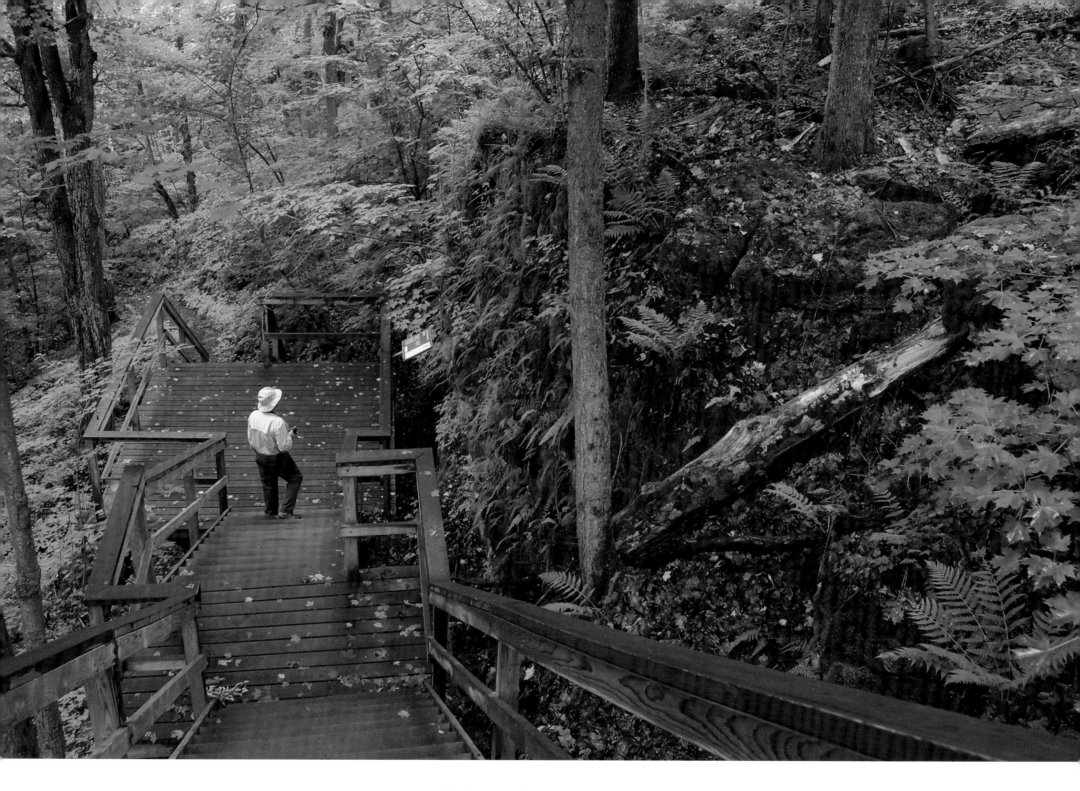

Stairs built into the side of the escarpment in Mono Hills Provincial Park provide easy access to the escarpment face and to the many ferns and other plants that thrive in the limestone crevices.

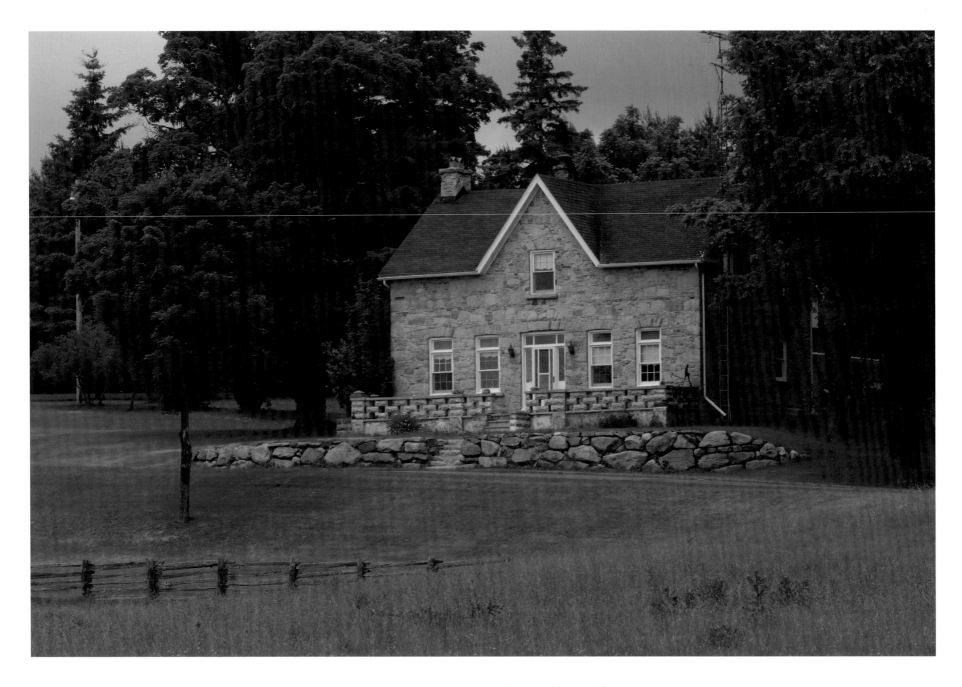

This beautiful old stone farmhouse is on Airport Road as you approach the Hockley Valley from the south.

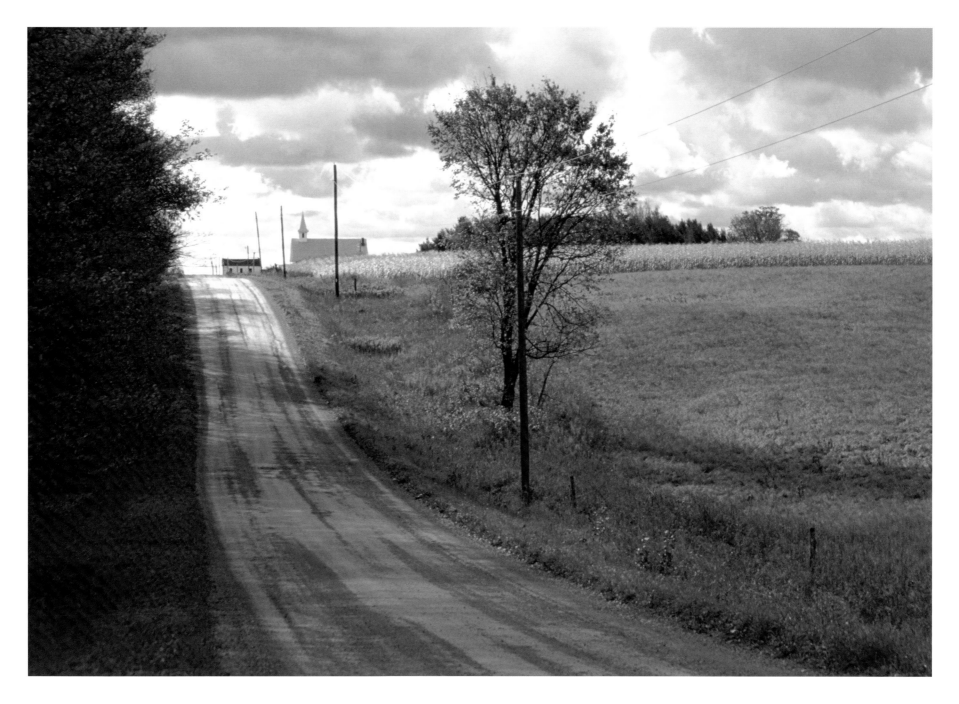

Driving back country roads, especially in the fall, gives one many picturesque scenes such as this one from the old community of Whitfield.

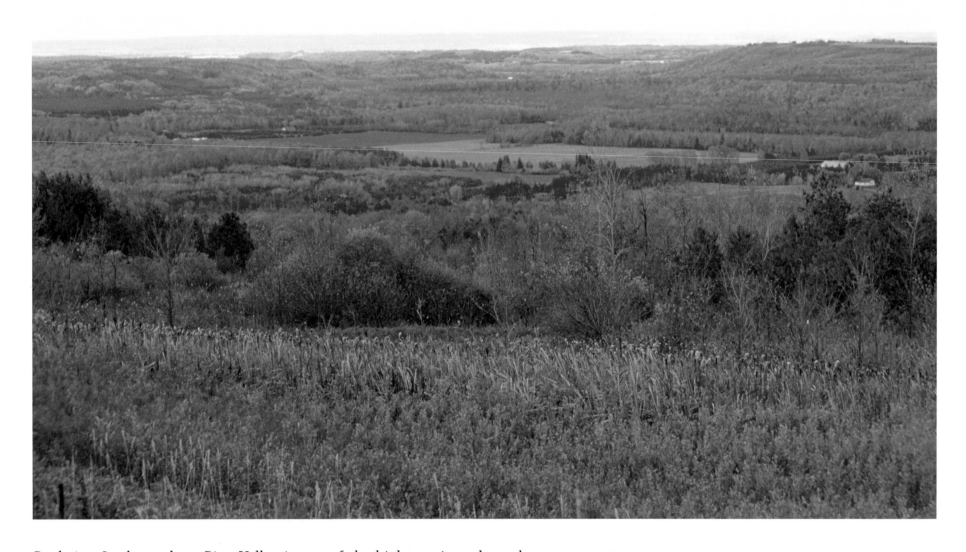

Ruskview Lookout along Pine Valley is one of the higher points along the escarpment.
Here one can see out to Georgian Bay on a clear day.

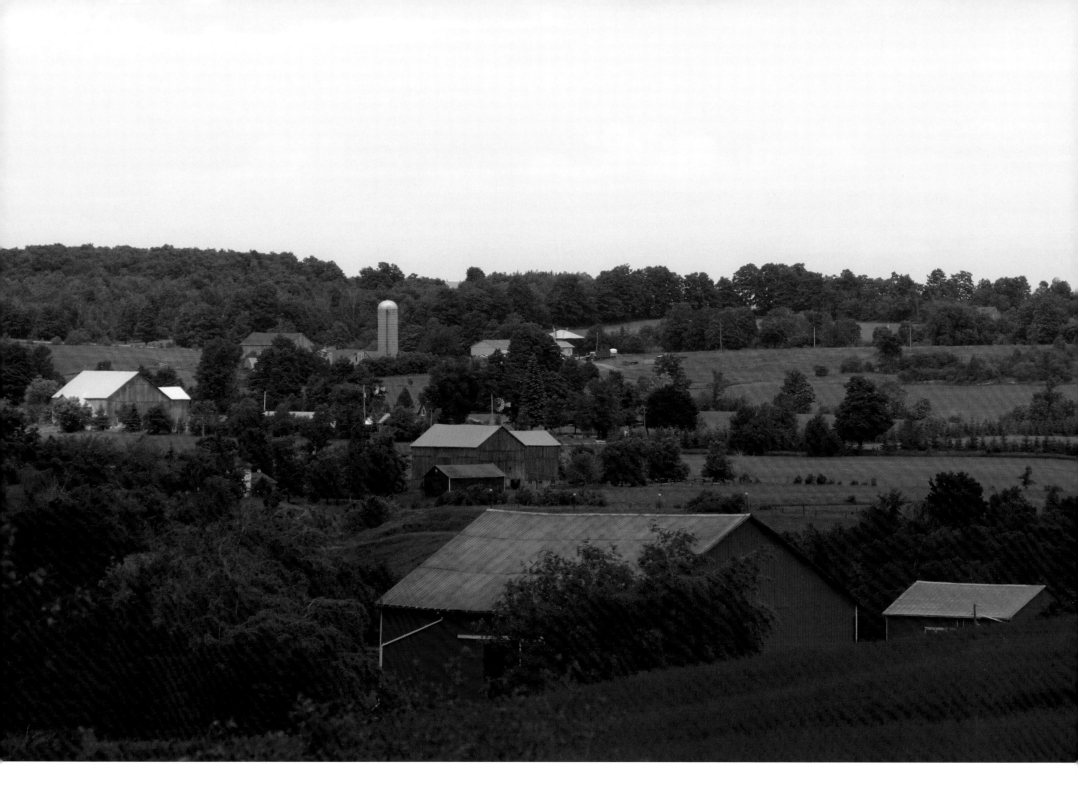

This pastoral view with numerous working farms was spotted along Centre Road in Mulmar Township.

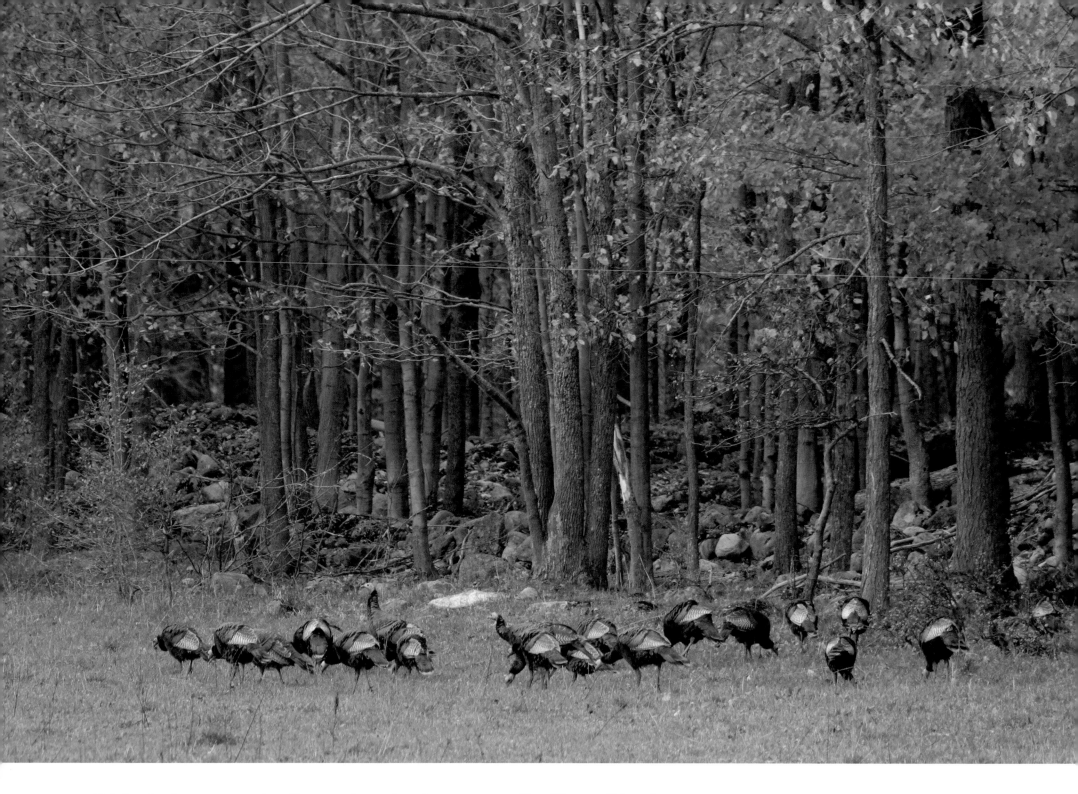

Driving backcountry roads offers much to the observant traveller. These wild turkeys were feeding along an old fencerow and at first, seen from a moving car, appeared as dark spots. A slow and quiet approach rewarded the photographer with this shot. The reintroduction of this bird into Ontario has been a great success story.

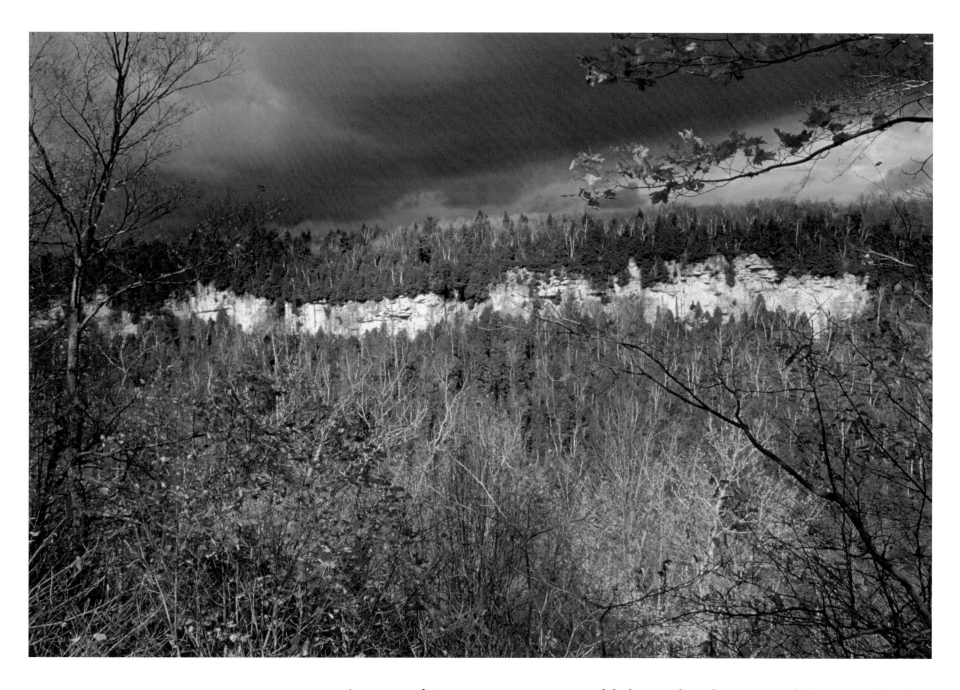

An approaching storm creates magical light on the white stone cliffs at Devil's Glen, where the Mad River has created this gorge.

Pretty River Valley Provincial Park is located just south of the Blue Mountains along the escarpment. Its forests and valleys provide an unbelievable show of colour in the autumn. The highest point on the Bruce Trail is located on one of the nearby hilltops.

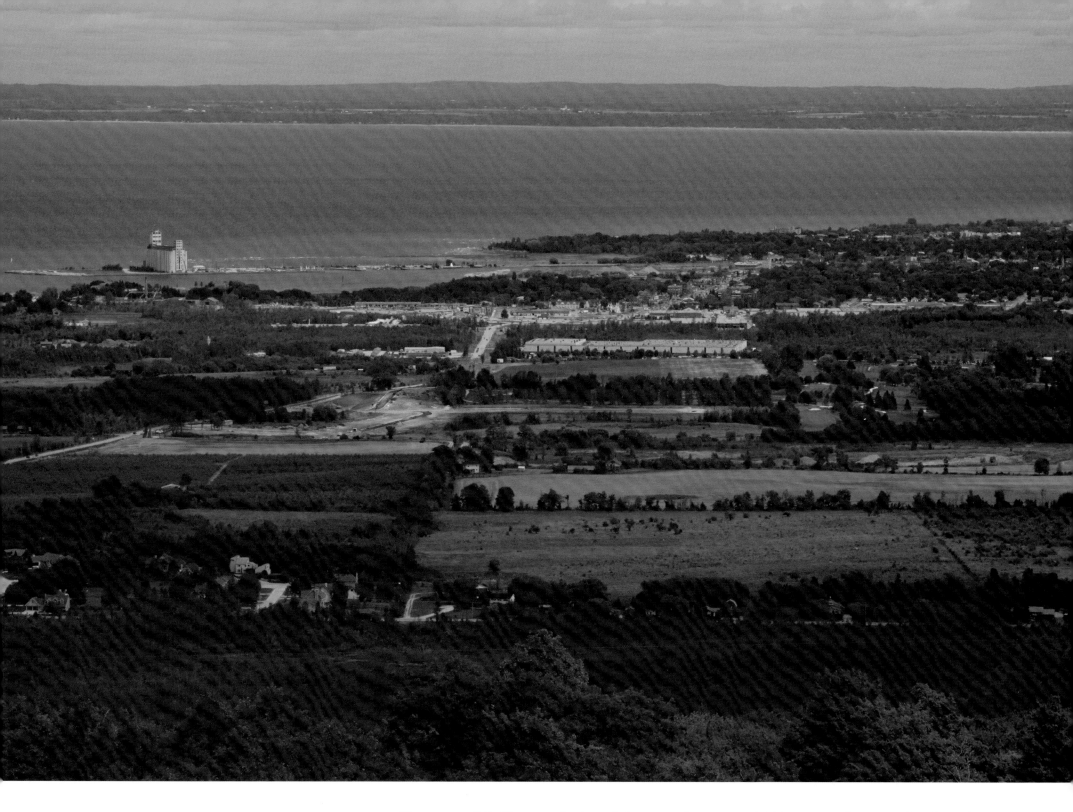

The town of Collingwood, viewed from an elevation of 550 metres above sea level on the escarpment at the property owned by Scenic Caves Nature Adventures. Here we can view approximately ten thousand square kilometres reaching out to Nottawasaga Bay.

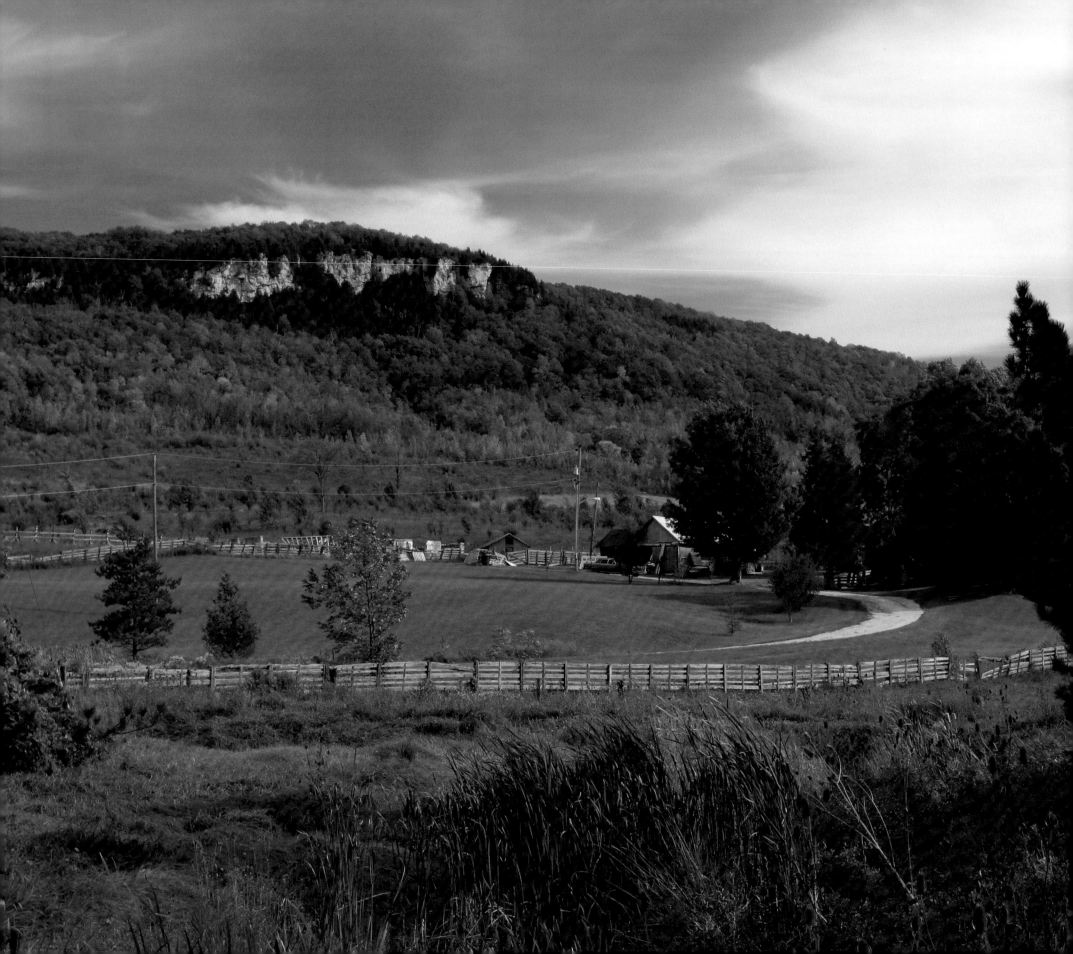

6 GEORGIAN BAY AND GREY COUNTY

THIS REGION, PROBABLY best known for Blue Mountain and its neighbouring ski resorts, also offers spectacular vistas overlooking dramatic cliff faces and some of the best rural landscapes a photographer could ever want.

The picturesque, U-shaped Beaver Valley offers some of the best scenery along the entire escarpment, and its unusual microclimate makes it particularly suitable for growing apples. The combination of apple blossoms in spring, the opportunity to hike, bike, and swim in summer, magnificent fall colours, and, of course, the best skiing in Ontario, is fast making this area a tourist mecca.

Farther north, the familiar jagged edge of the Niagara Escarpment returns, rising up over the rolling farmlands and patches of deciduous forests of northern Grey County. Hikers on the Bruce Trail travel through forests of ancient maple and beech trees and can marvel at the picturesque, gnarled, old-growth cedars that grow along the limestone cliffs of the escarpment.

Left: Old Baldy, an outcrop of Amabel dolomite overlooking the Beaver Valley, is a sentinel to travellers along Highway 13. A thirty-nine-hectare natural environmental area is located here on the rim of the escarpment.

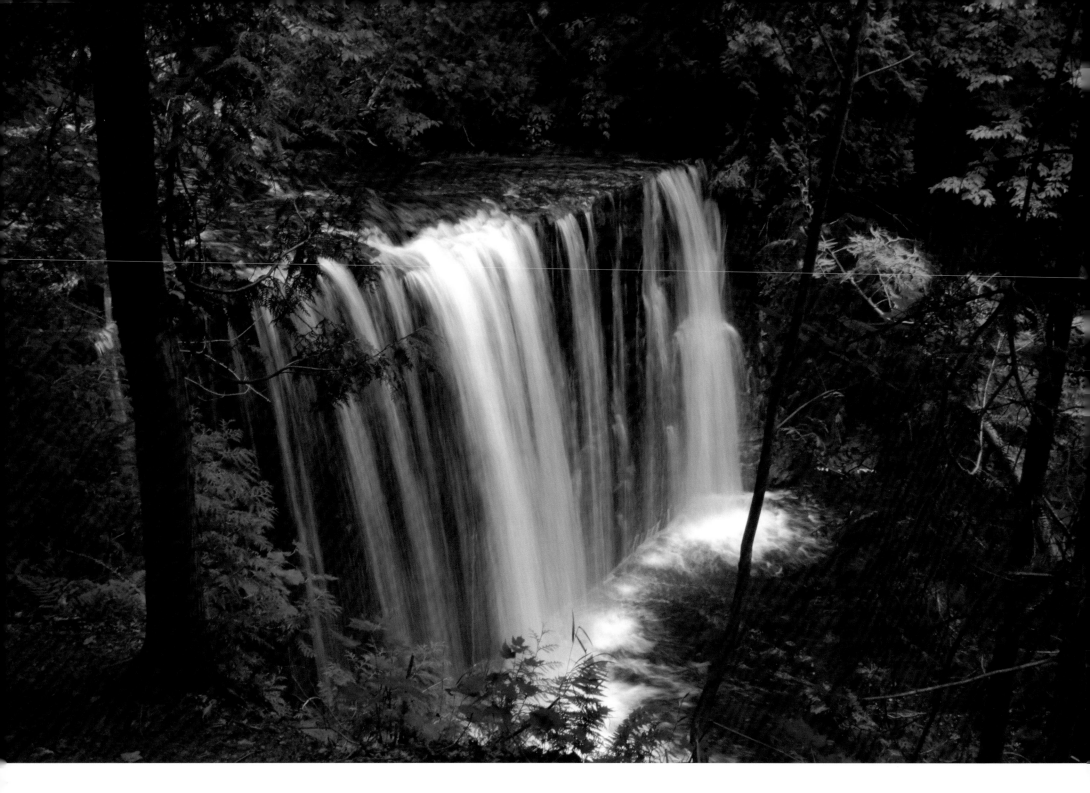

Hoggs Falls is located east of Flesherton off Highway 4. It is not easily found, but is reached by a short trail. Here the Boyne River drops over a small portion of the escarpment just below an abandoned mill site.

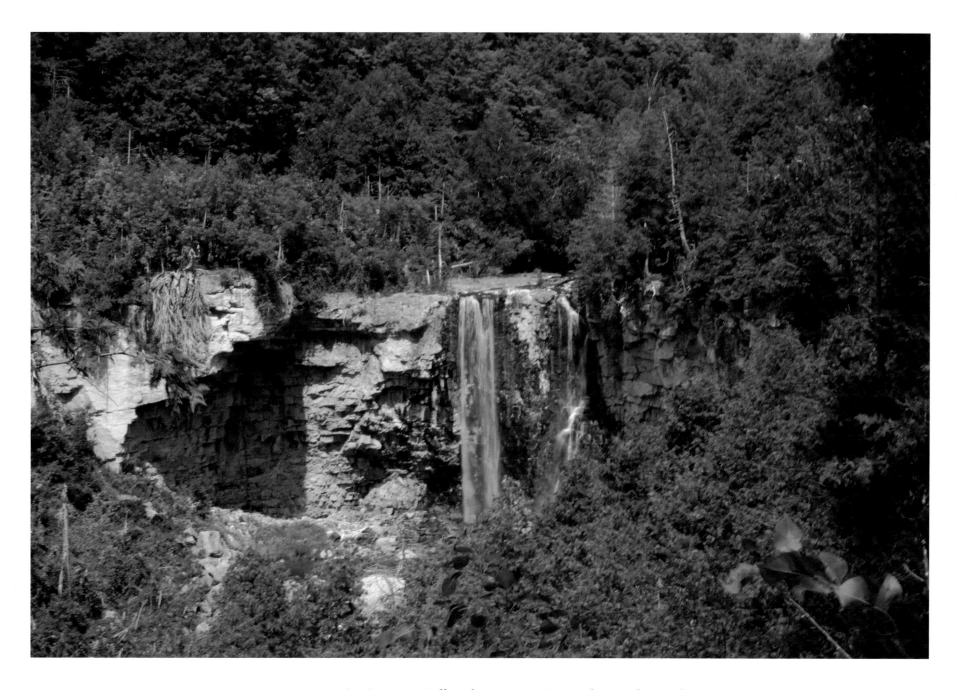

At Eugenia Falls, the Beaver River drops about thirty-two metres into a deep gorge. A pleasant picnic area is adjacent to the falls in the village of the same name.

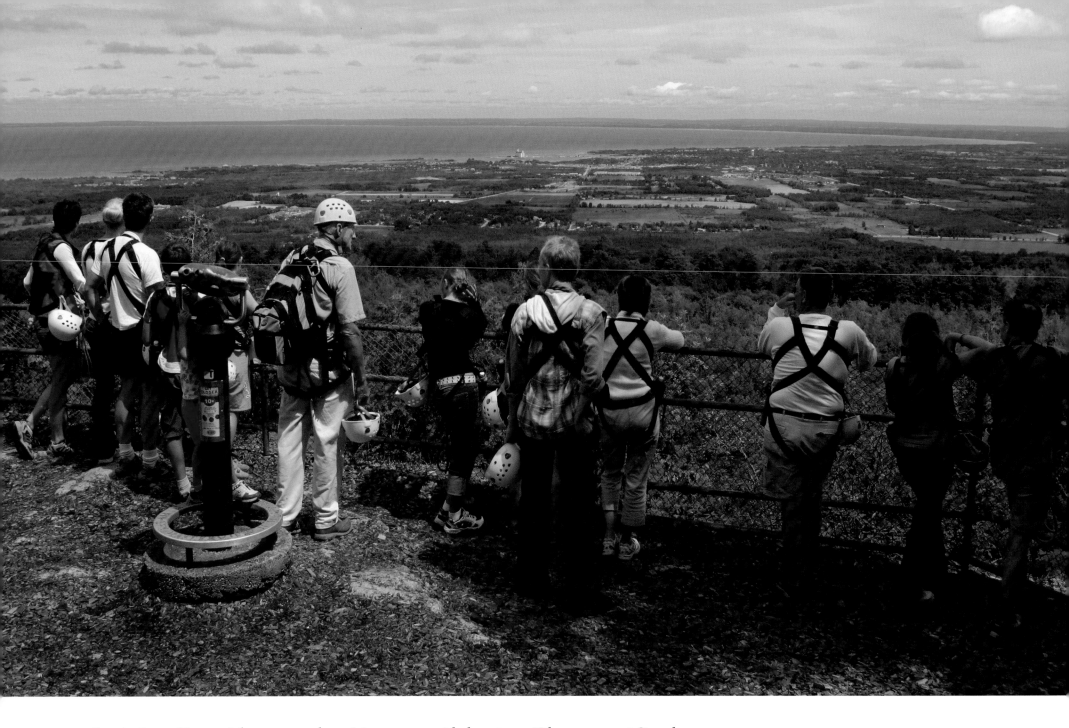

Scenic Caves Nature Adventures takes visitors on a guided ecotour. Hikers pause at Signal Point lookout to enjoy the broad vista across Nottawasaga Bay and the fertile fields below the escarpment near Collingwood.

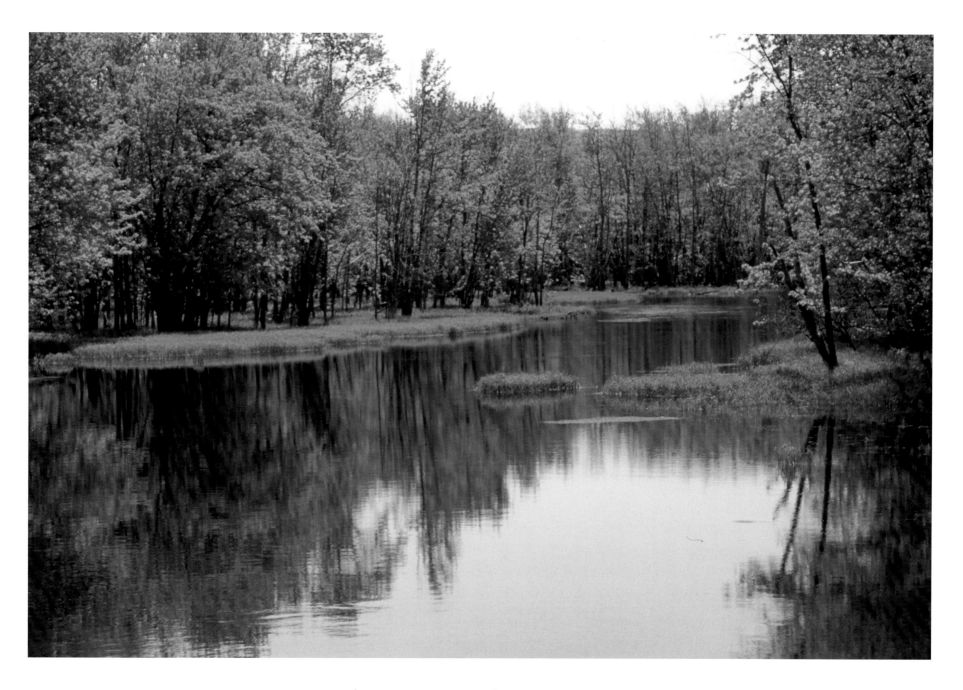

The Beaver River, seen here from Sideroad 19, is a major feature in the valley named after it. It is a popular and quiet canoe route.

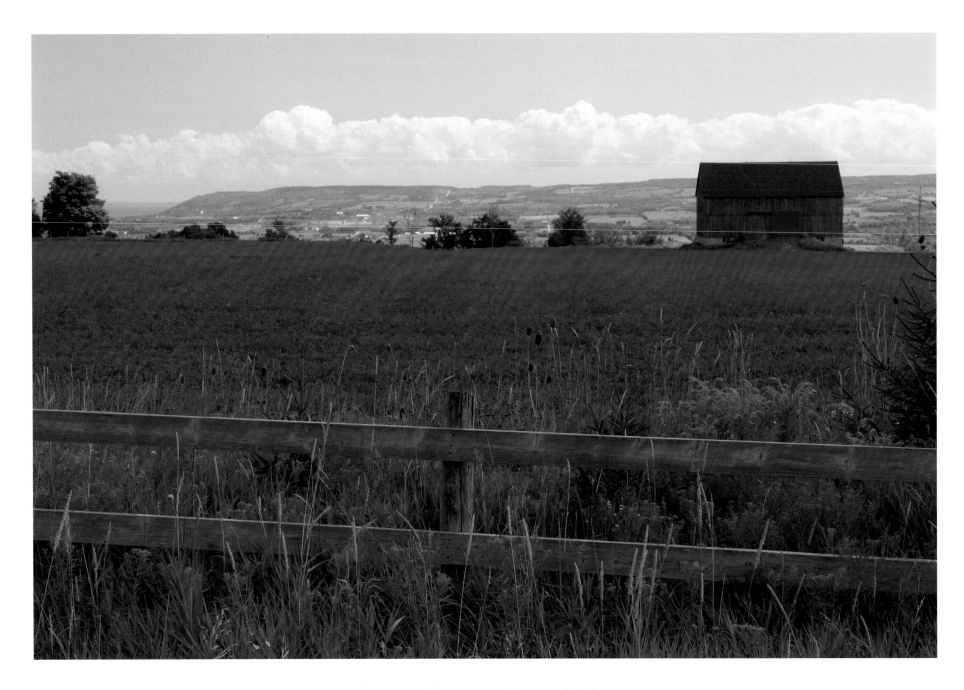

Travelling along Highway 7, one can enjoy many views of the Beaver Valley. It is hard not to envy people living here with vistas such as this on their doorstep!

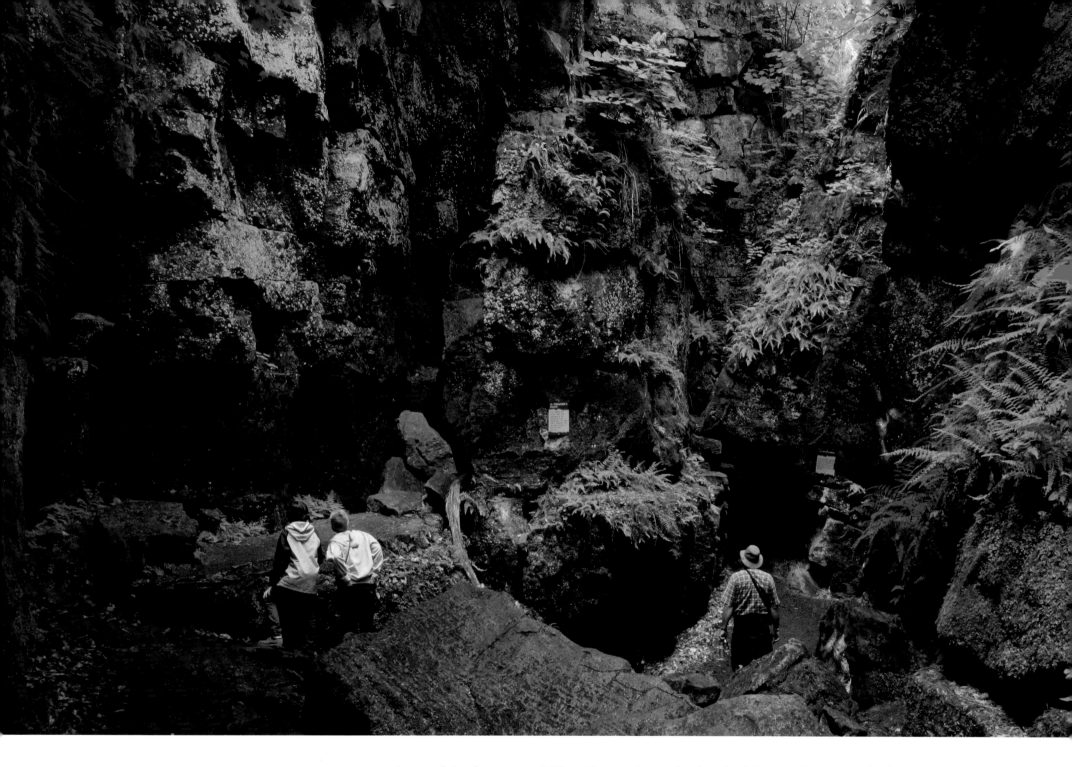

Located in the town of Blue Mountain at the head of Scenic Caves Road, these caves are found at the highest part of the Niagara Escarpment. They were formed by water action over the course of hundreds of millions of years. The first person to record having visited them was Samuel de Champlain in the first half of the seventeenth century. They have been a popular tourist attraction over the past seventy years.

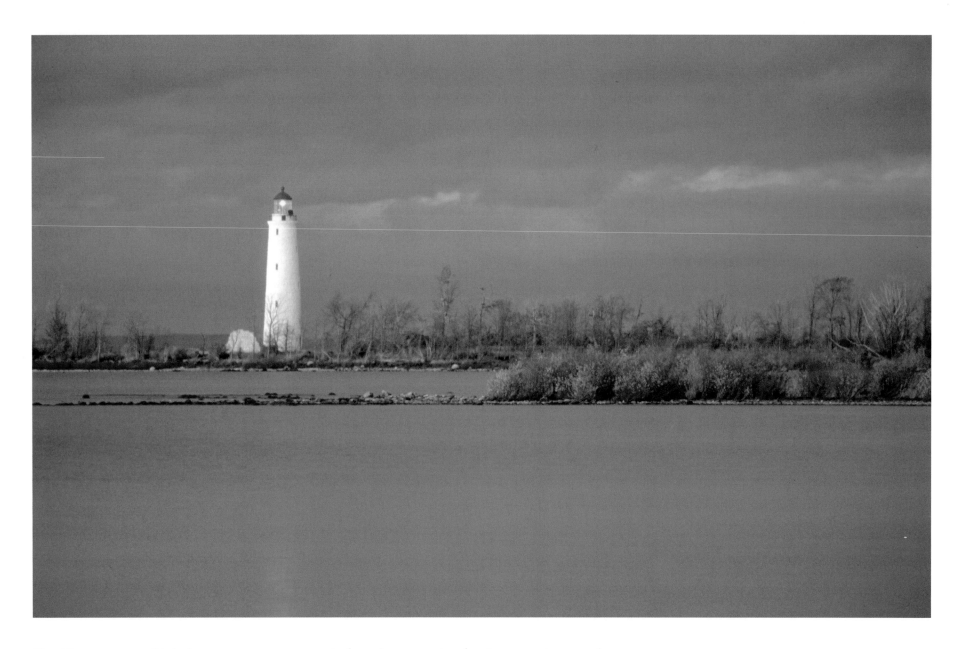

The Nottawasaga Lighthouse serves as a reminder of our marine heritage, as it served to guide ships around the treacherous shoals and fierce gales of Georgian Bay. It is located on an offshore island just west of Collingwood. This limestone structure was built in 1858 and stands twenty-eight metres tall, but now has a huge hole in its opposite side from the constant battering.

Craigleigh Provincial Park, located on the shore of Georgian Bay, offers 172 waterfront campsites. At this popular park one can find fossils embedded in the shoreline rocks and enjoy the clear water of the bay.

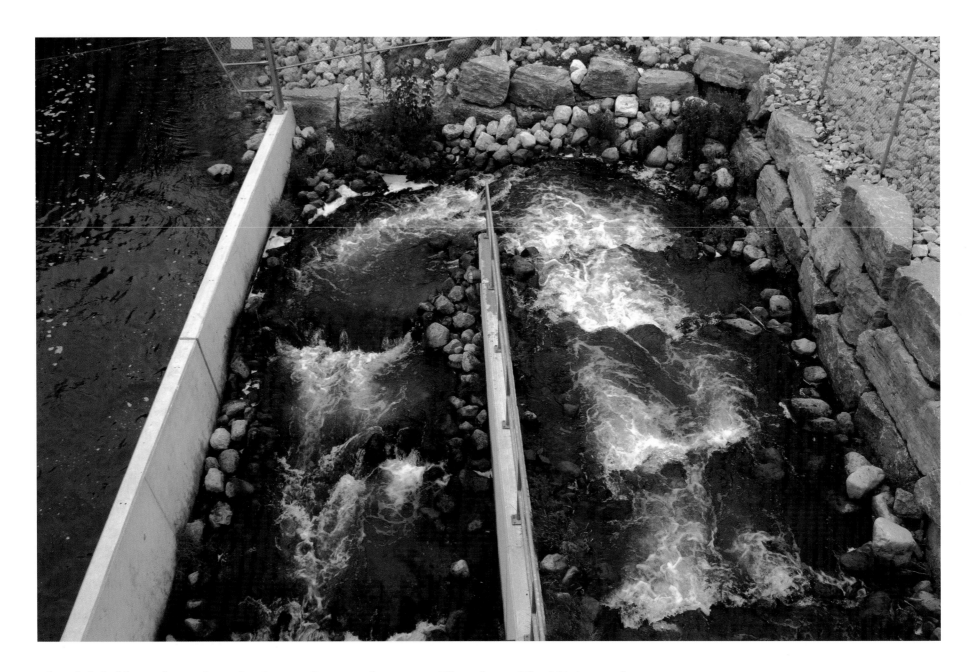

This fish ladder is located on the Beaver River in downtown Thornbury. The Ministry of Natural Resources built the ladder to allow salmon to get past the dam on the Beaver River and return to their original spawning grounds.

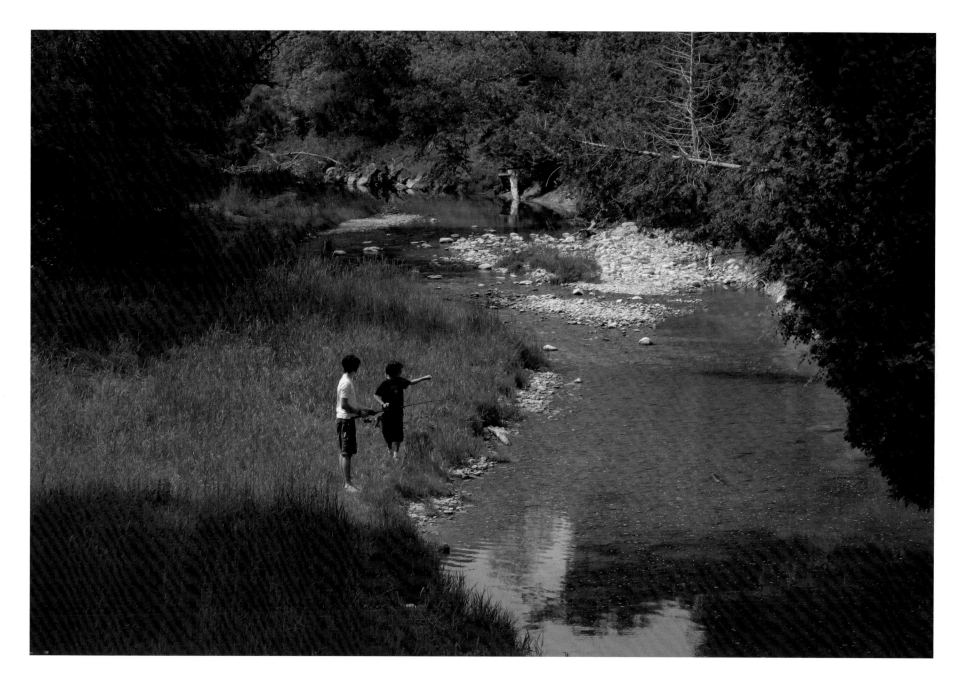

These young anglers are enjoying spending a summer morning fishing in the village of Leith on the shores of Owen Sound Bay.

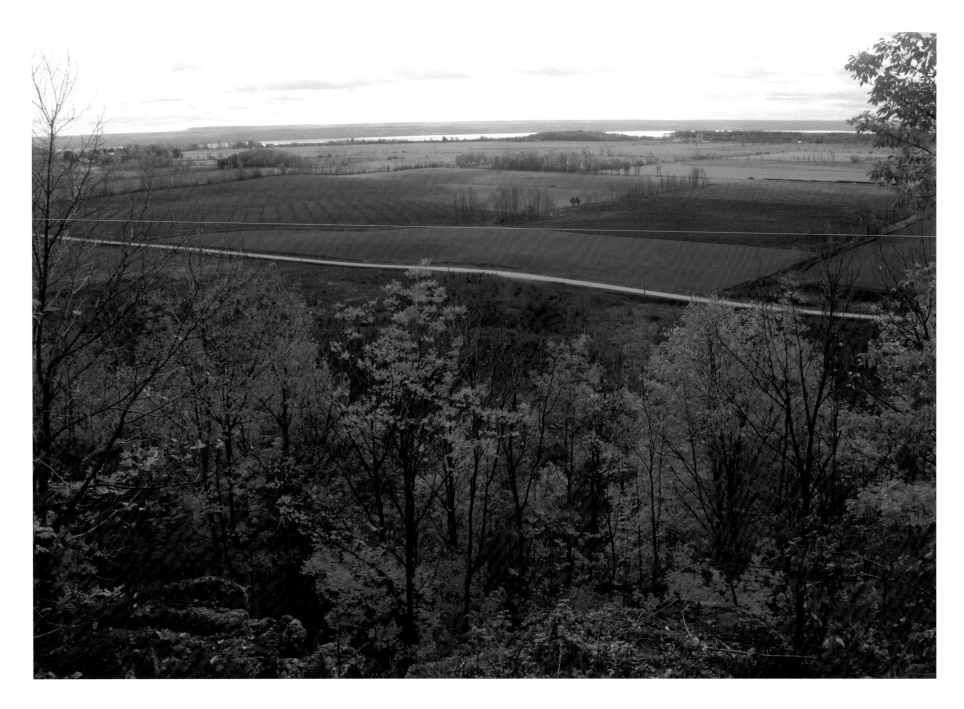

The Kemble Mountain Forest is an upland hardwood forest owned and managed by the Grey Sauble Conservation Authority. This lookout provides an impressive view out over the north Grey County farmlands. Owen Sound Bay can be seen on the horizon.

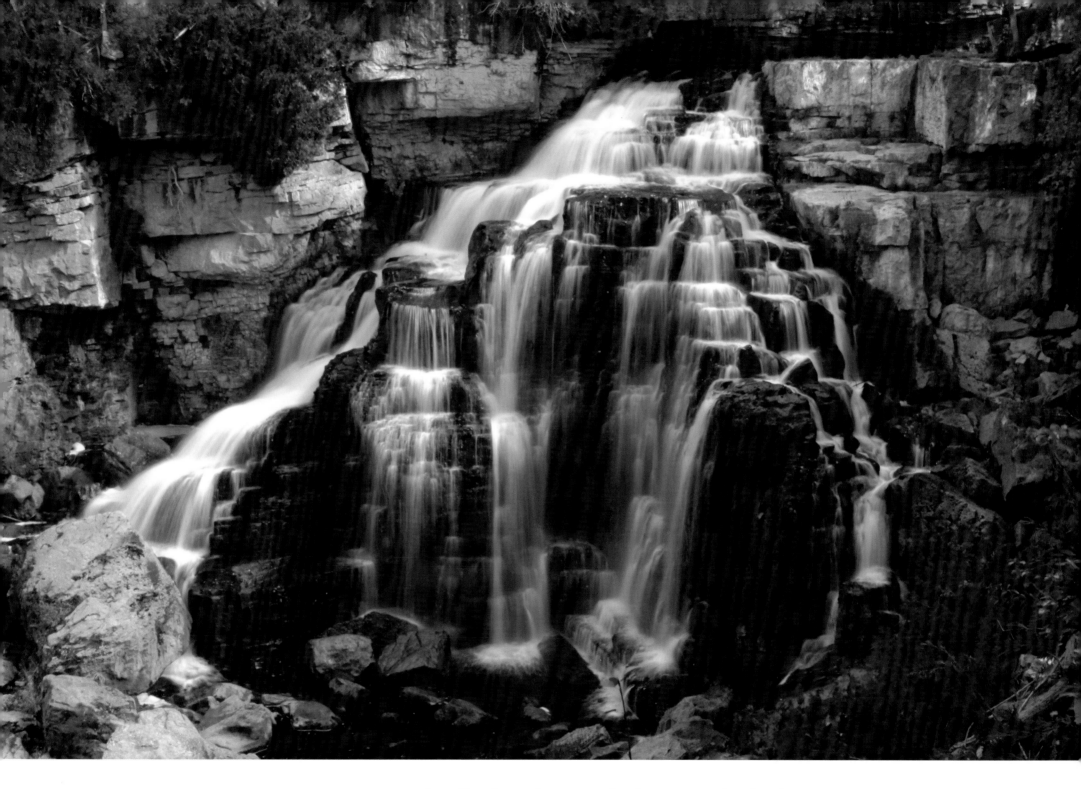

Inglis Falls is located just outside of Owen Sound and is the most spectacular waterfall in the northern part of the escarpment. Here the Sydenham River cascades eighteen metres, creating a deep gorge below the rock face.

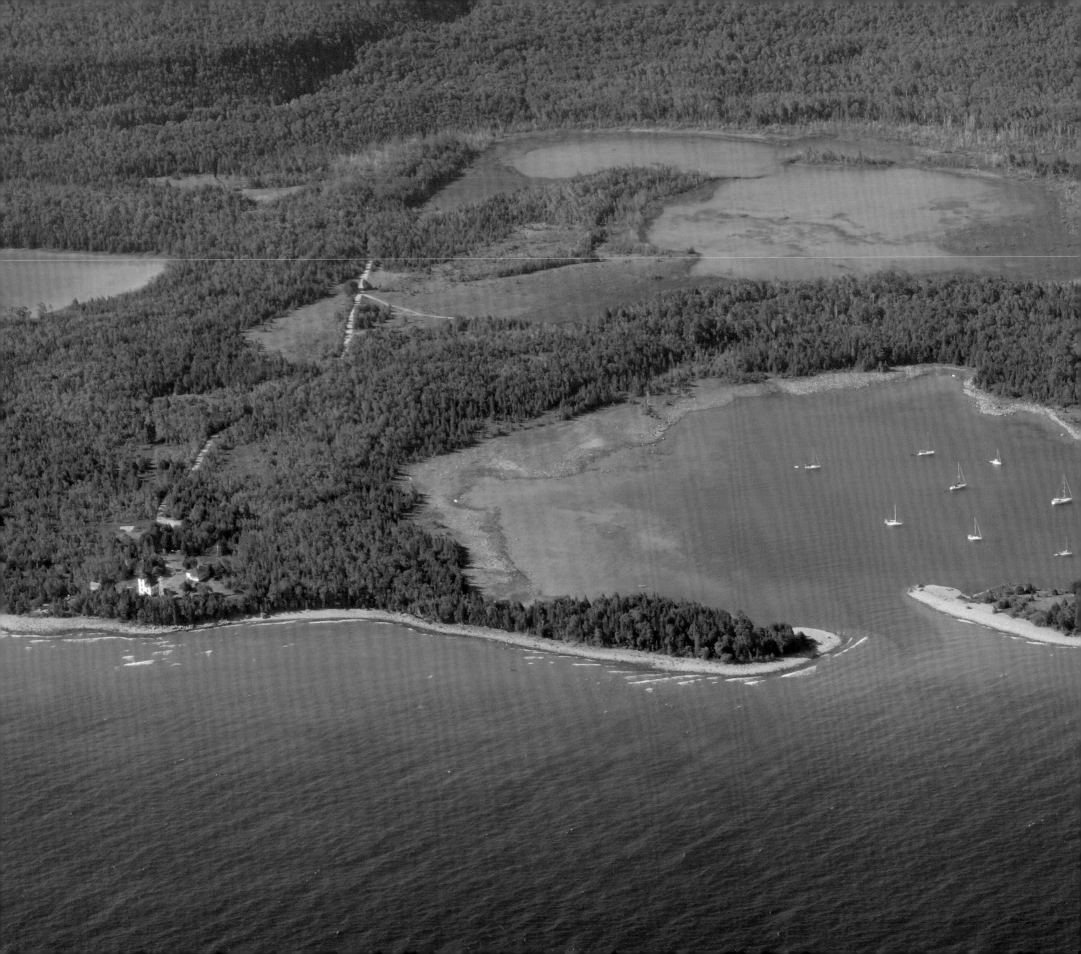

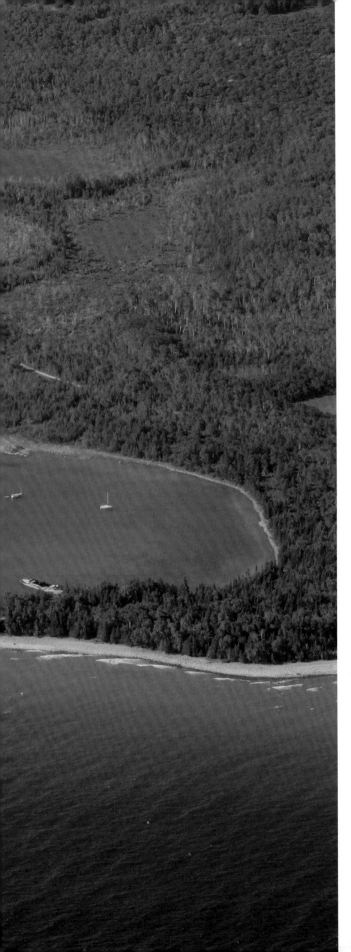

7 BRUCE PENINSULA

THE SHEER CLIFFS of the Niagara Escarpment stretch skyward, providing a dramatic backdrop for the clear blue waters of Georgian Bay. In some places, caves and grottos have been sculpted out of these cliffs by the constant pounding of the waves. Not far away, quiet fens and forests that are home to more than thirty varieties of wild orchid and delicate ferns provide a retreat for animals and humans alike.

This rocky finger of the Niagara Escarpment juts out into Lake Huron, where it then drops out of sight. But as the Giant's Rib sinks into the water, visitors have an opportunity to explore thirteen parks in this region, offering everything from shipwrecks to the unusual natural geological formations of Flowerpot Island.

Left: Wingfield Basin is located at Cabot Head, midway between Tobermory and Lion's Head. It is on the east coast of the Bruce Peninsula and has offered safe shelter to many boaters over the years. Reached via a very narrow channel, it creates an extremely safe anchorage.

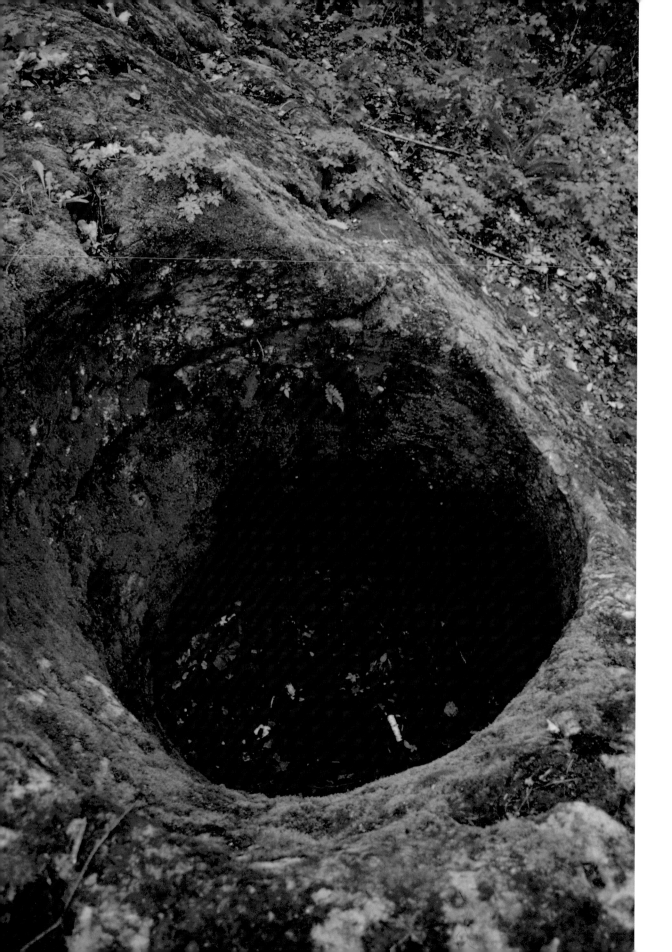

The limestone of the Niagara Escarpment contains many interesting geological features, including this pothole found within Skinners Bluff in the Township of Georgian Bluffs.

Potholes were caused by the erosional effects of moving water and abrasive boulders, or "grinders," acting in a swirling motion over a very long period of time.

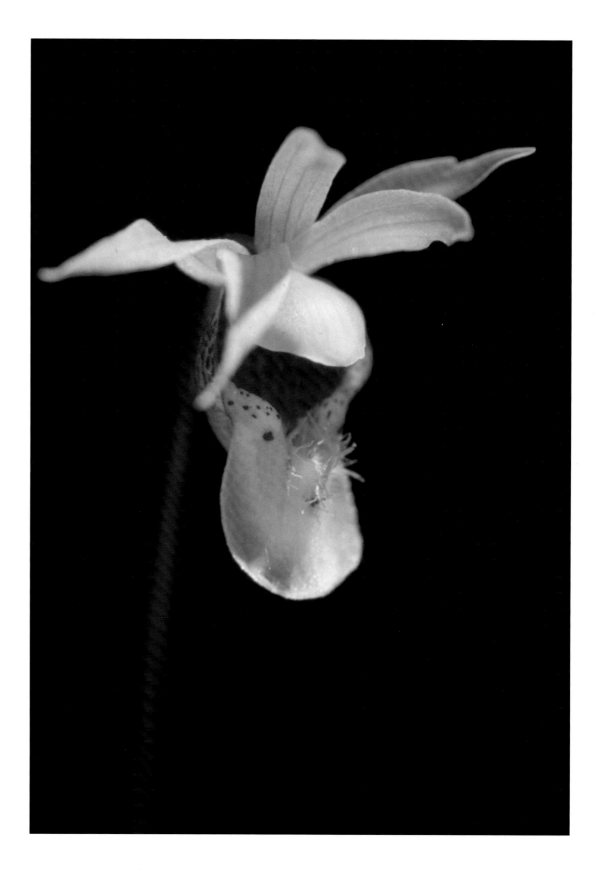

The rare Calypso Orchid, a small, 10 to 20 cm high flower stock, with its pink, slipper-like lip and yellow crest, is probably the most sought after of all the Bruce Peninsula's orchids. For years, botanists have marvelled at finding some thirty-eight of the world's fifty or so orchid species growing on the peninsula.

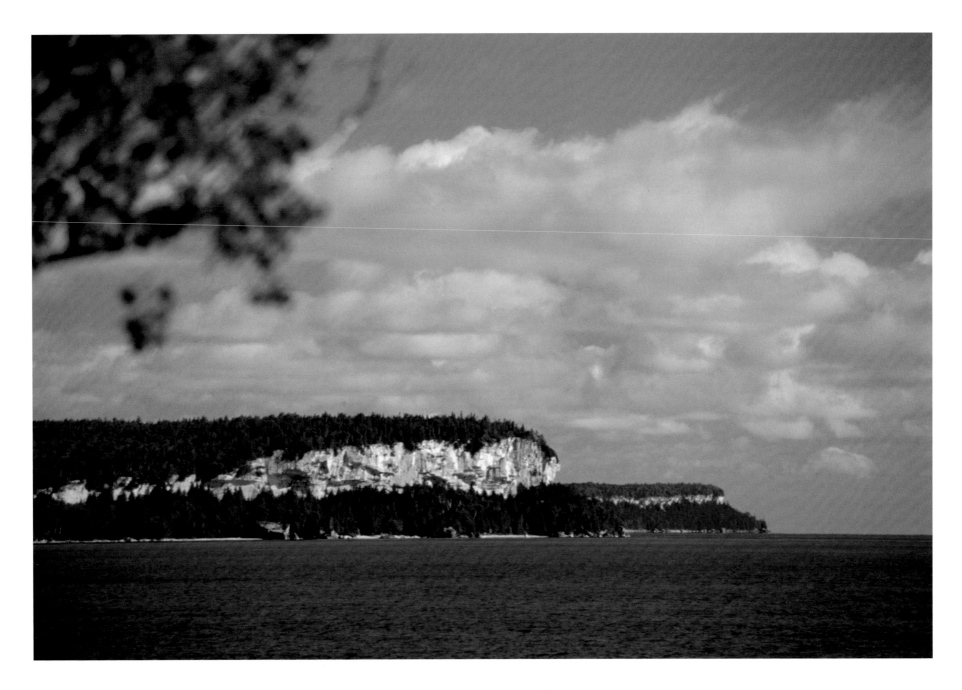

Colpoys Bluff is located on the north shore of Colpoys Bay near Wiarton. This summer scene was photographed from one of the popular outlooks on the opposite side of the bay.

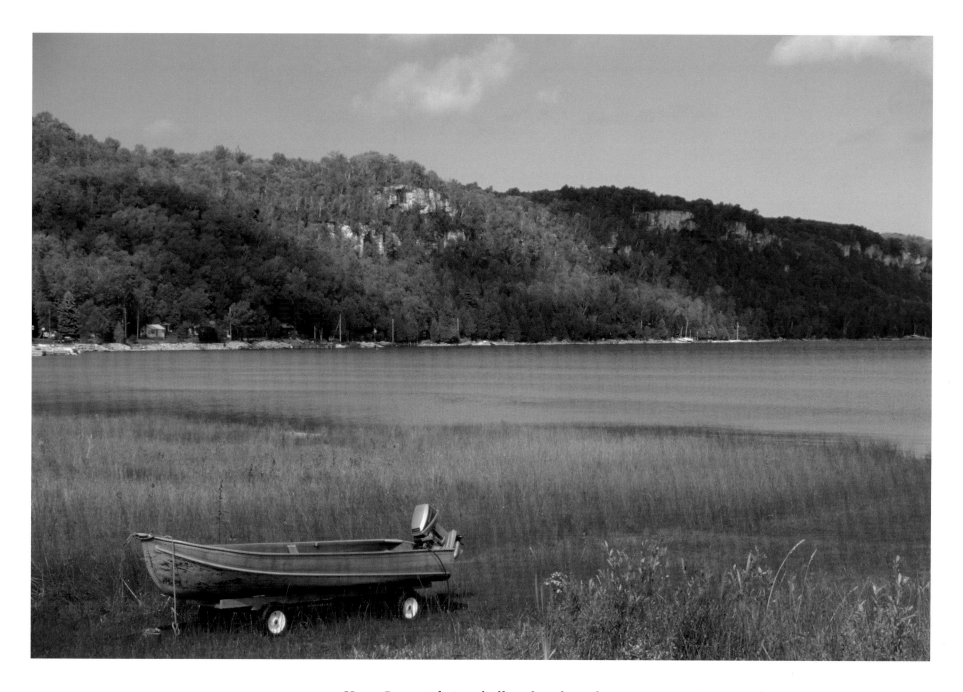

Hope Bay, with its shallow beach and warm water, is a popular summer vacation site south of Lion's Head.

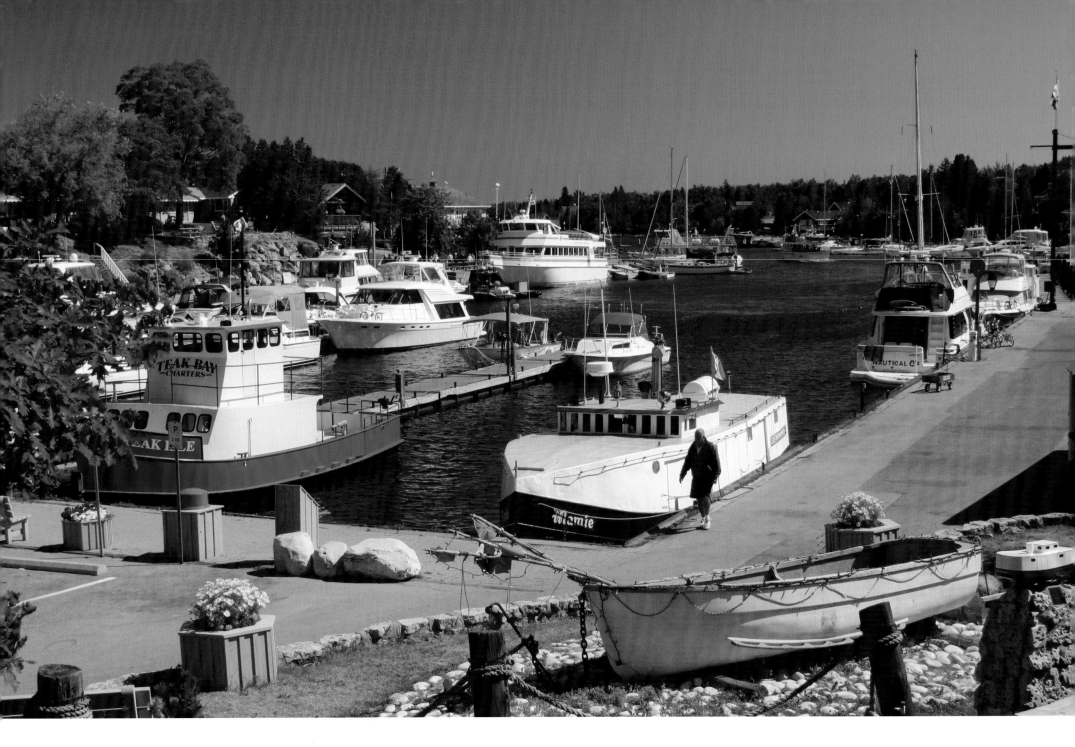

Little Tub Harbour at Tobermory is a busy stopover for boaters during the summer months. This community at the tip of the Bruce Peninsula was named Tobermory by its early Scottish settlers after their seacoast village on the Isle of Mull, Scotland. It is the northern terminus of the Bruce Trail as well as the headquarters of Fathom Five National Park.

Big Tub Harbour at Tobermory was the site of the sinking of the vessel *Sweepstakes* in June of 1896. The cold waters have preserved its hull, as well as some thirty other area shipwrecks, for generations of people to view. The unusually clear waters with visibility of up to ten metres make for easy viewing.

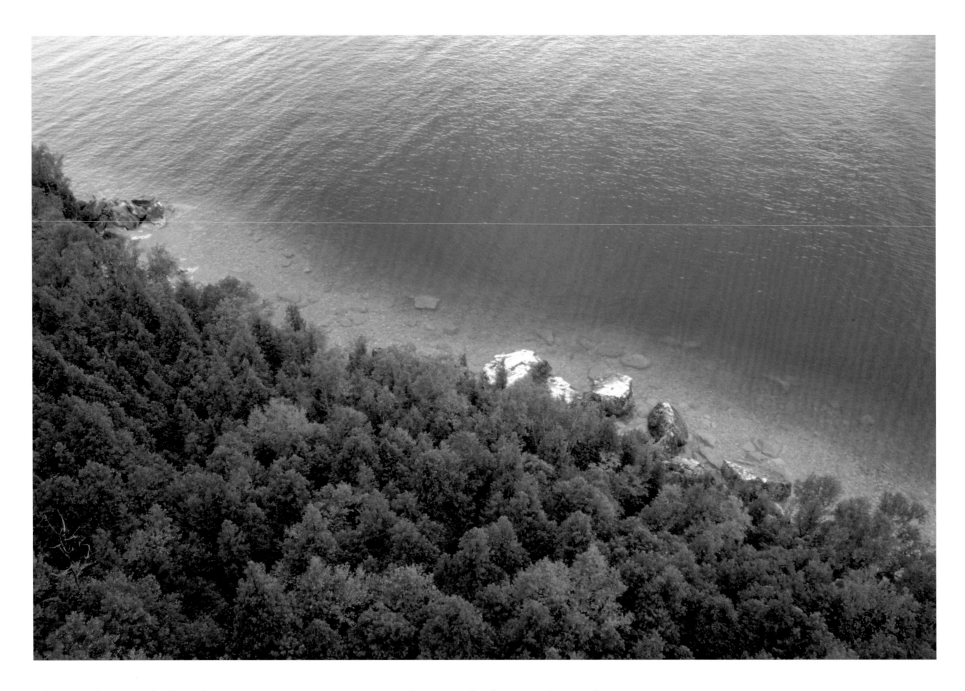

This undisturbed shoreline on Georgian Bay was photographed near Cape Chin. The clarity and colour of the water remind one of the Caribbean, though the temperature doesn't.

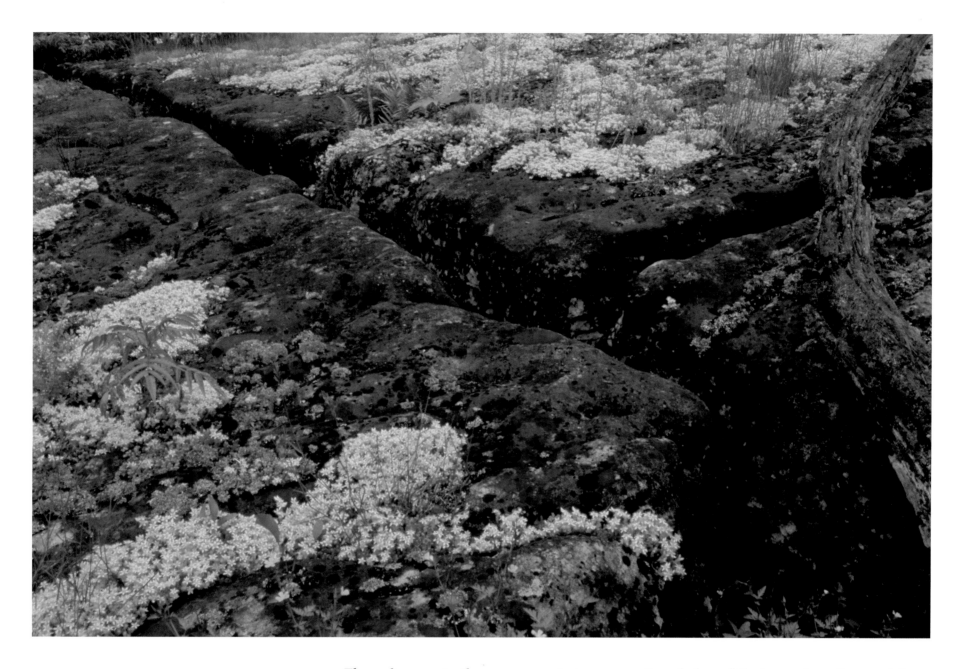

These fissures in the escarpment stone were found along "Chainsaw Lane," named for a local farmer who has a business of repairing and servicing chainsaws. The blackened rock contrasts with the Herb Robert and Stonecrop growing on its surface.

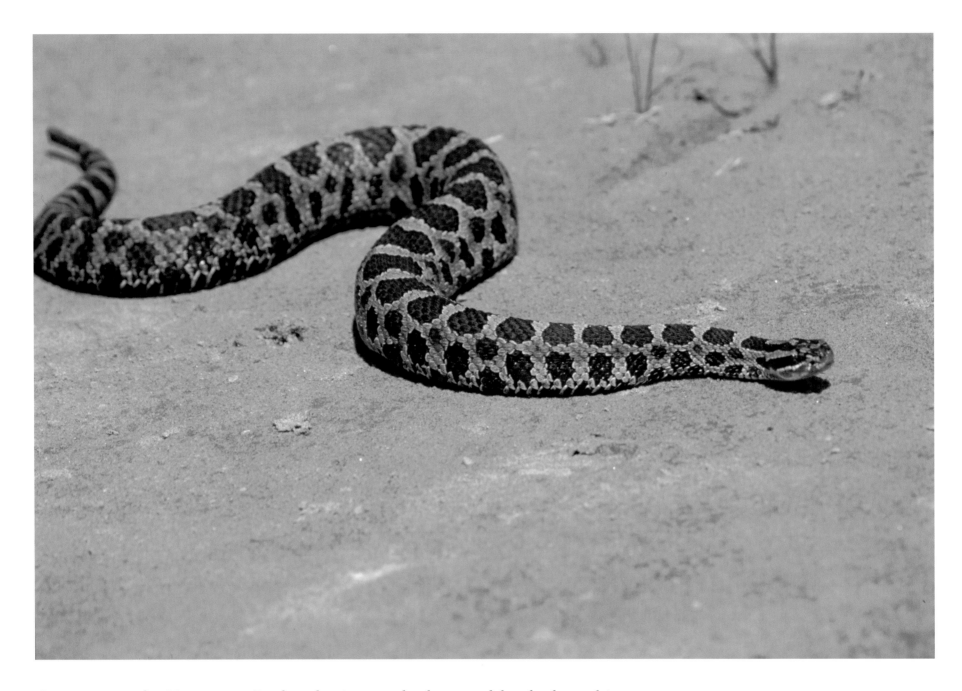

One creature, the Massasauga Rattlesnake, is severely threatened by the loss of its habitat due to the increased building of residences along picturesque areas of the Bruce Peninsula.

The Lion's Head Peninsula juts out into Georgian Bay. The large, relatively undisturbed forest is protected by a 526-hectare nature reserve. This image shows the exposed limestone cliff face and the talus slope, which consists of mounds of rock debris covered by vegetation.

Flowerpot Light is situated in Fathom Five National Marine Park and is accessible only by boat. The lighthouse has been guiding ships through this busy channel near Tobermory for over a century.

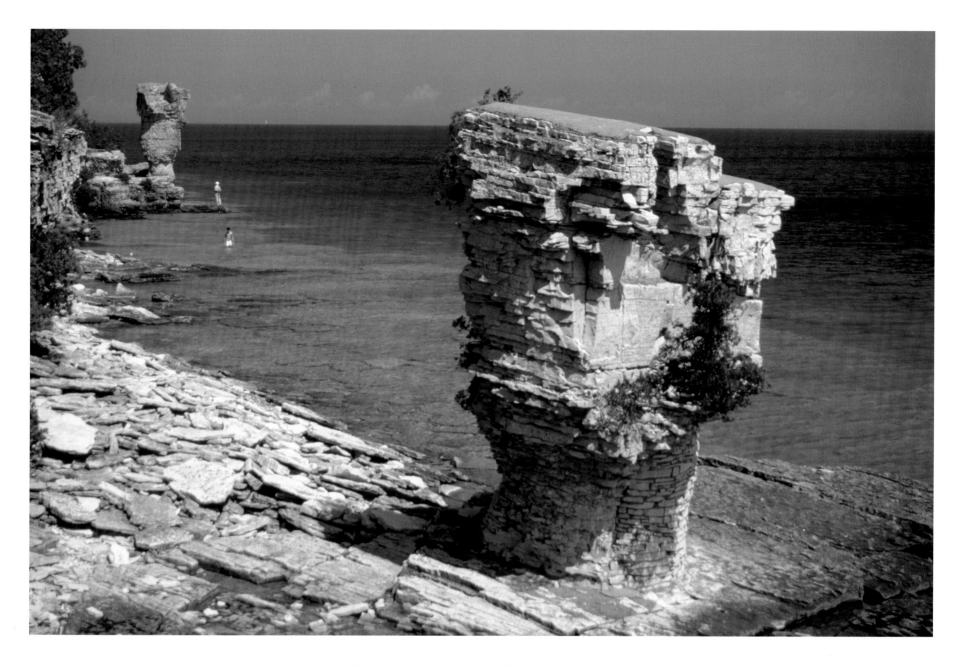

Flowerpot Island, lying five kilometres northeast of Tobermory, can be reached by one of the many local tour boats. The island is part of Fathom Five National Marine Park and a popular site for summer visitors and divers. One legend says the "Flowerpots" are effigies of a Native couple who were forbidden to marry since they were from different tribes. These pillars are actually the work of millions of years of natural forces.

ACKNOWLEDGEMENTS

We would like to thank the Giant's Rib Discovery Centre for first encouraging us to bring together our images of the Niagara Escarpment in slide shows, giving us the opportunity to not only share our love of the area and entertain people, but to contribute to the education of our audience about the importance of protecting the escarpment for future generations. Thanks also to the incredible and valuable work of the many conservation authorities that play such a vital role in the protection of the Niagara Escarpment. Special thanks to the many individuals who have helped us capture images for this book. Most importantly, a special thanks to our families for putting up with our passion for photography.